An artist's guide to painting *light*

Create depth, form and atmosphere with light in watercolour and oils

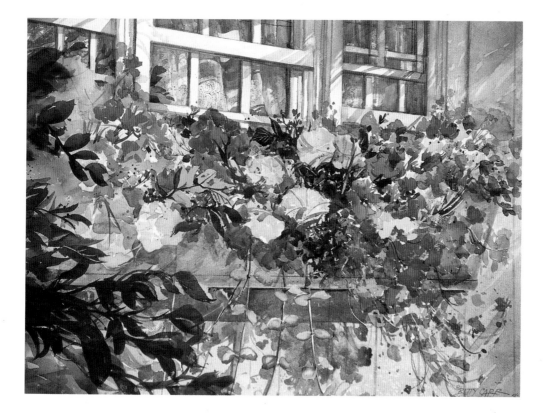

Betty Carr

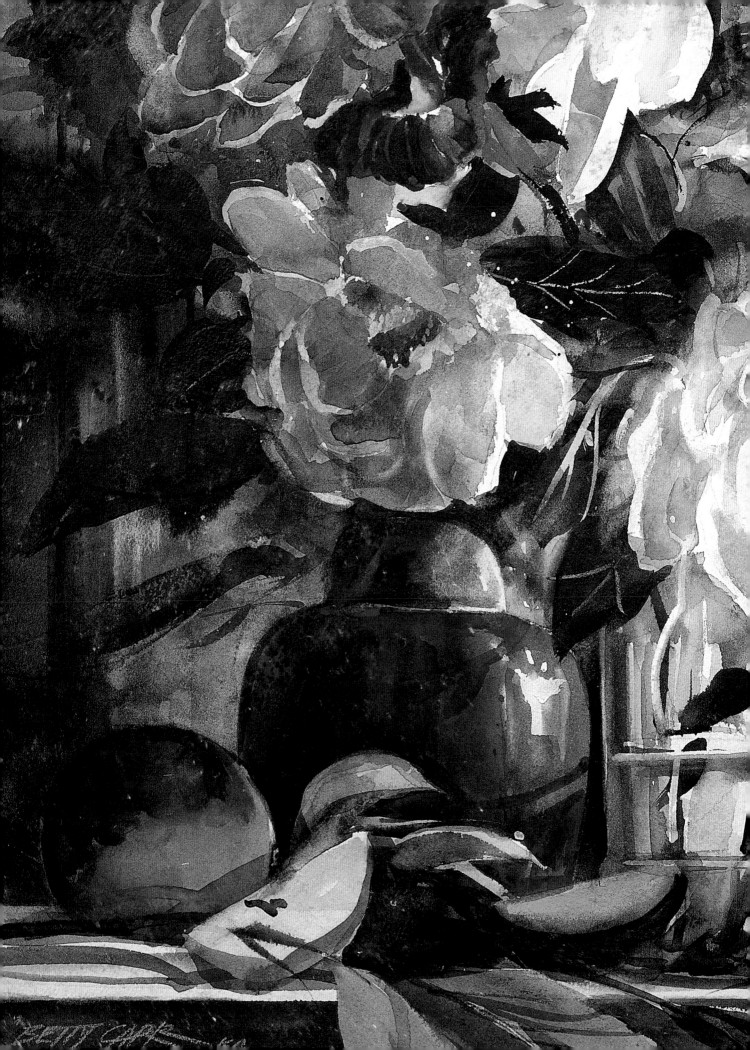

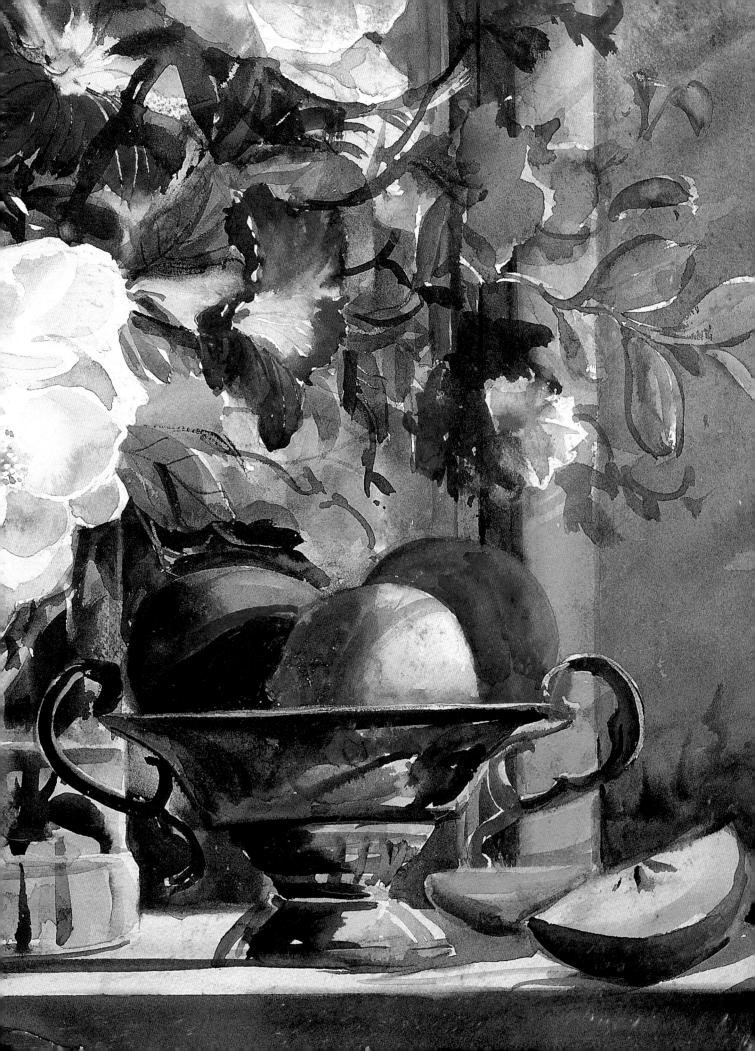

Art from page 1:

Window Fragrance • Watercolour • 22" x 28" (56cm x 71cm)

Art from pages 2-3:

Morning Light • Watercolour • 16" x 21" (41cm x 53cm)

A DAVID & CHARLES BOOK

First published in the UK in 2003
First published in the USA in 2003 by North Light Books, Cincinnati, Ohio
as *Seeing the Light: An Artist's Guide.*

Copyright © Betty Carr 2003

A catalogue record for this book is available from the British Library.

ISBN 0 7153 1715 6

Printed in China by Leefung-Asco
for David & Charles
Brunel House Newton Abbot Devon

Visit our website at www.davidandcharles.co.uk

David & Charles books are available from all good bookshops; alternatively you
can contact our Orderline on (0)1626 334555 or write to us at FREEPOST
EX2 110, David & Charles Direct, Newton Abbot, TQ12 4ZZ (no stamp
required UK mainland).

Editor: Stefanie Laufersweiler
Designer: Wendy Dunning
Layout artist: Christine Long
Production coordinator: Mark Griffin

Metric Conversion Chart

To convert	to	multiply by
Inches	Centimeters	2.54
Centimeters	Inches	0.4
Feet	Centimeters	30.5
Centimeters	Feet	0.03
Yards	Meters	0.9
Meters	Yards	1.1
Sq. Inches	Sq. Centimeters	6.45
Sq. Centimeters	Sq. Inches	0.16
Sq. Feet	Sq. Meters	0.09
Sq. Meters	Sq. Feet	10.8
Sq. Yards	Sq. Meters	0.8
Sq. Meters	Sq. Yards	1.2
Pounds	Kilograms	0.45
Kilograms	Pounds	2.2
Ounces	Grams	28.4
Grams	Ounces	0.035

{about the author}

Betty Carr received her M.F.A. from San Jose State University and has thirty years of teaching experience. Carr is a full-time painter who currently teaches art workshops throughout the United States, England and Europe. She is a signature life member of Knickerbocker Artists, and her work has been included in numerous books and magazines.

Carr is represented by Mountain Trails Gallery in Sedona, Arizona; El Presidio Gallery in Tucson, Arizona; Lee Rommel Gallery in Santa Fe, New Mexico; Taos Gallery in Scottsdale, Arizona; Judith Hale Gallery in Los Olivos, California; Oscar Gallery in Ketchum, Idaho, and The Lady Bug Gallery in Bishop, California.

Carr lives in Arizona with her husband, painter Howard Carr. They spend half the year traveling and painting scenes around the country.

{acknowledgments}

There are so many to thank that it seems impossible to cover. I appreciate the encouragement and guidance from my editor, Stefanie Laufersweiler, whose incredible expertise and patience were constant throughout the book's production. Thanks also to Rachel Wolf, fellow artist and author Pat Dews, and to the staff of North Light Books, whose confidence in my work gave me the opportunity to write this book.

Thank you to my helpful sidekick, Vivian Wynn, who was there as my super secretarial scholar and did a fantastic job.

I am grateful to my many students who have been suggesting that I consolidate my ideas about the importance of seeing the effects of light to paint realistically.

Thank you to my family, teachers, mentors, painting companions and God for their vigilant guidance, help and encouragement. Inspirational teachers such as Dave McGuire, Doug McClellan, Sam Richardson, Fletcher Benton and David Swanger have always kept me on my artistic toes.

Thanks to my loving parents, Barbara and Carl, who instilled in me at such an early age the beauty of God's light, the awe of nature's cycle and a thrilling excitement in artistically capturing nature's effects. Their love and faith in me to develop my artistic abilities was unwavering.

A special heartfelt thanks to my husband, Howard Carr, whose love has kept me smiling and focused. He was consistently helpful in numerous ways throughout the process of making this book.

{dedication}

I dedicate this book to

My husband, Howard, who has always been there with his inspiration, love, support, humor, patience—the list is endless.

Our daughter, Tammy, who is the loving delight of our lives.

My parents, Barbara and Carl, for their nurturing inspiration.

Introduction • 9

{ c h a p t e r o n e }

how to see and envision light • 10

In order to portray light you must first have the ability to identify its characteristics and how it falls on different subjects. Learn valuable techniques to help you see light: how to think like a sculptor, simplify lights and darks, and interpret color.

{ c h a p t e r t w o }

how to handle different lighting situations • 20

Accurately capturing a scene's lighting—early morning sunlight on a still life, the soft glow as evening falls on a small-town street—can mean the difference between a mediocre depiction and a painting that sings. Learn how to use perspective, color, value, intensity and proper design to portray various lighting situations.

{ c h a p t e r t h r e e }

getting started: materials and brushwork basics • 44

Now you're ready to paint! Gather the tools of the trade for painting in watercolor and oils. Practice simple drawing techniques and brushwork exercises that will prepare you to confidently create loose and beautiful paintings in either medium.

{ c h a p t e r f o u r }

painting light step by step • 62

See how the same subject is portrayed in both watercolor and oil through six dual demonstrations. Several additional demonstrations tackle the unique lighting situations of individual scenes in either medium (three in watercolor, one in oil). Scenes portrayed include a shadowy desert road, an intimate moonlit street, a dramatic arch, bright sunflowers, a rushing creek and a still life of various reflected textures.

Index • 142

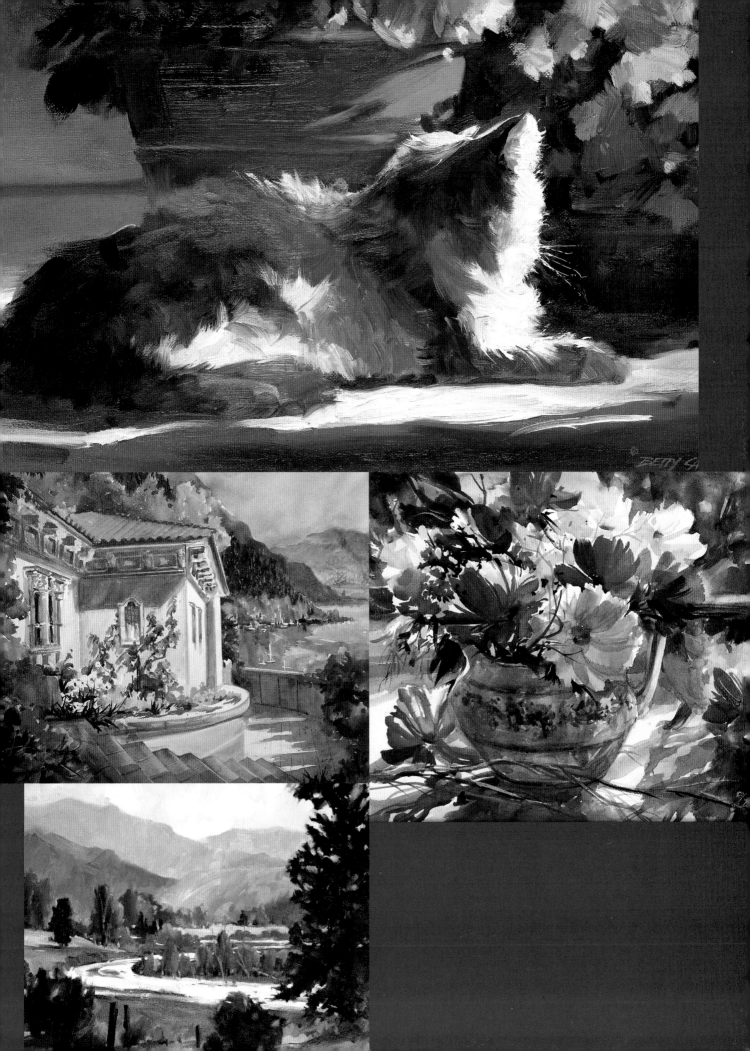

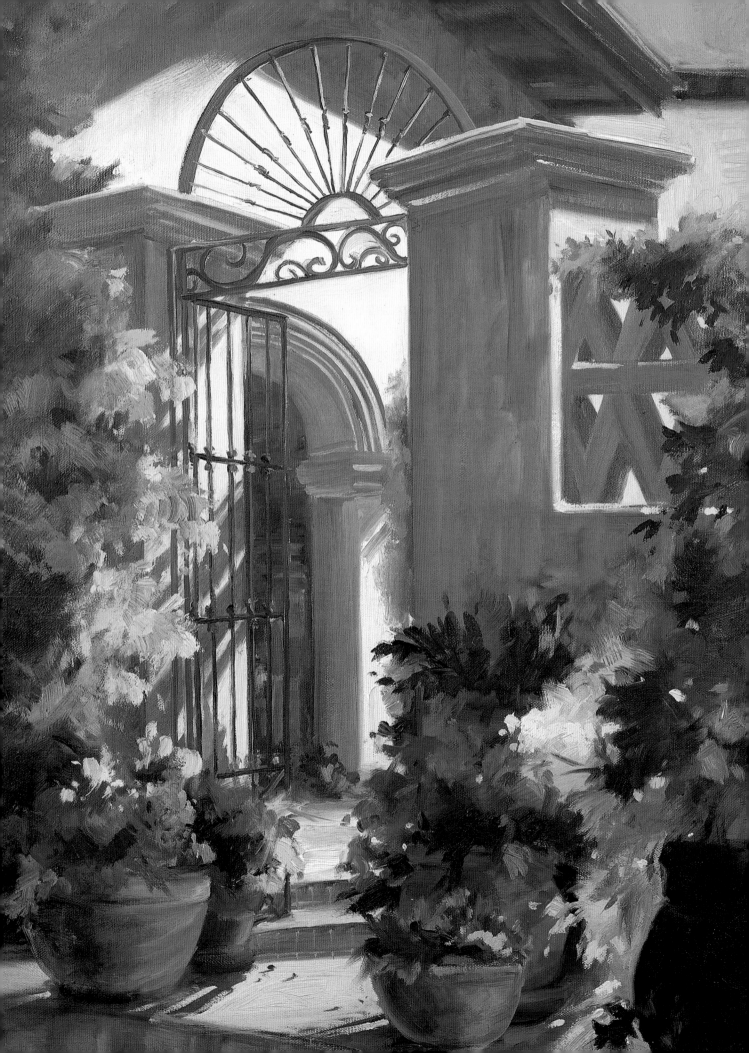

My inspiration and committed purpose for this book are based on a passion for art, art history, science and an understanding and awareness of certain truths in nature. My goal is that you will find the material in this book to be essential to your solid understanding of creating art—how to paint and how to understand the importance of drawing as it relates to your work.

The great historical wealth of fine artists' work has intrigued me for years. Artists have recognized, formulated, contemplated and shared certain profound truths in developing their various personal styles of art. At the early age of six or seven, my interest was sparked and I began studying and observing the enormous variety of artistic styles developed over the years while questioning, "How did they ever do that?"

How particular historical time periods related to various artistic styles and techniques was another point of curiosity. I was glued to the artistic images in museums, art stores and galleries, and as time went on, I asked endless questions. "Always take a look at the date in history when the work was created to relate its imagery to time and space," my uncle Joe would say while visiting the numerous art museums that we explored when I was a child. Remember that the importance of a work of art and its historical value, in many cases, is relative to the time period in which it was painted or created.

In order to gain a personal mastery of style in realistic painting and sculpture, an artist must learn to combine a scientific understanding of the characteristics of light with the artistic demands of formal composition. As you study art history and learn the techniques other artists used to express themselves, your own power of self-expression will evolve and your personal style will become more evident. This process takes patience, passion and commitment.

As a student in sculpture and through my years sculpting, I focused on the universality of growth patterns in nature and became dedicated to the idea that form follows function. To observe and understand the path and pattern a form follows when growing is very helpful in technically grasping and "seeing" how to draw the shape. This is a basis for how I see and paint light today. Studying science as applied to art—nature's repetitive growth patterns, sources of light and its effects on form—made me realize that there is a basic rhyme and reason to understanding light. This realization has given me fundamental principles to follow as an artist seeking to re-create the effects of light in realistic paintings.

As you discover the basics of seeing light and explore the light-effect techniques in this book, I hope you will find the sparks for your continuous growth as an artist. In learning these basics, I hope you will not only gain better skills and a better understanding of your own artistic expression, but that you will gain a profound appreciation of nature's beauty, as I have.

BETTY CARR

Entrance Celebration • Oil • 24" x 18" (61cm x 46cm)

how to see and envision light

How inspiring it is to surround yourself with flickering, sun-dappled leaves, view cool, distant silhouettes at sunset or sunrise, float on dazzling water ripples or watch a wintery dance of snowflakes glowing in backlight. Light surrounds us, exposing all kinds of forms, colors and textures for artists to render.

Light is a fantastic source of inspiration and a challenge to paint. In order to portray light you must first have the ability to identify its characteristics and how it falls on different subjects. In this chapter you will find approaches to seeing and envisioning light dimensionally. Learn valuable techniques to help you see light: how to think like a sculptor, simplify lights and darks, and interpret color.

Resting Spot • Oil • 12" x 16" (30cm x 41cm)

think like a sculptor

Years of sculpting three-dimensional forms by focusing on light and shadow has made me realize the importance of seeing dimensionally. It is crucial for a sculptor to see the pattern and play of light and shadow on a form in order to portray it aesthetically. Artists use small maquettes and models to ensure success for proper light and shadow play. This awareness of the dimensional aspects of light has stuck with me and is a prerequisite in my painting and drawing.

As representational artists, we are attempting to convince the viewer that forms portrayed on a flat surface are three-dimensional. We are trying to create the illusion of depth on a flat surface. Using phrases such as "sculptural thinking," "think fat not flat" and "paint negatively by carving and sculpting light in the positive" has helped my students to connect with dimensional thinking.

Think like a sculptor by using light, color, texture and value to paint forms as though you were building them by hand. In order to envision light sculpturally, you need to see the basic structure in dimensional terms (solid volume and weight). Every form is based on a cube, cone, cylinder or sphere, or a combination of these forms. By focusing on a dimensional approach to painting light, you'll add volume, dimension and weight to your paintings.

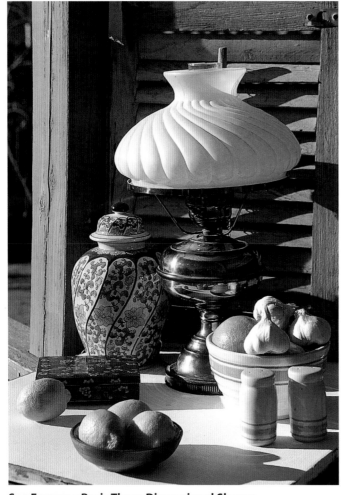

See Forms as Basic Three-Dimensional Shapes
Find the basic forms in this still life. Think forms, not shapes. For example, the table is not a square; it's a cube. An apple isn't a circle; it's a sphere. Three-dimensionally, triangles are cones, and rectangles are cylinders. By examining form in this manner, you are on your way to dimensional thinking and painting the effects of light effectively.

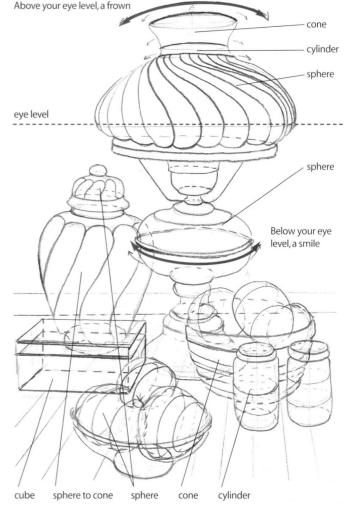

Above your eye level, a frown

cone

cylinder

sphere

eye level

sphere

Below your eye level, a smile

cube sphere to cone sphere cone cylinder

how light envelops form: the basics

Forms can reflect, diffuse and radiate light. It is important to understand this in order to capture the effects of light on objects. The benefits of seeing and grasping the characteristics of light when painting dimensionally cannot be overstated.

Go outside on a sunny day and stand with your back to the sun. (This exercise works best in early morning or at "the golden hour"—between 5 and 6 PM, depending on the time of year.) By observing value, temperature and edge changes of the shadows, you will begin to develop more sensitivity to light. Where your shadow connects to your feet, the shadow's edges are crisp. As the shadow elongates, its edges get softer and less distinct.

Let's analyze the lighting on a tomato and review some terms generally used when discussing light and shadow.

Light source

Highlight: A direct reflection of light.

Penumbra: A partially illuminated surface, often perpendicular to the light source, that serves as a transition from an area in light to an area in shadow.

Core shadow: An area that receives no light directly from the source but may be partially illuminated by reflected light.

Reflected light: Light that hits an object after bouncing off another object.

Form shadow: The portion of an object's surface area that faces away from the light source, consisting largely of the core shadow.

Cast shadow: The shadow cast by a lighted object onto another surface.

BETTY CARR

tips

Recognize the Nuances of Light and Shadow

Keep in mind the following points when analyzing how light falls on an object:

- Gradation is a term meaning the gradual transition from light to dark. Light abruptly changes on a cube; it does not gradually change. Not so with a cylinder, sphere or cone— the transition is smooth.

- Surface texture affects reflections. A shiny tomato is very reflective, unlike a fuzzy tennis ball, which absorbs much of the light.

- Cast shadows are generally sharper and darker than the form shadows.

- The core shadow is the darkest part of a lit object, while the highlights are the lightest in value.

characterize the light that falls on your subject

No matter what subject you attempt to paint, there are three common questions that you must answer to accurately capture the effects of light on that subject. They are:

• Where are you in relation to the scene before you—at eye level, below eye level looking up, or above eye level looking down?

• From which direction and at what angle is the light falling on the scene?

• What is the quality of that light? Everyone has looked out a window and experienced a changing view depending on the time of year, day, hour and even minute. When light's quality changes, every circumstance affects the shapes, colors, textures and general mood of the scene.

An understanding of your position relative to the scene is crucial because this affects how you see the forms within it and how you perceive the light falling on and around them.

Know the Light Direction and Angle Relative to Your Position
Look at this display of fruit and then guess the eye level of the viewer and the light's angle and direction. Squint if you must to help you concentrate on the basic forms and light only.

Because of the extreme shadow area at a sharp diagonal angle on the right of each fruit, it's apparent that the light is coming from the left and at a low angle. The viewer's eyes are looking down on the pears. Always be aware of the light direction and angle, and your position relative to the scene. Be aware of what you're after and choose the quality of light most appropriate to reflect the mood of your painting.

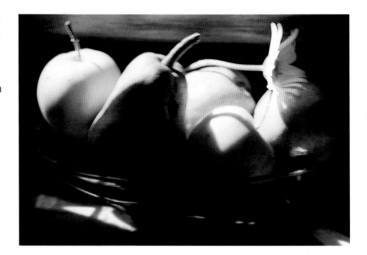

From Value Sketch to Finished Painting
This value sketch and the resulting watercolor still life demonstrate an awareness of eye level and light direction. The viewer is looking down just a bit, and the light is coming from the front right. The quality of light is low and dramatic. A value sketch was drawn first to guarantee success in saving the precious whites—the light.

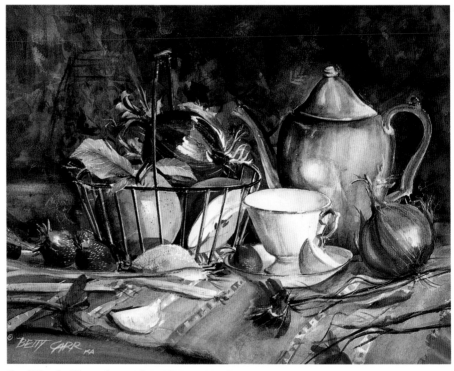

Good Blend • Watercolor • 12" x 16" (30cm x 41cm)

simplify a scene with values

Placing too much emphasis on the color and texture of a scene can distract you from two very important elements of design: value and shape. As soon as you start to think in literal terms—for example, defining each leaf on a tree or making sure the fence posts are equally spaced—you are forgetting about the big picture: light enveloping form. You can avoid this pitfall by simplifying a scene down to its basic values (darks and lights) to see forms.

By squinting your eyes at a scene to see the basic value range and eliminate unimportant details, you will be able to simplify lights and darks easily. Think almost abstractly. Place values and shapes in the "right" spots, and realism appears! Note your observations with value sketches. Start with your darks and leave whatever is in light as the white of the paper.

Lack of Contrast = A Boring Painting
In this painting, the texture and color are emphasized too much, while the elements of value contrast and shape are lost. The shapes of the trees are uninteresting; the colors are too bright; the values are all the same because there is no established light source. Obviously, literal thinking occurred when painting this boat surrounded by lollipop-perfect trees. If the values and shapes in a painting are wrong, even beautiful texture and color will not make it successful.

center of interest

escape route

Value Sketch
Using light and dark values correctly helps emphasize the center of interest and creates an escape route for the viewer's eye. Simply follow the lights.

A Big Improvement
In this example, the colors and textures do not dominate. The asymmetrical shapes are much more interesting and the values clearly show the direction of light.

Golden Hour • Watercolor • 7" x 9" (18cm x 23cm)

develop a keen eye for color

Often my students ask, "How do you know which color mixtures or pure hues to use to represent the colors you see? How do you determine the local color of something? When did you begin noticing areas of color like blues and violets in negative areas of a wintry tree's branches or the warm yellows and oranges under the arch of a bridge?"

Six months out of the year, I paint outside. As a result, my sensitivity to color and color temperature has developed. Studio light is often warmer (even with the presence of cool blue lighting) than the cool light found outdoors. Through observation, painting and studying, I've gathered information about seeing true color that is somewhat consistent, but is not set in stone.

In hundreds of books written on color, one fact seems evident: All colors become slightly cooler as they recede. Warm yellows and reds appear closer than cool blues. Yellow fades as it recedes, which means all color mixtures with yellow in them diminish in intensity as they get farther away. Think of the brilliant greens near your feet in a grassy meadow compared to the gray-greens of the distant hills. Yellow has diminished from the blue-and-yellow mixture with distance.

Blues and violets become more apparent in the distance. The next color to *decrease* in the distance is red; therefore, violets become duller in the distance, while blue appears dominant as well as lighter in value.

All of this information is relative to the lighting situation (moonlight, sunrise, sunset, artificial light, etc.) and environmental characteristics (cloudy, clear, foggy, etc.). This phenomenon is called atmospheric perspective and is a fantastic tool for the artist in creating dimensional aspects of light.

In examining what colors to use in capturing the scene before you, squinting is very helpful. In order to paint a specific tree on the distant horizon, for example, I'll squint and look around the tree but not directly at it (using peripheral vision). The coolness or warmth pops out. I also am able to judge the tree's shape and value more effectively and not get bogged down by useless detail.

Judging color relationships is subjective. The color may appear cool to me, while you might feel the warmth stands out. The material of which an object is made will also play a role in judging its color. However, one thing is consistent: it's not necessarily the actual color of the object that's important, but its relationship to the colors around it. Judging color will get easier as you learn to see and compare as an artist. Color is not an exact science, so just give it your best guess.

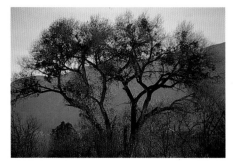

Tree Scene in Focus

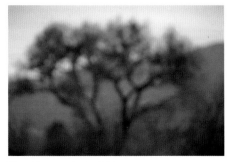

Tree Scene Out of Focus

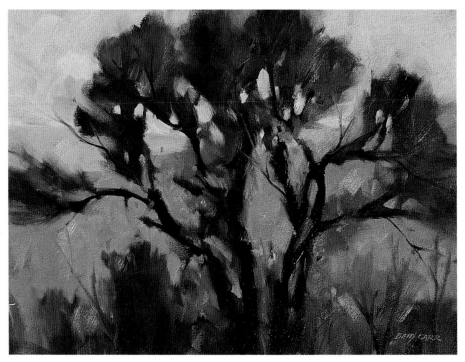

Finished Plein Air Study
When I squinted at this scene, the most dominant shapes, shadow forms and values appeared. The cool-blue negative areas of the tree popped. I punched up the contrast by bringing in yellows and violets for the sky against the blue of the mountain. It's fun to experiment with complements.

Proud Giant • Oil • 12" x 16" (30cm x 41cm)

recognize the importance of value in a painting

Color is powerful, vivid, moody and romantic. Most beginning artists are attracted to color's beauty and often forget to check out its best feature in painting light—its value. It is crucial to understand value to create the effects of light in painting. Every color has a value: a degree of lightness or darkness.

Value is color's most important characteristic. Placing a gray value scale ranging from 1 to 10 (white to black) next to a specific color's value scale (ranging from lightest to darkest) can help you determine the color's values through observation. By examining colors in terms of relative lightness or darkness, your skill as an artist will grow.

Often I'll tell a student when he is doing a painting, "Let's punch up the darks with vivid color." For example, the shadow side of a tree trunk could be more alive and exciting if dark purple were used rather than the typical brown. If the value is correct, it doesn't matter what color you use. Remember that color is not as important as value in painting, so have fun and play with variety in your darks.

Try this: Look around and pick a color. Squint at it and ask yourself, "What *value* am I looking at?"—not what color. Get into the habit of analyzing color like this and in no time you'll be judging value relationships.

Understanding a form's color value is crucial because the drama of dark against light is what creates the light in any painting. The viewer's eye will be attracted to the areas of highest contrast: lightest light against darkest dark. In developing a design, keep in mind the importance of a dominant value scheme. When a painting has no value plan—and is basically just a potpourri of values—it generally lacks punch and is just another pretty picture rather than a great painting. While developing a painting, simplify the forms to three values with a minimum of details.

In a high-key painting, the light values are dominant: on a scale from 1 to 10, values ranging from 1 to 4 or 5 are the focus. In a low-key painting the darker values dominate (values 5 to 10). The middle values range from about 4 to 5 and are important for unifying the lights and darks in a scene. Imagine a painting without its middle values. The dark and light values get the most attention, but the middle values do the transitional work and hold the overall value scheme together.

Try this value exercise: Using your own initials as art, create an interesting design with a light- or dark-dominant value scheme.

No Value Dominant
This design lacks spunk and drama. There is no dominant value theme. The light, medium and dark shapes all want attention.

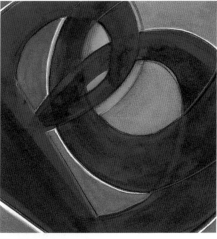

Dark Value Dominant
This dramatic design is dark-value dominant and has punch and excitement. The diagonals make it more dynamic. There's a definite center of interest. The overall design is basically better, but the unified values connect the forms.

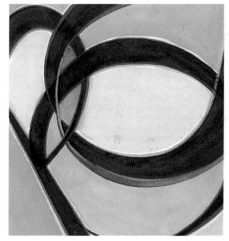

Light Value Dominant
Here I've developed more intrigue in the center of interest and enabled the light value to dominate. When you begin to develop a composition from a variety of decisions, keep in mind what value dominance you will have. It's the organization, balance and unity of values that create dramatic light.

know your complements

Every color has an opposite or complement. If you want to discover the complement of the primary color red, for instance, then merely mix the other two primaries together. Blue and yellow create green, a secondary color that is the complement of red.

Mix a color wheel to discover each color's complement. By mixing and discovering the complement of each primary color, it's easy to also fill in the intermediate or tertiary hues on the color wheel. Simply put the two names together (primary and secondary) to discover the tertiary color. For example: red + violet = red-violet. The primary color always comes first.

The use of complementary colors in a painting can create excitement as well as add important grays. Introducing the comple- ments of dominant colors will "turn on" the scene you're painting. For example, when my painting consists of numerous greens, I'll often add random subtle reds to turn on the greens. Two complements mixed together produce grays and browns which are used to harmonize and add vibrancy to a painting. It's these subtle colors that allow the others to shine.

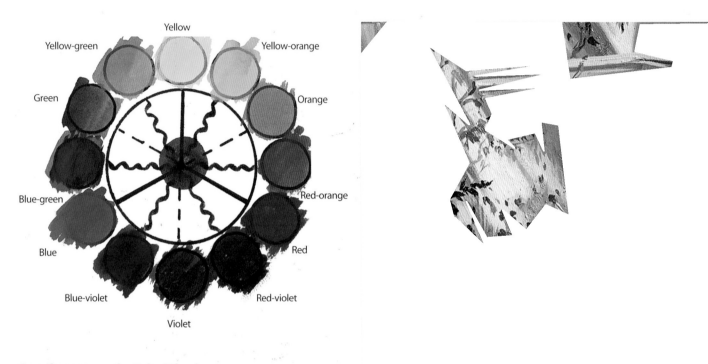

Complements on the Color Wheel
Colors that are opposite each other on the color wheel are comple- ments. The solid lines connect primary colors, the dotted lines con- nect secondary colors, and the curvy lines connect tertiary or intermediate colors.

Two complements mixed together in varying amounts produce grays and browns. I don't use black to darken or dull a color because a muddy mixture may result. Glazing or mixing opposites creates much more beautiful and natural grays and neutrals.

Using Complements to Your Advantage
The dominant, warm analogous colors—yellows, oranges, yellow- greens and red-oranges—come alive against the surrounding greens and touches of blue and violet.

Fragrant Entrance • Oil • 28" x 20" (71cm x 51cm)

use color to create dimension

This statement by artist Charles Hawthorne from *Hawthorne on Painting* tells it all: "Let color make form; do not make form and color it. Work with your color as if you were creating mass—like a sculptor with his clay."

In the illustrations on this page we see what happens when we glaze with opposites to create form. The red sphere and blue cube appear as flat shapes until their complements, green and orange, are used to create form. As you can see, various amounts of the opposite color were used to darken the value and lower the intensity, creating gradation while modeling with color.

The use of color temperature, value and even softening edges gives these basic forms their dimensional appearance. Create dimension in your work by glazing complements over colors, mixing complementary colors and placing complements next to one another.

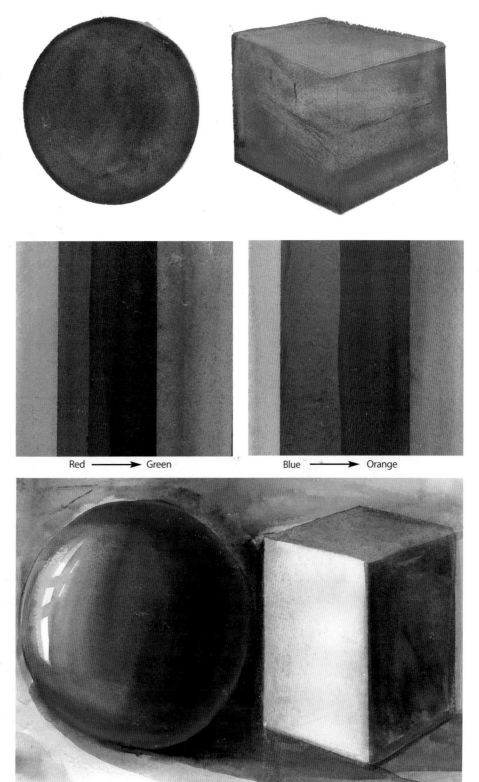

Red ⟶ Green Blue ⟶ Orange

"Sculpting" Form With Color

how to handle different lighting situations

A closer look at aspects of light is critical in painting. Still life, landscapes, seascapes and portraiture all rely on observation of light—how light affects color, value, forms, lines and textures—to render representational work. Accurately capturing a scene's lighting—early morning sunlight on a still life, the soft glow as evening falls on a small-town street—can mean the difference between a mediocre depiction and a painting that sings. Learn how to use perspective, color, value, intensity and proper design to portray various lighting situations.

Glowing Cosmos • Watercolor • 18" x 22" (46cm x 56cm)

using perspective and point of view

As a realistic painter, you are depicting volume and space—depth on a flat surface—so without a basic knowledge of perspective, your artwork will be at risk.

We've discussed various aspects of atmospheric perspective—the lessening of color, intensity, size and texture in the distance, which are somewhat obvious to the naked eye. Planar perspective refers mostly to the use of overlapping and partially seen shapes to create depth. Linear perspective takes more of an analytical approach; it describes the illusion of distance created when parallel lines seem to converge at a point on the distant horizon referred to as a vanishing point.

Before starting any painting, find the position of the horizon line, or eye level, on the paper. The eye level is the height of your eyes when looking straight ahead. If your eye level is low, place the horizon line lower on the paper; if your eye level is high, place the horizon line higher. All parallel lines below your eye level will slope upward toward the vanishing points, and all parallel lines above it will slope downward.

The height of your eyes relative to your subject will affect how you see your subject. For instance, if you were painting a cottage among the hills, the scene would look different depending on whether you were standing directly in front of it or if you were looking at the cottage from atop another higher hill.

In one-point perspective, objects appear smaller as they recede and converge toward a single vanishing point. You may want to place this point on your horizon or eye-level line before you begin drawing or painting.

When you look at your subject and observe two or more sides receding—for example, a corner of a building—you'll use two-point perspective, or possibly multiple-point perspective. Parallel lines will appear to converge at more than one vanishing point.

The following illustrations will show you some basic concepts that will help you use perspective correctly.

One-Point Perspective

One-point perspective gives the appearance of depth in this painting. I look for the most horizontal line along the receding side wall and windows, which will determine my eye level. In this case, the viewer sees the horizon line, where the ocean meets the sky. All the lines or receding planes below that line, such as the tile work on the patio, will angle up toward it. All the lines or receding planes above that line, such as the awnings, will angle down toward the horizon.

Spring's Response • Watercolor • 27" x 21" (69cm x 53cm)

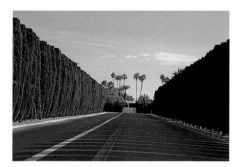

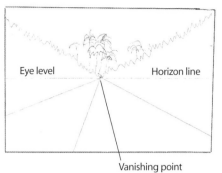

Eye level

Horizon line

Vanishing point

One-Point Perspective

You can't help but move directly to a vanishing point in this tree-lined road. As more buildings, trees and other elements clutter a scene, it may appear more complicated, but look for the basics.

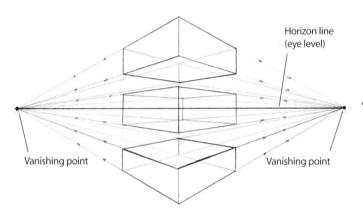

Horizon line (eye level)

Vanishing point

Vanishing point

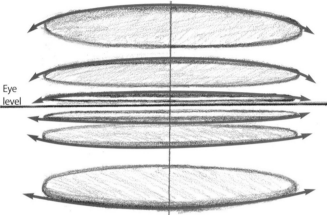

Eye level

Two-Point Perspective

Imagine that the three cubes above are connected together to form a building. Since you see two sides of the cubes, or imaginary building, each side's parallel lines converge at two separate vanishing points. Notice that all the parallel lines above the eye level go down and all the parallel lines below the eye level go up. Take a look around you and find your eye level and parallel lines to determine your vanishing points.

Ellipses in Perspective

Just as the cube can be examined in terms of analytical perspective, so can the cone, cylinder and sphere. Put a glass on the floor and stand over it, looking down into the opening. You will see a perfectly round circle. As you raise the glass, approaching your eye level, notice that the circle changes and becomes an ellipse. It is still a circle, but "tilted" in space. By drawing your ellipses through (in the round) and remembering that the ellipse widens the higher or lower you go from your eye level, you'll create correct dimensional forms in space.

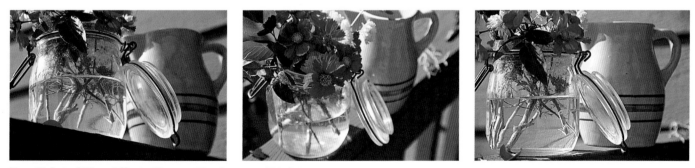

Your Point of View Affects Shapes, Shadows and Light

These photos of the same subject illustrate various eye levels: looking up, looking down and looking straight ahead. It is crucial to determine your point of view before you begin to paint.

the color and temperature of light and shadow

The changing position of the sun throughout the day and in different seasons will affect the colors of light and shadow. You can usually sense autumn in the air, winter approaching, and the fresh, fun feeling of spring and summer getting close. At summer's hottest time, the energy of yellow and yellow-orange light is more apparent, while blue and violet light surrounds you in the fall and winter. Generally, the sunnier the scene, the warmer the colors.

Atmospheric conditions will affect light and shadow as well. Mist, fog and rain are examples of moisture filling the air and consequently dimming the light. Imagine an intensely red tugboat approaching shore, slowly finding its way through heavy fog. The bright red will soon stand out on shore against the gray conditions. Subtle contrast is used often in painting for emphasis, but keep in mind that a cool or warm plan should dominate.

When painting a scene, take into consideration the lighting situation, temperature, moisture level, time of day, surrounding color value and intensity. Generally, the subtleties rather than the obvious features are more important and valuable to observe in creating great paintings. The temperature of the light source, the color of adjacent shadows and the character of a shadow's edge (soft vs. hard) are all important details.

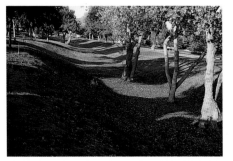

Autumn Morning Shadows
The cool blue shadows of an early autumn morning stretch across the contour of the land. The long shadows create fantastic patterns to paint.

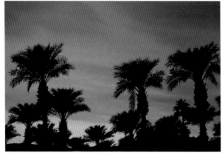

Warm Evening Glow
The warm evening atmosphere surrounds the palm trees and creates glowing silhouettes.

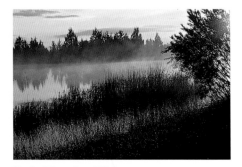

Early Morning Mist
The atmospheric qualities and cool morning glow create a soft and gentle feeling. The mist filters the view.

tip

Analyze Shadows

Observe the subtleties of shadow by asking the following questions:

- What is the color of your subject, and what are the surrounding colors?
- What kind of light source exists (natural or artificial)?
- Is the light warm or cool?
- What temperature is the shadow?
- Are the shadows long with fuzzy edges or short with sharp edges?
- What time of day is it?

Shadows have a few common threads. Notice that:

- Shadows are generally transparent, not just plain black or gray. Shadows tend to have a violet base when cast onto a white surface.
- The complement of the object's color will be slightly apparent in the cast shadow.
- Warm light will cast cool shadows, while cool light will cast warm shadows.
- The transparency or opaqueness of the form in light will directly affect the color of its cast shadow.
- Shadows get cooler and lighter as they recede.
- The color of a cast shadow is determined by the local color on which it is cast. As the shadow approaches the form that is doing the casting, it gets often slightly warmer, darker and the edges become sharper. Be careful not to paint cast shadows too dark.

Color Fun With Shadow Shapes in Natural Light

As you can see, the color of the fabric surrounding these objects really affects the colors of their shadows. The light source for these photos was daylight, at about 10:30 AM in late January. Cool light bounces into the colored fabric and is absorbed by some nearby objects but transmitted by others. By closely observing shadows, you'll become more sensitive to their colors and the temperatures they emit.

leading the eye with light, shadow and escape routes

Shadows are crucial to painting light. Essentially it's the shadow shapes which define the light, whether subdued or highly contrasting. They create mood, movement and direction, along with holding the painting's elements together. By using shadow shapes along with color, temperature, repetition, edges and escape routes, you can move the viewer's eye throughout a painting.

Escape routes are breaks or areas of rest that allow the eye to move through the foreground, middle ground and background of your painting. Pablo Picasso used this device often in his drawings by breaking his lines. These small breaks allowed the viewer's gaze to flow in and around the piece. By not closing all the forms with a line or hard edge,

your work will have a more atmospheric quality.

Oftentimes I'll be discussing a painting with a student who says, "I can't put a shadow there—it's not in the scene," or "How should I shape the shadow if I can't see the whole thing?" These are the pitfalls of literal thinking. Shadows are created for eye movement and are believable and in place if the light direction is consistent.

Let's examine the key things to remember when painting shadows:

- Shadows follow the contour of the objects on which they lie.

- Shadows are transparent and create drama, direction and movement.

- Temperatures are warmer closer to the object and cooler as the shadow disappears.

- The edge of the shadow is sharper closer to the object and blurs as the shadow recedes.

- The more contrasting the light, the deeper the shadow.

Shadows are the key element in my work. At times, I'll paint almost the complete network of shadows before I touch the positive objects. If the shadow shapes and the play of light are correct, I'm confident that the painting will be a success.

Creating a Path for the Eye
The overall design is based on the "L" composition, an asymmetrical overall layout, with the eye level straight on and light filtering in from the lower right. Eye movement follows the light, along the whites of the paper in the foreground and moving up through the lights of the flowers. The eye continues through the broken soft edge of the distant mountain in the background. Wall shadows bring us back and circle us up through the old jar's diagonal shape. Even the palm tree's shape points us inward.

Desert Bouquet • Watercolor • 12" x 18" (30cm x 46cm)

Value Sketch

This is the value sketch done in preparation for *Fragrance Finale*. In this painting, the light comes from the upper right. The connecting shadow shapes are great devices for creating eye movement. This asymmetrical design moves the eye through darks and lights, creating a circular movement.

Reference Photo

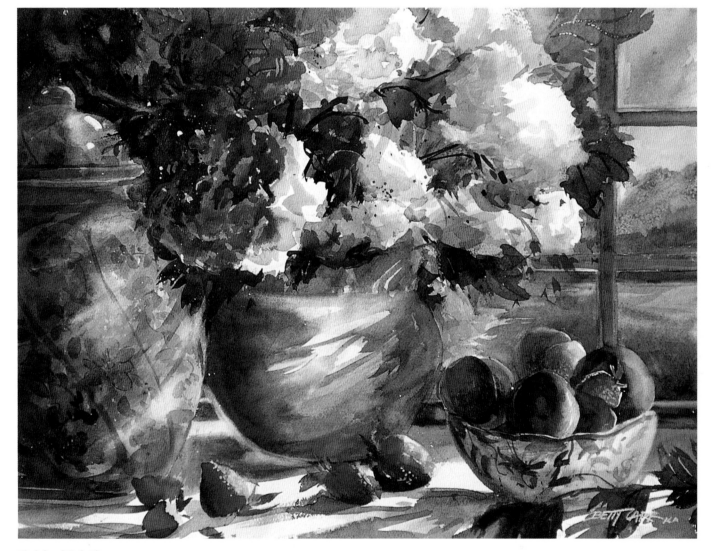

Finished Painting

The window is a fantastic escape route and backdrop to this pleasant scene. The overall arrangement of flowers demonstrates the use of gradation from light to dark. Each flower is modeled, as well as the grouping as a whole. This is a perfect example of how warm and cool shadows can connect forms.

Fragrance Finale • Watercolor • 18" x 24" (46cm x 61cm)

harmonious color creates a painting with impact

Harmony in color refers to the dominance of one or the other side of the color wheel while incorporating accents of the opposite (or complementary) side. Harmony in color creates a pleasing arrangement that does not fragment the painting with discord.

Does the scene before you suggest a cool or warm emphasis for your painting? Is the lighting generally cool or warm, muted or bright? Imagine a red, orange, yellow and pink sunset with a few blue and blue-green rooftops speckled about. As forms are bathed in the primaries of red and yellow, the warmth automatically creates a harmonious setting. The complementary blue specks add eye-pleasing contrast.

When planning a painting, keep in mind what color scheme (warm or cool) will dominate for the greatest harmonious impact. Using a bit of the chosen color scheme's complement in your plan is like a light switch that turns on the dominant colors.

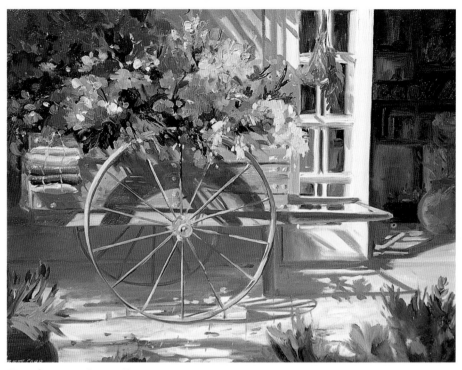

Complements Create Harmony
The overall warmth of this painting is enhanced by the complement of blue. The connecting shadow shapes add to the pleasant composition.

Patio Jewel • Oil • 16" x 20" (41cm x 51cm)

Cool Accents for a Warm Scene
The dominating warmth of this morning setting, packed with muted oranges, yellows and warm grays, is "turned on" by a speckling of complements. Use just the right amount of complements to enhance but not destroy the harmonious flow of warm light.

Morning Light • Watercolor • 22" x 28" (56cm x 71cm)

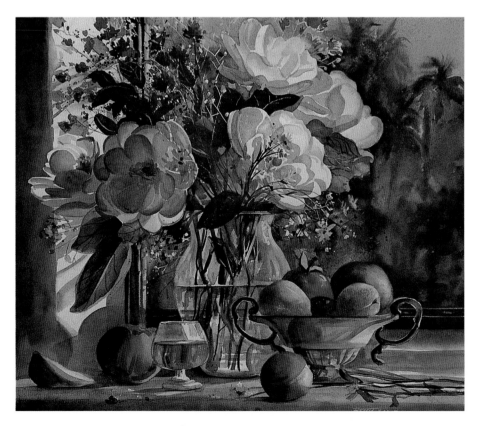

the key to painting light

Shadows play an important role in designing and defining the light in a painting. Understanding the characteristics of light and its causes and effects will help you develop your skill in seeing light to paint great paintings.

Oftentimes not enough attention is paid to the play of light on form, and too much emphasis is put on the local color and textural details of objects. As a result, these paintings lack interest and punch. Portraying the drama of light is much more interesting and eye-catching than a bevy of details. I enjoy limiting the light to emphasize the focal point of a painting, and creating shadows that are full of color.

Remember, light and shadow are an intangible source of energy. Think of a captivating book you read years ago—your thoughts are still there as if you just read it. You imagined the main character's appearance, the scenery, the action. A TV show or movie that describes it all may be forgotten the next day. It's the intangible thought that is the making of greatness. Light is similar: the intangible, invisible energy which, when understood and painted correctly, is fantastic and inspires the viewer.

It's difficult for the beginning student to imagine that it's possible for paint to convey the atmospheric qualities of misty morning air on a mountain or a radiant desert sunset, but by comprehending the essential features of light, we're on our way.

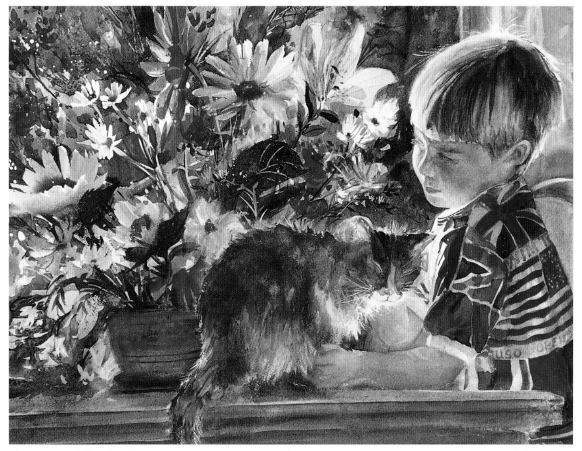

The Power of Illumination
To get the correct values, I carefully masked the small areas of glittering sunshine (on the hair of the cat and the child, for example) while using staining transparent pigments to build the soft muted background. The essence of light has been captured here.

Surprise Visit • Watercolor • 14" x 20" (36cm x 51cm)

To paint light, we need to understand some basic lighting phenomena. By grasping light's traits we can utilize it more effectively in painting.

Light is the incredible invisible energy that makes it possible for us to see. It can come from a variety of sources and can result in a number of visual effects. To paint light realistically, it is crucial to understand what it is doing to capture its effects. Let's look at a few common occurrences related to light: diffraction, refraction and gradation.

Diffraction

Diffraction is the breaking up of a ray of light into dark and light bands—or into the colors of the spectrum—caused by the interference of one part of a beam with another when the ray is deflected at the edge of an opaque object, or when it passes through a narrow slit.

Hang in there. This characteristic is crucial to great landscape painting. Imagine holding a long, white, tapered cone against the deep blue sky. The narrow tip of the cone will be cooler and bluer due to the diffraction of light rays surrounding the narrower part of the cone. This same principle of diffraction causes the narrow branches of a bare tree to seem cooler than the thicker branches.

At times it's difficult to see, but understanding the principle of diffraction will help you create more convincing, realistic paintings. Remember that the rays of light will sneak around the forms, and that the narrower the form, the more illumination you will see.

Refraction

Refraction describes the bending of a ray of light as it passes through a transparent surface. When light passes through different densities, slight bending occurs obliquely

Gradation and Diffraction in Action

The glowing shadows in this painting make a gradual transition from warm to cool, light to dark. Light is diffracted, reflecting throughout this scene from the radiant sky. Warm light gradually wraps the cylindrical staircase, while abrupt value changes occur on the cubical building.

Refreshing Retreat • Watercolor • 24" x 30" (61cm x 76cm)

from one medium to another. Refraction causes a stem in water to appear distorted—bent, off-line or even thicker—as it crosses below the water line (see page 32 for a few examples). We know that the stem itself has not changed, but it appears different to our eyes. Being aware of this lighting phenomenon will help you make your paintings more lifelike.

Gradation

Gradation is the gradual transition from light to dark. Imagine holding a white ball in your hand, with a light source at your right. The light will gradually envelop the round object, creating a transition of value from lightest (on the side of the ball in direct light) to darkest (on the side farthest away from the light). Now imagine holding a cube in the same light. Because of the sharp angles created by the sides of the cube, the light will not gradually envelop the form as it does the ball, but will change more abruptly.

Knowing how gradation affects different forms is essential to painting light. Gradation is one of the characteristics which most effectively portrays depth. Exaggerating gradation in a painting can produce dramatic lighting effects. Getting the different gradations of light correct is a major step toward making objects appear dimensional and the illumination in your paintings realistic and vibrant. On page 31 you will see how different angles of lighting affect gradation.

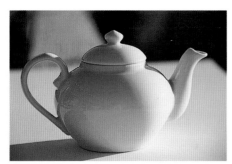

Side Lighting

This type of lighting is the most effective for painting dimensional form. You can see the subtle shifts in value quite well. Long, dramatic shadows can result and fulfill the purpose of connecting forms in your composition.

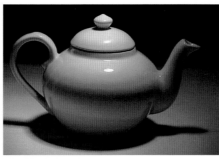

Top Lighting

Gradation of value is easily seen in top lighting as well, but shadows are generally short. The core shadow of the shape and areas of reflected light are readily found on this shiny teapot.

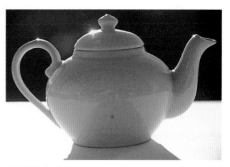

Backlighting

Little gradation results from backlighting, but this kind of lighting can create very dramatic paintings. A luminous glow often radiates around the silhouetted form, and the excitement of the shadow shape reaching out to you is fantastic.

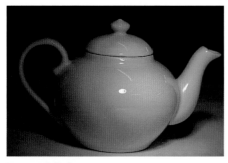

Front Lighting

As you can see, front lighting is the least pleasing. Gradation of value is minimal, and there isn't much shadow to play with.

tip

Experiment With Natural and Artificial Lighting

Most of my photographic references are shot outside in natural daylight. Studio light can be balanced using proper cool and warm lighting, but I prefer the energy of outdoor light, even for traditionally indoor scenes such as still lifes. Experiment with various types of lighting to see what you prefer.

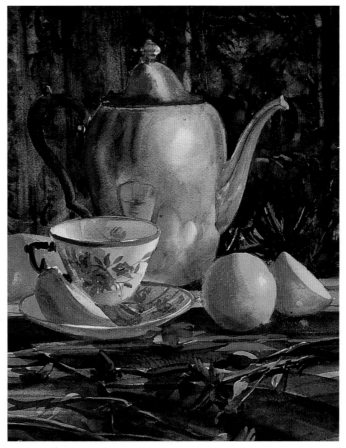

Gradation in Action: Side Lighting

The natural morning light coming from the right side allows the gradual transition from light to dark on the silver teapot's form.

Morning Reflections • Watercolor • 16" x 12" (41cm x 30cm)

Refraction Exercise

Try this: Fill a glass half full of water, place a few stems in it, and take a close look. As you can see from these different eye levels, the line of each stem shifts.

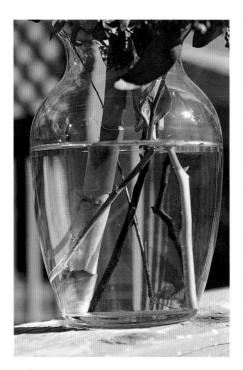
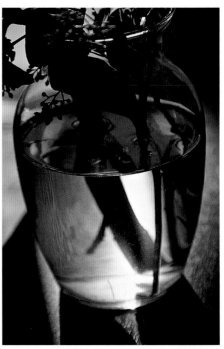

Refraction In Action

Notice how the stems change as they pass through the water. The greater the angle of a particular stem, the more broken the line of the stem appears. Overlapping these various lines at the water's edge also helps to create the illusion of leaves and stems in the water.

Fresh Pick (Pears)
• Watercolor • 16" x 22" (41cm x 56cm)

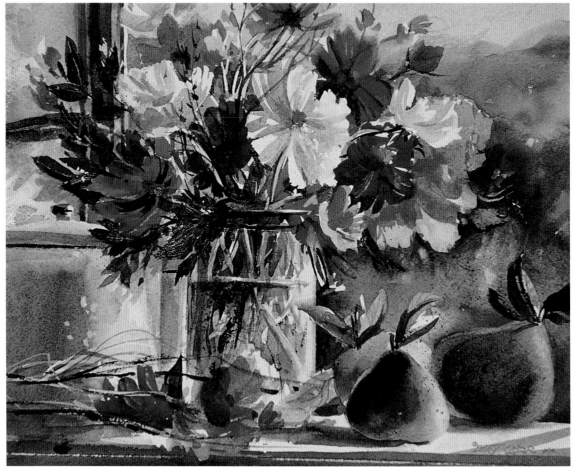

radiating light points the way

When light radiates or is sent out in rays from a center point, it effectively portrays a strong directional feeling. There are numerous forms in nature that employ the growth pattern of radial design, such as a spider's web or a dandelion. The radial design is a favorite for artistic compositions because it has a unifying effect.

Seek out the universal growth patterns in nature, and you'll see the similarities in how light affects seemingly different forms. Observing and understanding the growth pattern of a form is so valuable because it gives you extra insight into how light envelops the form, and therefore, how to paint it. Discover the growth patterns in your subject matter and you'll be able to employ light effectively.

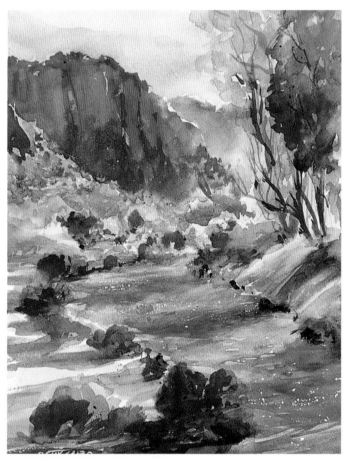

Radiating Light in Watercolor
The radiating glow coming from the right sneaks across the foliage, valley terrain and blue waters, connecting the forms in the composition. My goal was to re-create the rays as they radiated outward from the central light source. The glow was created by lifting the paint, using a spray bottle to lighten the values of the radiating sun. To bring in the sparkle, little specks of white were lifted with a razor blade.

River Path • Watercolor • 22" x 16" (56cm x 41cm)

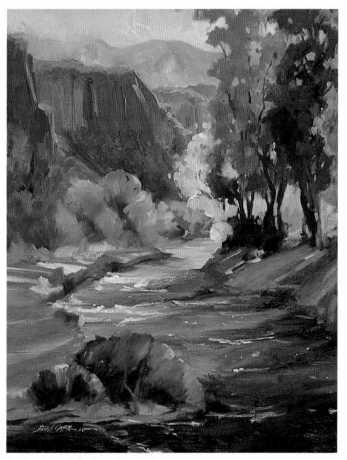

Radiating Light in Oil
As in *River Path,* the rays radiate outward to create harmony in this painting. The painting began with thin, lean darks—glowing blues—and ended with thicker, heavier lights—warm whites.

Blue Waters • Oil • 24" x 18" (61cm x 46cm)

reflected light

My earliest memory of learning about reflected light is when my dad said, "Let's see if you really like the taste of butter." He picked a nearby buttercup and placed it under my chin in morning's light. We looked in a mirror. Wow! My neck and chin glowed with vibrant yellow.

Understanding how to capture reflected light will help you create more realistic, vibrant paintings. The luminosity you can incorporate through using the colorful ener-gy of reflection is very effective. Generally the more intense the color that is bouncing into nearby forms, the brighter the reflec-tions will be.

The surface of a form greatly influences the amount of light that will be reflected. Imagine an apple and a tennis ball placed next to a bright yellow light. The shiny sur-face of the apple is more reflective than the fuzzy tennis ball, which reflects much less light.

Knowing the direction of the light and its quality, angle and color (artificial or natural) will direct you when painting reflected light. Discovering the color and color relationships of reflected light in shadow shapes is also helpful. The bouncing of light into nearby shadow shapes renders the shadows' value more transparent, lighter and generally warmer. It's this quality that can give a paint-ing great luminosity and a bit of mystery.

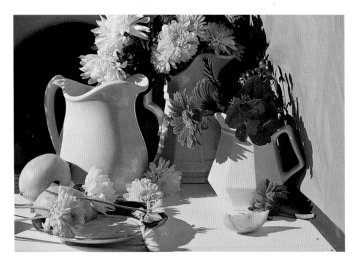

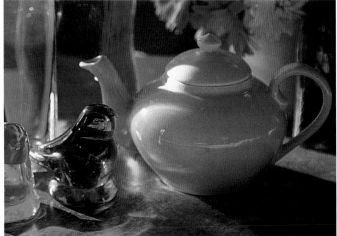

Dancing Colors
The beautiful array of color dancing in and around this teapot illus-trates the property of light called transparency: rays of light transmit-ted through colorful transparent glass hit the reflective white glass surface. Playing with the transparency of light in painting is a great way to portray the dimensional effects of light.

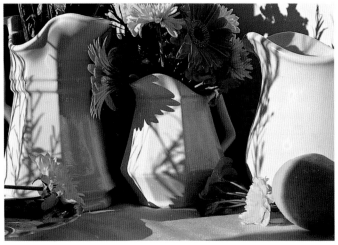

Observing Reflections
These white pitchers were photographed in natural daylight. Notice that the cubelike vase reflects light and shadow differently than the rounded vase, which has a gradual, smooth reflective transition. Again, we see that light envelops basic forms differently.

Reflections Encourage Eye Movement

The mirrorlike reflections along with the warm colors of the fruit and flowing shadows move the eye through this harmonious painting.

Refreshing • Watercolor • 18" x 24" (46cm x 61cm)

Reflect the Terrain in a Desert Sky

The power of reflected light is apparent in this painting. The glow of approaching cumulus clouds reflects the warmth of the crimson rock formations.

Desert Glow • Oil • 16" x 12" (41cm x 30cm)

backlight

The opposite of front lighting is the backlit situation. Backlight produces exciting connecting shadow shapes, great value contrasts and little color. Backlight is at times challenging to paint due to its high-key, contrasting characteristics. Because forms are often silhouetted and details limited in a backlit situation, dramatic, even abstract, compositions can result.

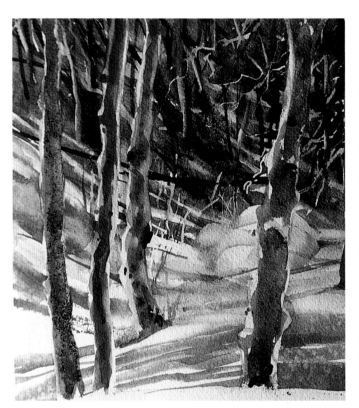

Backlit Trees
The backlit trees and pattern of shadows form a peaceful winter scene. I masked the trees before painting the warm and cool shadows with one-stroke action. The background was painted with numerous glazes for grand contrast. I did the trees last, concentrating on the dance between warm and cool, light and dark.

Winter Shadow Dance
Watercolor
12" x 12" (30cm x 30cm)

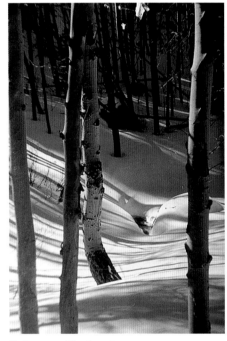

Reference Photo

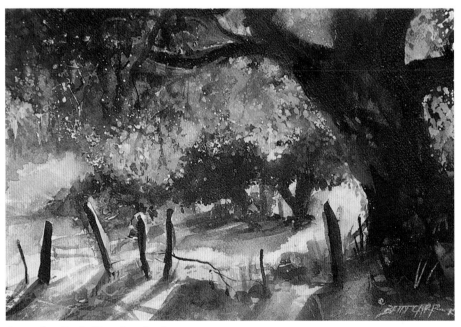

Capturing Early Morning Sunbeams
The gentle flow of morning light as it bounces and sneaks around form is a delight to capture in watercolor. This pastoral scene was filled with warm lights and cool shadows. I painted a small sketch on location and photographed the scene. This larger version was done back in the studio. Notice how little detail there is on the backlit tree and fenceposts.

Morning Glow • Watercolor • 22" x 28" (56cm x 71cm)

choose a composition that suits your subject

Up to this point we've focused on seeing as an artist. Once you know how to see something properly, it's time to figure out how to portray it on paper in a compelling, attractive composition. This is when you take the time to really think it through. The planning stage is a part of the artistic process that many would just as soon overlook. Some artists make the mistake of jumping head-first into a painting without a plan. They aim to convey "prettiness," sentimentality or a concept without regard to its overall design.

This is similar to a home builder beginning construction with the light switch covers and wallpaper rather than a solid foundation. One of the most important reasons for having a plan for a sound design is that you will have more confidence that the work will be the best it can be. This confident attitude will show in your brushwork and painting style, making your compositions come alive.

Follow these tips to ensure a great composition every time:

- **Ask yourself what excites you about the scene you want to paint.** Your goal should be to convey that excitement to the viewer.

- **Do a number of quick sketches.** How can you best position the colors, shapes and values to best show the scene? Vary the point of view (eye level) from sketch to sketch to find one you are most satisfied with.

- **Edit the scene as needed to create a more powerful design.** Just because you see a silo in the field before you doesn't mean it has to make it into the finished painting. When you design a painting, you are taking a little section out of nature and selecting, arranging and balancing— basically, composing.

- **Establish a general direction of movement.** For example, horizontal forms move the eye across, and vertical ones move the eye up and down.

- **Use unequal division of space.** An asymmetrical design is almost always more interesting than a symmetrical one.

Great art withstands the test of time primarily because of its good design. The principles of rhythm, movement, balance, direction, unity and proportion are all considered in establishing a successful design. Preliminary drawings, value sketches and compositional thinking will help you gain momentum in becoming a great artist.

Let's take a look at some of the most common formats used to design a painting. Observe the organization of big, simple shapes. Remember that detail is not considered at this point; just design the big picture!

Asymmetrical Balance Scale Format
The largest mass is close to the center, balanced by a subordinate, smaller mass. The movement between the two is eye-pleasing. The value sketch is especially handy for constructing this type of composition—small darks balance light and medium values.

"S" Format
The "S" format leads the eye through your painting and toward the center of interest. It usually takes the form of a road, path or river.

"L" Format

The center of interest is generally placed at the point where a strong vertical and an important horizontal connect.

Three-Spot Format

Three masses (or any odd number) is more artistically interesting than an even number. Counterbalance when a third mass is placed among two; the design will be more pleasing.

Tunnel or "O" Format

Use the tunnel or "O" format when lines or masses are grouped together and form a tunnel or bull's-eye effect. In this format there is no mistaking where the center of interest is.

Triangle Format

A triangular composition suggests sound structure. A triangle is created by the placement of the main "players" in your painting.

Off-Center Placement Format

This format follows the golden mean. Think of a tic-tac-toe grid: any of the four off-center intersections is a pleasing visual spot for your center of interest.

Pattern Format

This is the most abstract format, with no formal center of interest. Its emphasis is placed upon similar masses or a pattern of harmonious shapes.

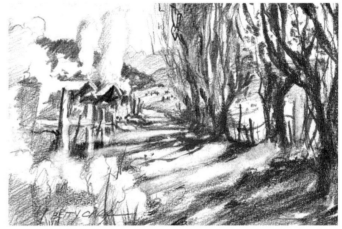

Radiating Lines Format

Think of radiating lines as similar to sun rays or spider legs. Where the lines (or masses) seem to or do converge, they meet at the center of interest. Designs with one-point perspective are good examples of this format.

bad composition versus better composition

Let's take a look at a few examples of boring compositional designs and demonstrate some possible corrections to make them more interesting.

Bad Composition

Better Composition

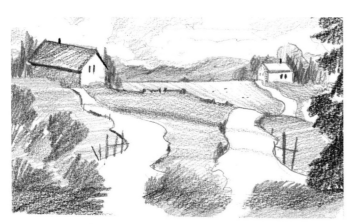

Bad Composition

Better Composition

Bad Composition

Better Composition

Bad Composition

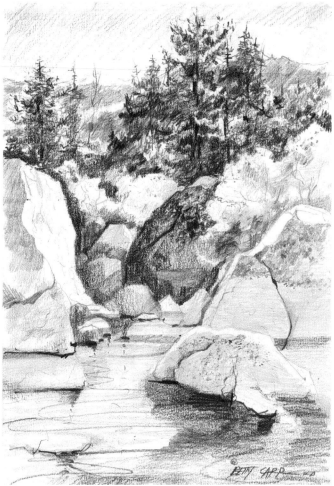

Better Composition

making a poor composition better

Now let's evaluate a completed painting with composition, color and value problems to see how it can be improved.

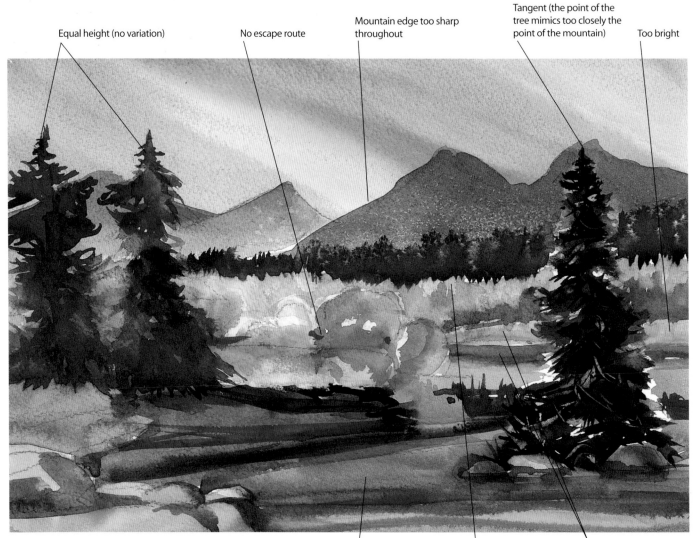

Equal height (no variation)

No escape route

Mountain edge too sharp throughout

Tangent (the point of the tree mimics too closely the point of the mountain)

Too bright

Sky color is not reflected in water (as it should be)

Composition cut in half

Too similar in value

Painting With Problems
Tangents, close-offs, inaccurate values and inappropriate edges plague this painting. Although it looks "pretty," the problems create a stylized effect instead of a realistic scene.

Painting Improved

This "S" format leads the eye pleasantly and suits the subject matter. The values and colors have been corrected to reflect a more natural, true-to-life scene.

Still Water • Watercolor • 20" x 14" (51cm x 36cm)

Value Sketch

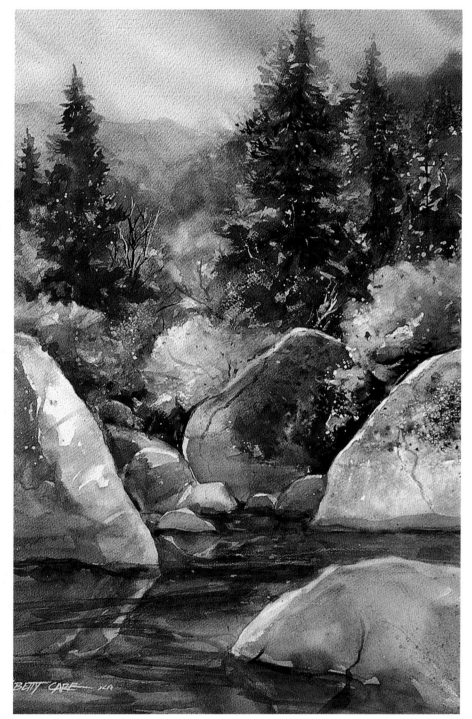

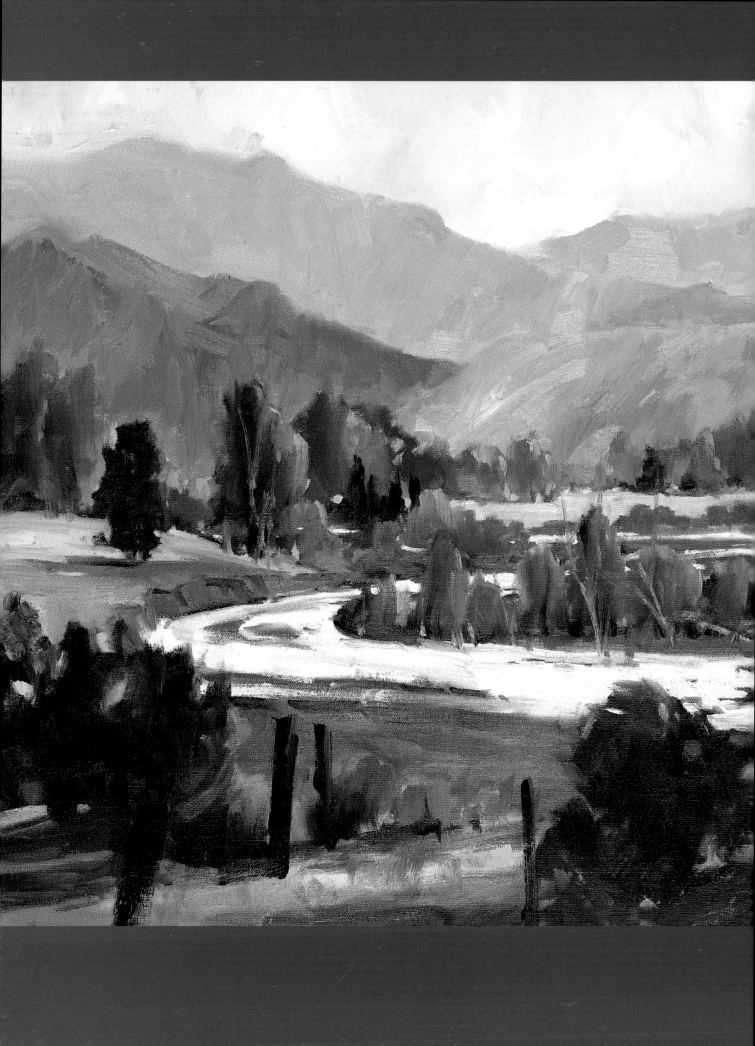

getting started: materials and brushwork basics

Now you're ready to paint! Gather the tools of the trade for painting in watercolor and oils. You will accumulate more materials as you develop your personal painting style, but these tools will get you started. Practice simple drawing techniques and brushwork exercises that will prepare you to create loose and beautiful paintings in either medium.

Winding Through • Oil • 18" x 24" (46cm x 61cm)

watercolor necessities

Brushes and Palette Knives

You will need a collection of rounds and flats in various sizes, a couple of small riggers and a few palette knives for applying paint. Generally, bigger brushes are used to cover larger areas and smaller brushes are used for details. As I tell my students, "Begin with a large mop and end with a toothpick."

A few of my must-have brushes are:

- 1½-inch (37mm) flat, for large washes of even color

- 1-inch (25mm) flat, for glazing and laying-in washes

- no. 10 round kolinsky sable, my main brush because it holds a great point along with lots of water and paint

- no. 8 round kolinsky sable, for details

- no. 6 round kolinsky sable, for more precise detail work

- a small rigger, for smaller details and thicker paint action, primarily linework (grasses, telephone lines, etc.)

Use good brushes. The hair is what holds the water and pigment, so it needs to be durable. To preview soft watercolor brushes for quality, dip each one in water, shake it and then check its shape. A good round will bounce back to a point. A good flat will maintain a unified shape and not "fuzz out." A good brush always returns to its original shape.

For lifting paint, have on hand a few Fritch scrubbers of different sizes and a baby toothbrush for lifting large areas. When lifting paint with a toothbrush, first wet the area you want lifted, then lightly brush the area and use a soft cloth to pick up. Scrubbers are also good for softening hard edges.

Palette knives are used for many textural effects in watercolor. Choose a few that have a firm spring, can hold paint well and that spatter paint effectively.

The Palette

There are as many choices in palette style as you can imagine. When purchasing a palette for your studio work, make sure the wells can hold an adequate amount of paint. I prefer deep wells. Remember that if you want color (not barely colored water!), you need to put enough color in the well. Once in a while one of my students will bring in an old palette with dried-up little marbles of paint rattling around—basically, no paint. This is equal to painting with water and hardly any color.

Watercolor Paints

The colors on my palette change from time to time, but my core palette contains the pigments shown on the opposite page.

My Palette

Shown above is my well-used palette of watercolors. A few tips:

1 Keep warm colors on one side and cool colors on the other. Otherwise, when complements (such as red and green) are placed next to each other, they may spill over into each other's wells and become muted.

2 Always keep your palette in the same direction when painting. It's easier to memorize the position of each color.

3 Keep two yellows on your palette. Primary yellow is used to mix both warm orange and cool green, so it will muddy up fast if you only have one yellow.

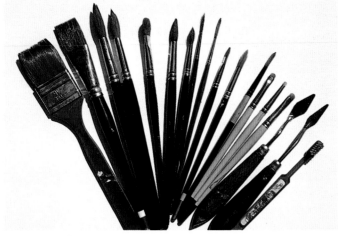

Some Favorite Brushes and Painting Tools

This is my standard collection that's always on hand: a variety of flats, rounds, small riggers, palette knives, Fritch scrubbers (for lifting paint) and a baby toothbrush (for lifting paint in large areas). I reserve a no. 4 round for applying masking fluid.

My watercolor technique of painting light relies heavily on glazing transparent layers of paint, but I have an equal amount of opaque paints on my palette. Saved whites, transparent layers that allow the white of the paper to show through, and opaque colors that block any light all combine to form successful, light-filled paintings. We build with transparent glazes and save the opaque touches for last.

Color properties vary among manufacturers, so you should test the transparency or opacity of each color you use with a simple pigment test. Paint a horizontal strip of black India ink (a permanent ink that won't lift) across a piece of paper. Then paint vertical strips of pigment across the ink strip. Allow the paint to dry, then take a close look at how each color appears on the surface of the ink. Color disappears on black if transparent; color stays on top if opaque. You'll notice that cadmium colors are mostly opaque.

My Pigments

My palette has changed over the years, as I'm always experimenting. I chose these core colors not only for the actual hue, but also for their properties: transparent (T), semi-transparent (ST), semi-opaque (SO) or opaque (O). These are the colors we will use for the demonstrations in this book. Occasionally I will add other colors to my palette as needed, or just for fun.

You may find that you prefer colors in certain brands. For instance, over the years I have found that I prefer Grumbacher's Thio Violet and Holbein's Indian Yellow to other brands of these colors. Keep in mind that the opacity of watercolor pigments may vary from brand to brand.

Paper

I often use Arches 140-lb. (300gsm) cold-press watercolor paper because of its ability to take all the technical torturing I give it, from palette knife work to masking. Also, its bumpy texture adds to the textural effects in my paintings. I've experimented with almost every type of watercolor paper out there. Experimentation is very valuable in growing as an artist and finding out what you prefer.

I always stretch my paper before I paint for a solid, smooth, tight surface. Any board (foam core, Gator board or even plywood) will work as long as I can get a staple into the board. I moisten the paper first, staple the paper to the board, let it dry and put masking tape around the edges.

Watercolor blocks are great for on-location painting. A block is a stack of watercolor paper whose sides have been glued together. Individual sheets can easily be separated with a palette knife. Keep sketch pads handy for preliminary drawings.

Other Supplies

Soft lead pencils such as ebony 4B or 6B, soft charcoal or felt-tip markers may be used for preliminary value sketches. Use a 4B pencil to make your final drawing on watercolor paper.

For various textural effects, have the following supplies on hand: masking fluid, salt (various types), water-soluble opaque white, rubber cement pickup, a spray bottle and a razor blade. In the next chapter you will see examples of these materials in action.

When I want an area of my painting to have a textured look (a rock formation, for example), I might use a granulating medium for a more realistic effect. Lifting preparation medium allows you to lift painted areas more easily than if you used brush and water alone.

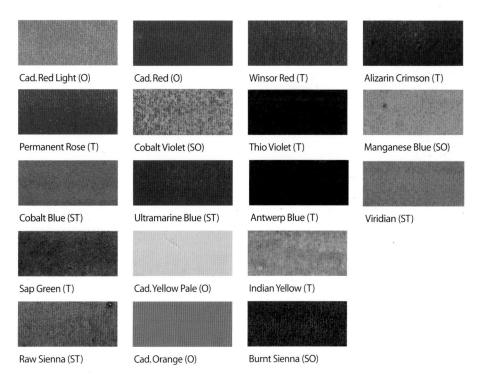

Cad. Red Light (O) Cad. Red (O) Winsor Red (T) Alizarin Crimson (T)

Permanent Rose (T) Cobalt Violet (SO) Thio Violet (T) Manganese Blue (SO)

Cobalt Blue (ST) Ultramarine Blue (ST) Antwerp Blue (T) Viridian (ST)

Sap Green (T) Cad. Yellow Pale (O) Indian Yellow (T)

Raw Sienna (ST) Cad. Orange (O) Burnt Sienna (SO)

glazing transparent colors and using opaques

Using transparent glazes is effective in building beautiful, light-filled forms because they reveal the natural glow of the paper underneath. These layers of color also result in gorgeous darks and intermediate colors. When you introduce opaques, you cover the surface, blocking the glow. However, opaques can be used effectively to emphasize the light areas of your painting. You as the artist must know each color's makeup in order to use transparent and opaque pigments successfully. Get to know your pigments, and you'll be in control of your painting.

When building a painting with transparent glazes, be sure to let each layer dry before applying the next. Keep your brush action to a minimum, especially when laying one color on top of another. This will help you avoid muddied color. If you are building transparent glazes, be careful when introducing opaques. It's easy to pick up the color underneath, especially if the underlying pigment is an opaque.

When you are painting with pigments that seem to float on the paper and appear chalky—the ones that aren't staining the paper but instead are sitting on the surface—label these color mixtures for future reference. These again are predominantly opaque and, unless thinned a lot with water, are not as effective for glazing as transparents and semi-transparents.

Learning the qualities of different pigments will help you determine the colors to use for painting different scenes. For example, I tend to use more opaques in my landscape paintings and more transparents in my still lifes.

I do more glazing in my still-life painting than I do my landscape painting. When we use transparents in watercolor, we build our darks through consecutive layering of glowing transparent colors, which is a very effective technique for creating a dark background against a glowing light. When I paint landscapes, I do more direct (plein air) painting and thus cannot rely on time-consuming glazing techniques. Instead, I use granulation medium and heavy applications of opaque pigments to simulate the variety of textured surfaces found in nature.

Glazing Exercise
Divide a sheet of watercolor paper in half and begin painting circles, using opaque colors on the left and transparent colors on the right. Let each color dry completely between layers. As we paint layers and layers of pigment on top of underlying circles, observe what happens. The opaque colors on the left appear messy and, when used heavily, do not result in clean glazes. The transparent colors on the right are clean and produce beautiful glazes.

This exercise shows how important it is to know the properties of your pigments—which are opaque and which are transparent. Can you find the one opaque circle on the transparent side?

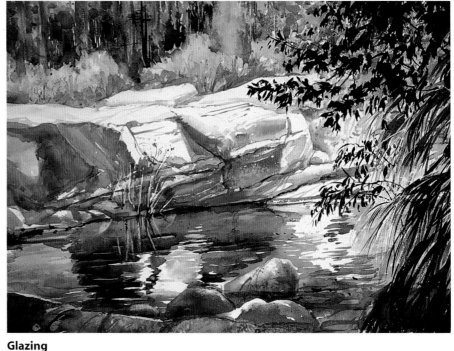

Glazing
Mostly transparent pigments were used to paint this luminous water scene.

Creek's Edge • Watercolor • 18" x 21" (46cm x 53cm)

manipulating watercolors

In order for the light in your painting to shine, you need to know how to manipulate color—not just how to mix color, but how to place colors next to each other for a desired effect. Areas of dark or dull color in a painting accentuate the light. Less intense colors will pump up the intensity of your brightest ones. These color relationships are key to creating luminous watercolors.

Complementary colors are a natural phenomenon. Your eyes will naturally seek out a color's complement to give rest to your eyes. Try this: Place a bright red square on a white surface and gaze at it for a few seconds. Take the square away quickly and look at the empty space. A green square will suddenly appear. Complements neutralize. The Impressionist painters of the past realized this; today's painters also try to effectively utilize complements in their work.

Generally, paintings have more punch if one color—warm or cool—is dominant. Adding small areas of the dominant color's complement will add sparks of contrast, igniting the piece. Gradate all of the colors on your palette from light to dark and warm to cool to see the range of color available to you. Also, practice mixing beautiful darks and dull colors that will expand your palette.

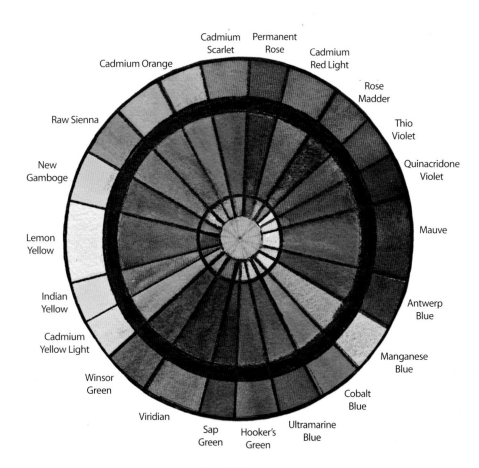

Create a Color Wheel of Gorgeous "Dull" Colors

Glazing a color with its opposite (or complement) dulls or warms that color and is effective in showing dimension. Get to know your colors by creating a color wheel using the colors on your palette. Discover low-intensity colors (browns, grays and various greens) by glazing with complements.

Mixing Beautiful Grays and Blacks

It's the grays and blacks that show off the color and light in your painting. Mix glowing darks for contrast against the lights. A simple approach to mixing darks is to basically look at your pigments—the darkest ones make the darkest darks when mixed. I don't use pure black; black absorbs light and often deadens a color. Mixed blacks are more vibrant and luminous. My most commonly mixed dark is Thio Violet, Antwerp Blue and Burnt Sienna.

Beautiful grays can result by mixing complementary colors. Warm and cool colors, opposites on the color wheel, neutralize each other to make grays and browns. Adding more of the cool side of the mixture will create a cooler gray, while a warmer gray will result from a warmer mixture. This characteristic of warmth or coolness of a gray or brown is very important in enhancing the mood of a painting. When I want textural grays, I mix opaques, which often separate and yield fun natural effects for surfaces such as rock or rust.

Gray Mixtures

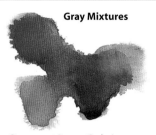

Permanent Rose + Cadmium Orange + Manganese Blue

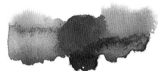

Cadmium Red Light + Cobalt Blue

Venetian Red + Cobalt Blue

Black Mixtures

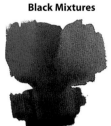

Cobalt Blue Hue + Thio Violet + Quinacridone Burnt Orange

Viridian + Alizarin Crimson

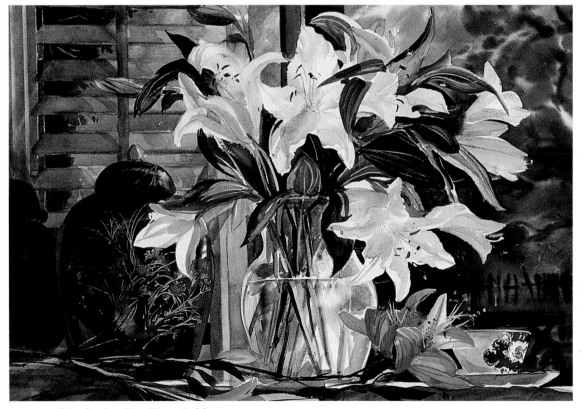

Grays and Darks Can "Pop" Your Subject

Fresh-cut lilies convey a feeling of purity. They have a proud shape: distinctive, pure and confident. This painting demonstrates the idea of vitality—the liveliness of the white flowers exaggerated by the various subtle grays and greens which surround them. The muted grays help to show off the star of the show: the lilies.

Fragrant Lilies • Watercolor • 20" x 28" (51cm x 71cm)

brushwork exercises in watercolor

You can always tell when confident brushwork took place during the creation of a painting. From the largest wash to the smallest brushstroke, the artist obviously knew what to do with the brush and where to put the paint.

Practicing various brush techniques enables you to gain the necessary confidence to make your work look effortless. Get to know your brushes and what they are capable of doing. Remember that your whole body should be involved in the brush action, not just your fingers. Consider painting as an athletic event, and do it with gusto.

Whatever appears in a painting is the result of action done by you, the artist. Getting creative with a variety of tools can be exciting and will add variety to your work. Practice the following techniques and develop your personal way of doing them.

Applying a Flat Wash
Flat brushes are ideal for large washes because they can cover a lot of paper in just a few strokes.

Flat Wash
Tilt your moistened paper, then with a loaded brush start at the top and gently pull strokes from one side to the other. Allow a bead of paint to continue down your paper. Remember that the less water in the mixture, the darker the wash will be.

Graded Wash
Begin with a loaded brush of color and float the hue at the top. As you proceed down the paper, increasingly dilute the paint with water. Let the value of the pigment gradually go from dark to light. Tilt the paper so that gravity can help create a smooth transition.

Drybrush
Using different types of brushes, vary the amount of pigment and water in your brush along with the speed at which you move the brush over dry paper. Use the handle of your brush to scrape into the paint. As you can see, you can create a great variety of effects with watercolor brushes.

Applying Salt
Try sprinkling a little salt on a painted surface that has a dull shine to it.

Finished Result
Once the paint has dried, brush the salt off and notice the interesting effects that result.

Spattering Paint With a Loaded Brush
Tap a loaded brush against the handle of another brush to spatter paint on your paper. Spatters can be done on wet or dry paper for different effects. Here, spatters were applied to a moist area.

Painting Wet-Into-Wet
When you apply different mixtures of pigments to moist paper, the colors blend and move around pleasantly.

Spattering Paint With a Toothbrush
Try putting paint on a toothbrush and spattering it onto damp paint.

Lifting Paint
Dip a Fritch scrubber or a stiff bristle brush in water. Scrub on dried paint, then dab with a paper tissue to lift the pigment off the surface.

Combined Techniques
The wet-into-wet technique, shown here, is very effective in creating a distant background or soft textural effects. Wetting most of the paper and dropping heavy paints here and there, letting them flow, will offer a spontaneous result. Lifting and spattering can be used to re-create a number of different textures.

Spattered masking fluid

Painted masking fluid

Masking tape, painted after removal

Masking Fluid and Tape

Mask an interesting torn edge with masking tape. Paint thin lines of masking fluid and spatter spots, then paint with gusto after the fluid has dried. Remove the masking fluid with a rubber cement pickup, and paint the area masked by the tape once it has been pulled off.

Painting With a Palette Knife

Put paint on a palette knife and rub it lightly on the paper. This is a great technique for giving texture to such elements as granite, rock or weathered wood.

Linework With a Palette Knife

Linework can be done effectively by applying paint with the side of a palette knife, gliding it over the paper.

Scraping With a Palette Knife

When the pigment on the surface of the paper is slightly moist, scrape into and remove paint. This technique is great for natural forms such as grasses and twigs.

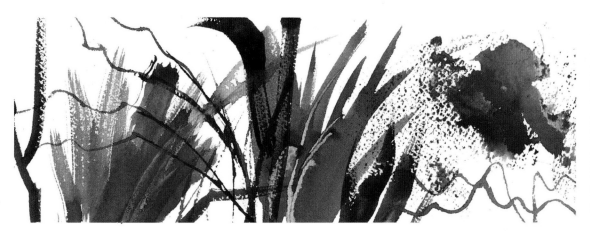

Finished Result

Brushwork and palette knife action can combine for realistic effects. Vary the direction of a loaded brush on the paper. Vary the size of your brushes when doing this exercise.

oil necessities

Brushes and Palette Knives

As with watercolor, you will need a variety of larger brushes to cover bigger areas of an oil painting, and smaller brushes for detail work. Their bristles should be pliable enough, but firm to maintain their shape. Select brushes that fit your particular style and the way you like to work. A few of my "must-have" brushes are:

- no. 10 or no. 12 filbert bristle, for the large block-in at the beginning stages of a painting

- no. 8 filbert bristle, great for laying in the final "serious" paint

- no. 6 filbert bristle, a favorite for beginning the final stages and handling details

- nos. 4 and 6 flat hog bristle (Connoisseur), for linework (using the side of the brush) and laying in thick, impasto sections

- half-inch (12mm) flat red sable, for small details

- no. 2 filbert, for softening edges and blending one form into another

- no. 6 filbert (Silver Ruby Satin), for applying paint as well as softening edges

- half-inch (12mm) and ⅜-inch (10mm) filbert grass combs (Silver Ruby Satin), for final touches, blending edges and detail work

There are a number of solvents you can use to clean your brushes. Wash your brushes with mineral spirits or odorless turpentine, while occasionally doing a final wash with mild soap and water.

If you are in a hurry and cannot completely clean your brushes, clean them as best as you can and coat them with petroleum jelly. This will prevent any paint that is still on them from drying up. Vegetable oil is also helpful for keeping almost-clean brushes from drying out while awaiting a better cleaning. Place your brushes in a plastic container and fill just enough to cover the bristles to protect them.

A sturdy container for your turpentine is invaluable. One with a lid that can be securely fastened is important, as bouncing down a dusty, bumpy road searching for a subject to paint could otherwise result in a spill. When switching colors while painting, wipe most of the paint off with a soft paper towel and then rinse with turpentine or mineral spirits.

In addition to brushes, I collect numerous palette knives which are primarily for mixing paint, cleaning the palette and applying paint to the canvas.

The Palette

There are various options for oil palettes, but certain aspects are key to have. You need a large enough mixing area to mix clean color and a neutral color (light brown or light gray). The color of the mixing surface itself could become an issue. A stark-white mixing surface is a little tough on the eyes, especially when painting on location. Paper palettes will do in a pinch.

Oil Paints

Red, yellow and blue are the primary colors. All other colors can be mixed from these, but to save mixing time you may want to include additional colors on your palette. White is a neutral and is used to tint or lighten a color. Using a limited palette tends to harmonize your work. Try to limit your paints to one palette. Some beginning artists may have two or three color palettes, which isn't really necessary.

Painting Surfaces

A variety of canvases and canvas boards are available for oil painting. Stretched Belgium linen canvas is a favorite for oils.

I use Utrecht gesso-primed, stretched canvas. Gesso is an acrylic plastic-based paint that seals the surface of the canvas, preventing the absorption of paint. Generally I will apply an extra layer of gesso to the canvas because sometimes the manufacturer does not put the gesso on thick enough. You can also use an oil primer.

Canvas board is similar to stretched canvas but without the bounce. You can prepare your own panels for painting. Use a small roller to spread polyvinyl acetate (archival quality, also used for bookbinding) or acrylic soft gel medium onto a wood panel. (Maple boards are quite good.) Place canvas on top and weight it down for a day or so. To avoid warping, spray or sponge water on the back of your panel. I usually carry small canvas boards for studies on location.

Other Supplies

Use a charcoal stick or a small no. 1 or no. 2 bristle brush with oil paint to make your drawing on the canvas.

Additional solvents, mediums, varnishes and primers can help in the painting process. Turpentine, paint thinner and odorless mineral spirits all can be used to clean brushes and thin pigment as needed. The alkyd medium of Liquin can be used to speed the drying time of pigments, as well as copal. My workable medium is primarily a mixture of five parts turpentine, one part linseed stand oil and one part damar varnish.

When your work is entirely dry, various varnishes can be used, from matte to gloss. I generally use a spray final picture varnish (gloss). A paint-drying agent is used before the final varnish.

My Palette

My oil palette, with a large area in the middle for easy mixing.

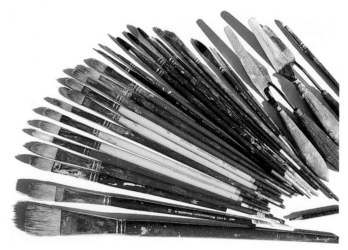

Some Favorite Brushes and Painting Tools

I've accumulated a large collection of brushes and painting knives for working in oils.

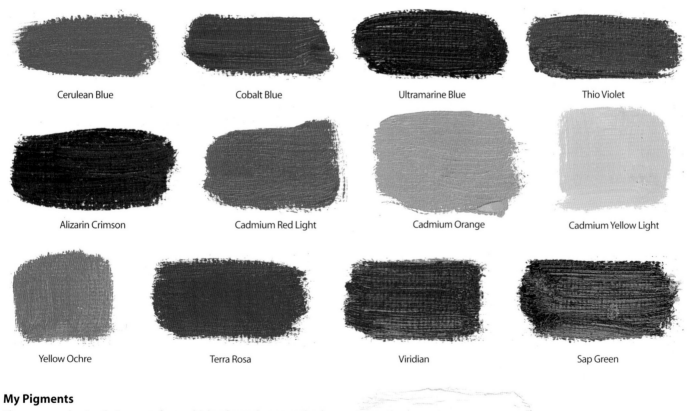

| Cerulean Blue | Cobalt Blue | Ultramarine Blue | Thio Violet |

| Alizarin Crimson | Cadmium Red Light | Cadmium Orange | Cadmium Yellow Light |

| Yellow Ochre | Terra Rosa | Viridian | Sap Green |

My Pigments

These are my basic oil pigments from which other colors are mixed. The oil pigments I tend to use the most are Cadmium Yellow Light, Sap Green and White.

White

mixing oils

Understanding how different paints react when mixed together is just as important when painting in oils as in watercolors. The more aware you are of the various mixtures available, the more confidence you will have in your work.

Color saturation refers to how pure a particular color may be. How neutral can a color go before losing its identity? When mixing colors, get to know each color's degree of warmth or coolness, transparency or opaqueness, value range and degree of saturation.

Below are some of the colors you can make. Create your own favorite greens, grays, browns, tints and darks.

Tints, Darks and Grays

The grays and darks here are only a few examples of the numerous great neutrals you can make. The list is endless when you mix complements. Create a wide range of color charts to learn the possibilities. When mixing grays, mix the intense color and its complement first, then touch in the white. You'll soon learn how much white you need to gray a complementary neutral.

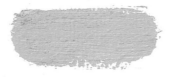

Cerulean Blue + white = tint

Ultramarine Blue + Alizarin Crimson + Sap Green = dark

Terra Rosa + Cobalt Blue + white = warm gray

Ultramarine Blue + Cadmium Orange + Thio Violet + white = cool gray

Greens

Viridian + Cadmium Orange

Cadmium Yellow Light + Sap Green

Cadmium Orange + Sap Green

Yellow Ochre + Cobalt Blue

Yellow Ochre + Cerulean Blue

Cadmium Yellow Light + Ultramarine Blue

Browns

Viridian + Cadmium Orange + Thio Violet

Cadmium Yellow Light + Sap Green + Thio Violet

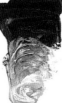
Cadmium Yellow Light + Cobalt Blue + Cadmium Red Light

Yellow Ochre + Cobalt Blue + Alizarin Crimson

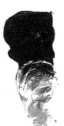
Yellow Ochre + Cerulean Blue + Cadmium Red Light

Cadmium Yellow Light + Ultramarine Blue + Thio Violet

Grays

Cerulean Blue + Cadmium Orange + Thio Violet

Cadmium Orange + Cobalt Blue + Thio Violet

Terra Rosa + Ultramarine Blue

Greens, Browns and Grays

Generally, but not always, combinations of reds and greens produce browns, while blues and oranges produce grays. Adding white to these colors will create tints. See how many mixtures you can create.

brushwork exercises in oil

By its nature, watercolor offers more variety in spontaneous action than oil. The fluid qualities of watercolor encourage all sorts of exciting surprises, sometimes called "happy accidents." You can lift it, glaze it, scrape it, apply salt to it and more, but generally you must work quickly because of the quick drying time of the medium. Oil paint, on the other hand, stays wet all day and enables you to make adjustments more easily (working your edges, for example). This feature can get you into trouble at times if you overwork this flexible medium.

The most effective way to develop your own method of moving the brush is to practice, practice, practice. Remember, it is not just your hand that moves the brush, but your entire body. Other variables involve the fluidity of the paint, the stiffness of the brush and, of course, your particular painting style. I find that using an impressionistic style is the most exciting way to work. Most can learn to take a no. 2 round brush and a magnifying glass to paint details; but confident, direct painting is a bit more challenging and much more exciting. You can sense the exuberance of the artist in looser brushwork.

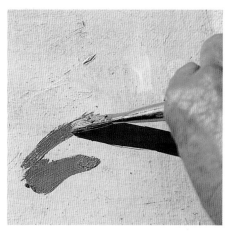

Side Action With a Loaded Brush

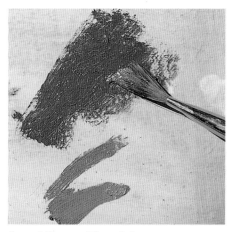

Scumbling and Smudging

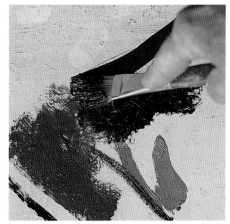

Pushing the Paint

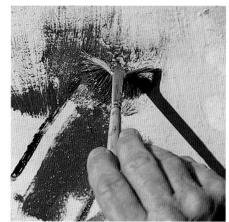

Fanning the Brush

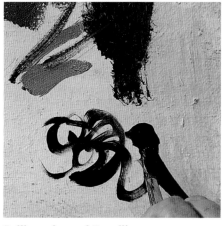

Calligraphy and Doodling

Springing the Brush

Direct Painting With a Loaded Brush

honing your drawing skills

Drawing is critical to great painting. Make a habit of doing warm-up drawing exercises to get your brain and hand moving. Preliminary sketches will get you thinking dimensionally and will help you determine how forms are modeled in light. A thick, soft-lead pencil can cover the paper quickly and will help you capture your idea and the direction of light with more spontaneity.

To become a good painter, learn to draw these types of sketches:

- **Weighted contour line drawing.** This is an effective way to get to know your subject by illustrating form through contour line. Look at your subject, pick a place to start, and begin drawing. The contour lines within a form are more critical to observe than the outline. Do not look at your hand while you draw; just move the pencil according to the nooks and crannies that you observe. When you come to an area that is out of the light, press down on your pencil. The weight of the thicker line will suggest shadow or heaviness.

- **Value sketch.** Value sketches establish the value play and paths for basic eye movement throughout. Do as many small sketches as necessary until you feel sure that your future painting will be a masterpiece. This preliminary step is crucial in developing strong, confident art.

- **Final drawing.** You need to be able to transfer your sketched idea to a loose drawing on your watercolor paper or canvas. Use your value sketch as a guide, but keep it simple so that you don't get locked into the drawing and obsess over details, which will result in an overworked painting.

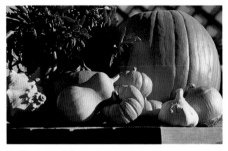

Reference Photo

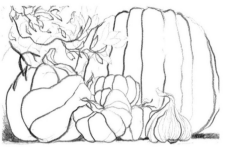

Weighted Contour Line Drawing
Focus on the contour of the growth lines of the pumpkins, garlic and squash. Bear in mind the eye level, which in this case is straight ahead.

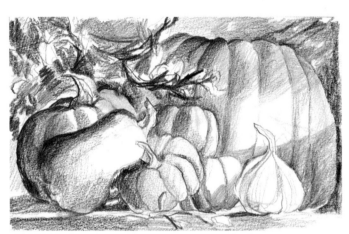

Value Sketch
Focus on limiting the light and modeling the forms.

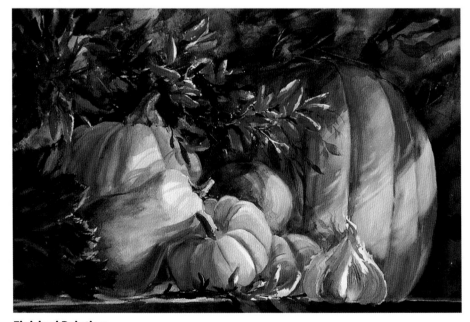

Finished Painting
Once you have made a light, loose drawing as a general guide, you can complete the painting.

Backyard Garden Treats • Watercolor • 16" x 22" (41cm x 56cm)

58

using reference materials

When composing a painting from photographs, it is valuable to refer to a number of photos for your design and composition. When beginning artists use only one photo for reference, they often end up copying it. They get caught up in literal thinking and fret too much over the little details. Expand your imagination by incorporating various photos that emphasize your center of interest. You may end up using ten to fifteen photos to find the right balance of features.

Few reference photos come perfectly composed for painting. Normally, you will want to make some changes to enhance the scene. You can control the composition when you set up your own still lifes, but when you use photos of inspirational scenes, you will probably have to practice the art of elimination to create a pleasing design. Experiment with eliminating or moving forms around as you make your preliminary line drawings and value sketches.

If you use many photos, remember that the eye level and light direction may vary among them. You as the artist—the composer—are responsible for determining the height of the viewpoint and the path of light in your painting. Be sure to keep these elements consistent.

Look for a subject that turns you on; for example, the autumn light streaking across a field. Most often, it is not a "thing," but the light on an object that will inspire you to paint. The more information you can capture while plein air painting, the more resources you will have to draw from as you return to your studio to work. Photos can help you recall the elements of a scene, but a quick study on location may be the best reference to start with once you return to your studio.

Pooling Resources
The reference photos and value sketch used to create *Patio Pleasures*.

tip

Loosen Up With a Gesture Drawing Exercise
Pick a shape near you and give yourself thirty seconds to draw it using pen, pencil or brush. Try another for sixty seconds. Every form has a gesture, and by forcing a speedy drawing, you will find that you'll zoom in on it. Say you choose to draw a pine tree. Is it proud and upstanding, or droopy and forlorn? Are the branches parallel to the earth? Perhaps those branches closer to the sky bend upward while the heavy branches near the ground are affected by gravity. Sensing the way a form grows will greatly assist in your gesture drawing, and in turn, your painting.

Patio Pleasures • Oil • 24" x 18" (61cm x 46cm)

equipment for plein air painting

The main objective of painting outside is fact gathering. We've been discussing how to see as an artist. One of the best ways to develop this skill is to paint on location.

There are many gadgets on the market to make the process of painting on location easier. Keeping the process simple is the key. My setup for plein air painting is the same for both oil and watercolor, with a few exceptions.

The lighting on location changes quickly, so usually I do small studies to capture the light for reference and I paint larger works back in the studio. Prestretched panels or watercolor blocks allow watercolor paintings to be transported easily. Wet oil paintings are trickier to transport, so I recommend using special boxes (shown at right).

Because we are painting in ever-changing light when out on location, it is important to take note of the sun's path. Long morning shadows are a delight to paint, but they quickly shorten as the day progresses. Move through your plein air sketches quickly to capture the effects of light on what you see. Several spontaneous sketches are much more successful than one overworked, muddled attempt.

Every time you set up for plein air painting, memories of previous experiences, failures, ho-hum paintings and successes are with you and will intuitively guide you. Rely on your intuition without belaboring the little details. Remember that light moves fast, especially in the morning. Finally, have fun! Think of this chasing-the-light experience as similar to an athletic event, with a gorgeous painting at the finish line.

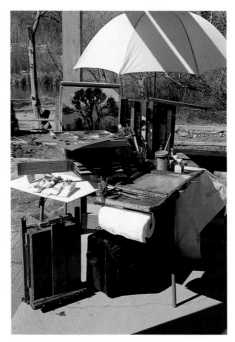

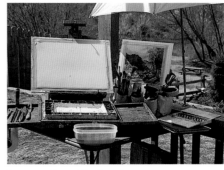

Watercolor Painting Setup

My essentials for painting outdoors in watercolor are: an easel, a full palette, a water container (with fresh water nearby for refills), an umbrella, a sketchbook, paper towels, and a bag for holding brushes, palette knives, a spray bottle, masking fluid and any other painting tools that I may need. I set up my materials on an easily portable card table.

Oil Painting Setup

My essentials for outdoor oil painting are: an easel, Easel Pal (holds paint), umbrella, paper towels, panels, a sketchbook and boxes to carry wet paintings. The blue bag contains panels, turpentine, paints and brushes for easy transport. Boxes like the ones shown here are a great help in moving wet oil paintings. These boxes generally come in sizes 12" x 16" (30cm x 41cm), 16" x 20" (41cm x 51cm) and 18" x 24" (46cm x 61cm).

tip

Be Prepared

Keep the items on this checklist handy for plein air painting at a moment's notice:

- Pencil and paper for value sketches
- Small canvas, toned and ready (8" x 10" [20cm x 25cm], 11" x 14" [28cm x 36cm] or 12" x 16" [31cm x 41cm])
- A watercolor block or stretched watercolor paper (11" x 14" [28cm x 36cm] or 16" x 20" [41cm x 51cm])
- Camera, loaded and ready
- Brushes and paints
- Containers of water and turpentine
- A few basic still-life objects, if you choose to paint a still life outdoors
- A water-filled spray bottle to keep newly picked flowers fresh
- A painting plan set in mind
- Anything else you may need for an action-packed morning (sunblock, drinking water, etc.)

before you turn the page and begin painting…

Don't Limit Yourself to One Medium
The value of working with both oil and watercolor to portray your inspirational subject cannot be overstated. Comparing materials and techniques as they relate to your particular way of working is tremendously helpful in gaining skill as an artist. Experimenting and trying out new materials keeps you on your creative toes. As you develop as an artist, an underlying approach will evolve as "your style," and it will not depend on the type of material you use.

While teaching workshops, I often hear, "I want to loosen up my work"; I never hear, "I'm here to tighten up." Many artists realize that clean, confident, almost effortless strokes result in a solid painting. Painting impressionistically in either medium can help you loosen up. Through value sketches and planning to paint light realistically, you'll know where to put the various values of paint. You'll learn to "put it down and leave it alone," as I often instruct my students.

It's often said that watercolor is more difficult than oil, primarily because of its more spontaneous nature. But whether you scrape out a judgment error in oil or scrub out a bad situation in watercolor, the fresh spontaneity of the painting has been lost. The skill and knowledge you gain from making preliminary sketches and having to plan ahead to save the whites in watercolor will be incredibly helpful when you tackle oils. Watercolor techniques can train the eye for developing clean, confident oils. Painting in both watercolor and oil truly benefits your technical skill in each medium.

Don't Let Technique Replace the Heart of a Painting
Why does certain great art have such value and withstand the test of time? Memorable paintings have some form of emotional impact, show the skill of the artist and establish an intangible sense of connection between the viewer and the painting. Greatness is based on what we feel is worth saving; what we want to pass on to future generations. The spirit of the artist must, in some way, touch the soul of the viewer. Great music, literature, philosophy, dance, science, mathematics and even athletics all have this enduring element in common.

Technique is certainly part of greatness, but the individual spirit of the artist and his or her mode of expression is what painting is all about. Technical skill comes as you gain a deep understanding of your materials and why they are effective for a particular expression in your work. This skill will become second nature only by putting miles and miles of paper and canvas behind you. But keep in mind that if you are more fascinated by technique and the time it takes to finish a painting rather than being struck by the inner beauty of your subject, the painting will have missed its mark.

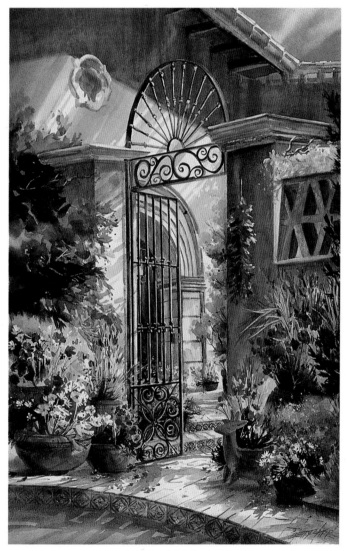

Colorful Entry • Watercolor • 24" x 18" (61cm x 46cm)

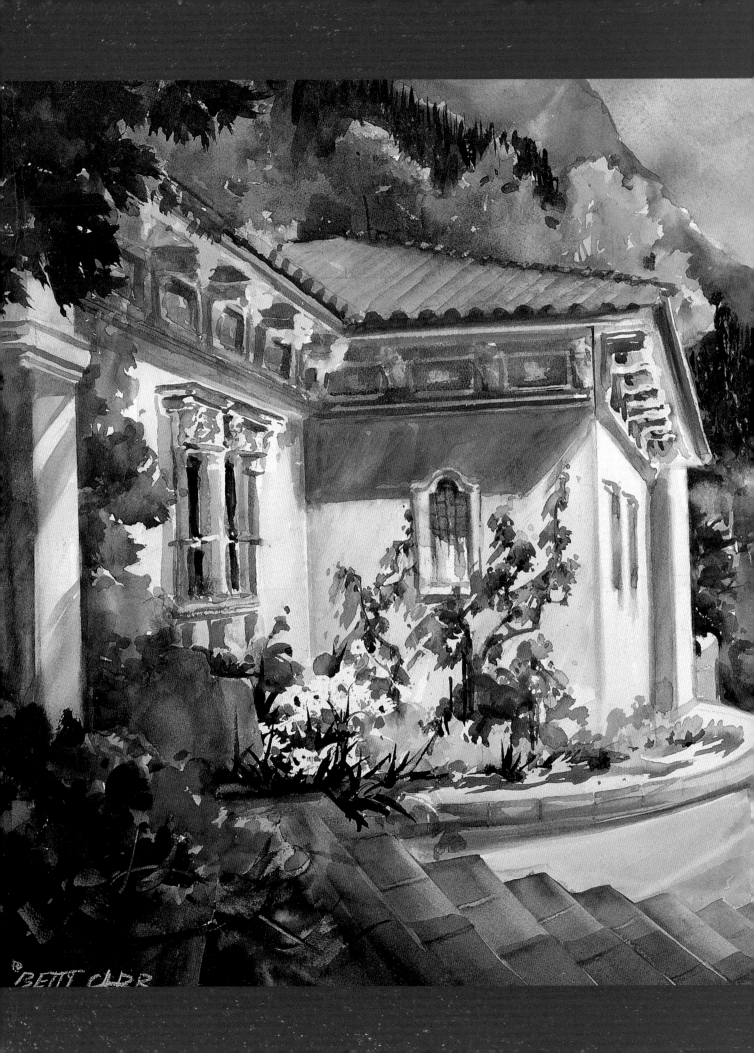

painting light
step by step

It is exceptionally valuable to execute the same painting in both water-color and oil. Your ability to sculpt the effects of light with fundamental shapes and values ultimately is reinforced through working in both mediums. In this chapter, you will see how the same subjects are por-trayed in both watercolor and oil through six dual demonstrations. Several additional demonstrations tackle the unique lighting situations of four individual scenes, three in watercolor and one in oil. Scenes portrayed include a shadowy desert road, an intimate moonlit street, a dramatic arch, bright sunflowers, a rushing creek and a still life of various reflected textures.

Vista Getaway · Watercolor · 16" x 22" (41cm x 56cm)

portray a sandy desert road in glowing light

While strolling the tops of the desert dunes near Lake Havasu, Arizona, my husband and I mounted a grassy hill that overlooked a valley. The sandy, narrow road grabbed our attention as it wound through the desert toward the gorgeous blue lake.

The memory of long, incredible violet and blue shadows, and the sense of warmth and distance I felt while there inspired these paintings. Peering down into a landscape creates a viewpoint that is exciting to paint.

We'll approach this demonstration beginning with the foreground, then proceed through the middle ground to the background. The glowing feeling of light is accomplished through its contrast with the gorgeous stretched shadows. We'll paint in a loose style, leading the viewer's eye down the sandy road.

Reference Photo

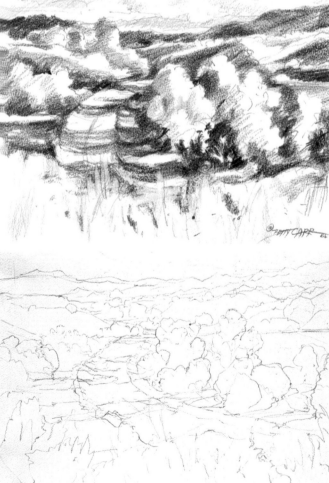

Value Sketch

1 Make a Line Drawing

In preparing your light drawing on watercolor paper, you decide what level of detail you are comfortable with. More detail does not necessarily mean that you will tighten up the painting. In the impressionistic manner of painting, you aren't bound by the little details—they're just used as guides to confidently approach your painting.

Apply masking to a few edges of the foreground grasses; otherwise it will be tough to save these delicate whites while painting the dark shadows on the road in the middle ground.

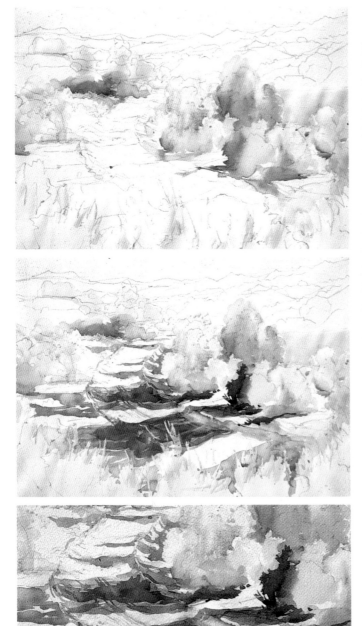

2 Block In the Foliage

Most of the painting at this stage is done wet-into-wet. Start by painting the bushes and trees with various light washes of Raw Sienna, Cadmium Yellow Pale, Manganese Blue, Permanent Rose and a touch of Sap Green. Begin the foreground grasses with a light wash of Cadmium Yellow Pale, making the overall shape interesting. Because the shadows will enhance the dramatic light against these bushes, the building of these light-value shapes is a critical stage for the future shadow play.

3 Start Road Shadows

Using Viridian, Burnt Sienna and Cobalt Blue, darken the shaded side of the trees and shrubbery, pulling the directional shadows toward the road. Confidently paint the violet and warm-gray shadows following the contour of the ruts in the sandy road. Use Permanent Rose, Cadmium Orange and Manganese Blue with touches of Raw Sienna. Use a little more Cadmium Orange in the gray mixture when you want to warm it up.

Keep the shadows loose and soft-edged. Remember to vary the elongated shapes and keep the light coming from the right.

Detail

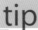

tip

Know Your Painting Strategy

In watercolor you generally start with the lights, gradually building up to the darks. In oil painting you begin with the darks and build up to the lights.

4 Begin the Dark Mountain Region

It's time now to create horizontal drama against the vertical shapes of the bushes and trees. Use Alizarin Crimson, Ultramarine Blue and Raw Sienna to paint the muted dark mountains in the background that will eventually contrast with the middle ground. Make sure the mountain lines are soft and that the shape does not appear to be manmade. Work more violets, greens and oranges into the background. Deepen the values of the distant trees in the upper left. Add touches of blues to begin the illusion of distant shapes.

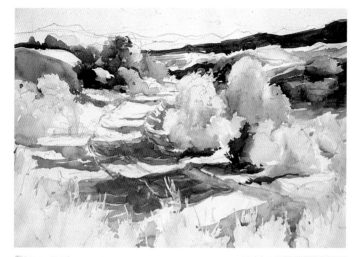

5 Add Distant Mountains

Continue developing the darker mountain area with various colors. Create the distant gray mountains using Cobalt Blue, Raw Sienna, Cadmium Red Light and lots of water to create a very light tint. Keep the edges soft and subtle. Drop a few water droplets into the wet mixture to add an atmospheric aura.

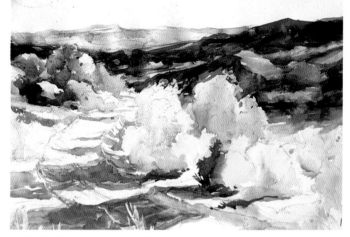

6 Add Darks to the Foliage and Paint the Lake Area

Glaze with Viridian, Antwerp Blue, Burnt Sienna, Alizarin Crimson and Cobalt Violet to strengthen the value and contrast of the foliage, especially on the dark side of the forms. Paint the lake with combinations of Manganese Blue, Cobalt Blue and Ultramarine Blue and touches of Cadmium Red Light to subdue. Wet the lake area and, when slightly dry, drop in the blues and touches of yellow, greens and oranges for the water's edge and reflection. Make sure the edges in the reflection are soft.

Apply Indian Yellow, Ultramarine Blue and Sap Green along the shoreline and additional parts off shore. Suggest grasses, twigs and other textures with a few palette knife strokes while the paper is wet, but not too wet. Add a few small branches to the large middle-ground trees using Burnt Sienna, Ultramarine Blue and Alizarin Crimson. After removing the masking on the foreground grasses, begin darkening this area using Viridian and Burnt Sienna.

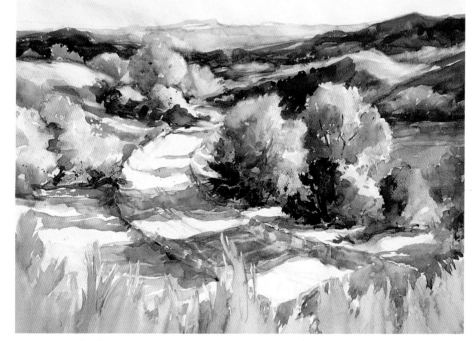

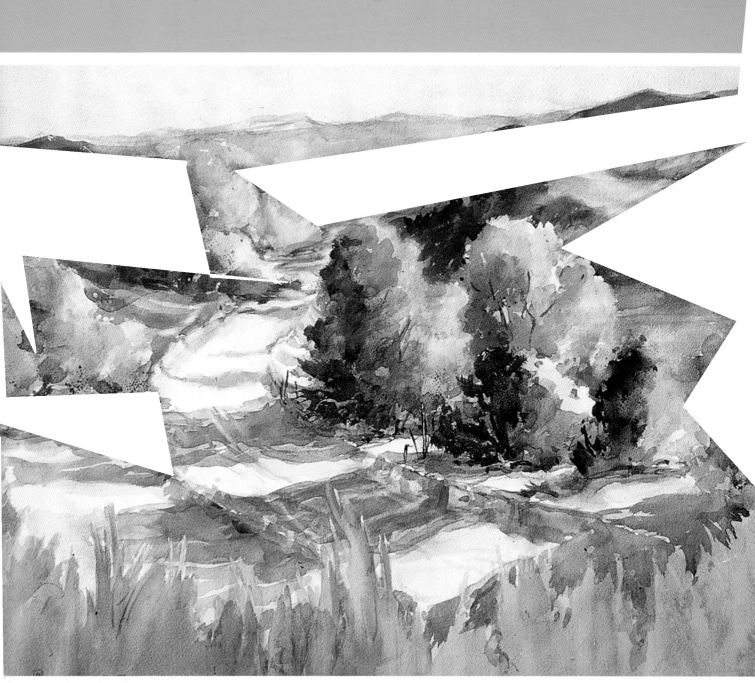

7 Finishing Touches

Generally the sky is painted last unless it is the focus of the painting. Here the center of interest is the shadow-laden desert road with beautiful adjacent trees. A busy sky would distract the viewer from our star. Paint the sky with Cobalt Blue, Alizarin Crimson, Cadmium Yellow Pale and a touch of Manganese Blue, using lots of water.

Apply a glaze of Cobalt Blue and Raw Sienna to the foreground grasses, along with a slight glaze of Cobalt Blue on the cool lake. Soften the edges of the middle-ground tree near the road by lifting with a Fritch scrubber, allowing air to envelop the form. Apply a light, warm glaze of Raw Sienna on a few of the remaining whites. Sparingly add Opaque White for touches of light hitting the trees and on the road ruts.

It's often difficult to know when to stop, but it's more difficult to fix an overworked painting. It's best to stop a half hour before you think it's done in order to keep your painting fresh. There's always something you can add, but it is important to leave something for the imagination of viewers to enable them to participate in the finishing of the painting.

Scenic Desert Shortcut · Watercolor · 16" x 21" (41cm x 53cm)

portray a sandy desert road in glowing light

before you begin

Eye level—high
Light quality and direction—glowing,
late-afternoon light coming from the
right
Dominant value—high key
Color dominance—warm

materials

Surface

Prestretched, gesso-primed canvas,
18" x 24" (46cm x 61cm)

Oils

Alizarin Crimson • Cadmium Orange •
Cadmium Red Light • Cadmium Yellow
Light • Cerulean Blue • Cobalt Blue •
Sap Green • Thio Violet • Ultramarine
Blue • Yellow Ochre • White

Brushes

Bristle flats nos. 4 and 6 • bristle filberts
nos. 6, 8, 10 and 12 • Ruby Satin filbert
no. 6 • soft brush (for blending)

Other

Palette knife (for mixing) • painting
medium (for thinning paint) • odorless
mineral spirits (for cleaning brushes)

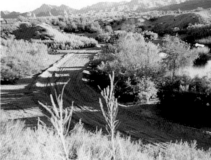

Reference Photo

Value Sketch
We will work from
the same value
sketch used for the
watercolor version
of this scene.

Tone the Canvas and Line It Out
Pick up a dab of Yellow Ochre and spread it on the canvas with a
palette knife and a few paper towels dipped in turpentine. Wipe up
the excess, removing most of the paint but leaving a slight tone.

Pick up a mixture of Alizarin Crimson and Yellow Ochre with a
small bristle brush and draw your composition on the canvas. Keep
the drawing simple and concentrate on creating interesting shapes.
Refer to your value sketch, keeping in mind your eye level and the
direction of the light when drawing the shadows.

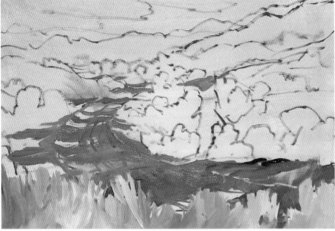

2 Begin Foreground Foliage

Block in the subtle blending of warm color using Yellow Ochre, Cobalt Blue, Cadmium Orange and Sap Green and bold, upswinging strokes with a no. 10 or no. 8 brush. Soften edges as you go to keep the foreground slightly out of focus, making the viewer's eye move toward the center of interest. The foreground should gently lead the eye to the middle ground, where the center of interest will be.

3 Add Shadow Punch

Begin the middle ground with your darks by blocking in your cool and warm shadow shapes. The violet shadows are a rich mixture of Ultramarine Blue, Thio Violet and Cobalt Blue, which complement the rich yellow-oranges of the road in between. The yellow-oranges are mixtures of Cadmium Yellow Light, Yellow Ochre and Thio Violet with white. Let's exaggerate—the violets give punch to the shadows.

Perspective is important in gaining the depth we want in this painting. Variation in shadow shapes as well as in the negative spaces between the shapes will give interest to the road as it reaches the horizon. The shadows become bluer toward the horizon and the closer shadow shapes have a touch of warmth to them.

Detail

Here we can see the effective use of positive and negative space to create shadows. The canvas showing through is where your lights will be placed. Notice the variation from small to large, narrow to wide.

4 Bring In the Light

When painting the light areas of the road, vary the shapes in size and interest. Follow the contour of the weathered and rutted road. Take a large amount of white with a tad of Cadmium Yellow Light in the mixture and confidently work the paint along the trail. The intensity and value of a color can be judged only when its neighboring color is in place. The violet shadows don't appear exciting next to the yellow tone of the canvas, but when placed next to the white, pleasant color interplay takes place.

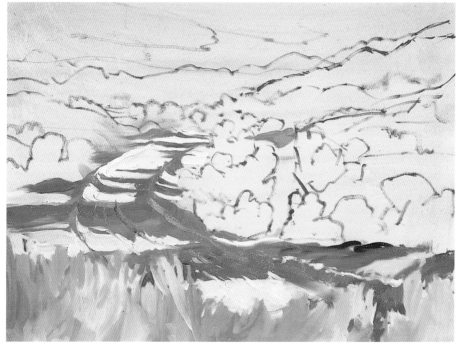

Detail

Use a loaded brush to touch up the shadow shapes with Alizarin Crimson and Ultramarine Blue. If you use a brush with a skimpy amount of paint, you can't make a confident stroke. Use another loaded brush filled with white paint to touch the surface of the shadows and light here and there for sparkle. Concentrate on where highlights might be hitting the ruts of the road.

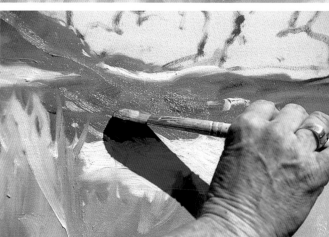

tip

Repeat Colors

Echoing or repeating color is a great device to add color harmony to your painting. Your eye will be attracted to one color if it is by itself, and then it will get stuck there. But if you use that color hither-skither, your eye can move around the whole composition.

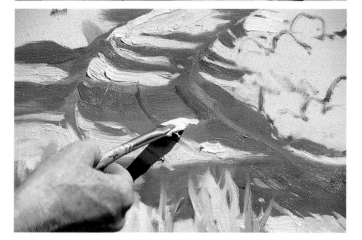

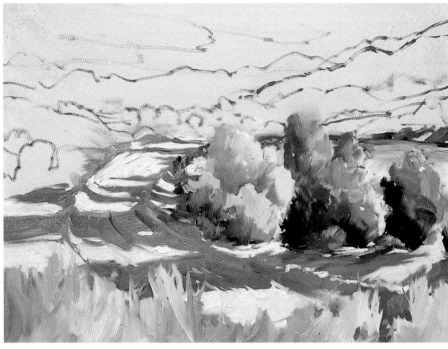

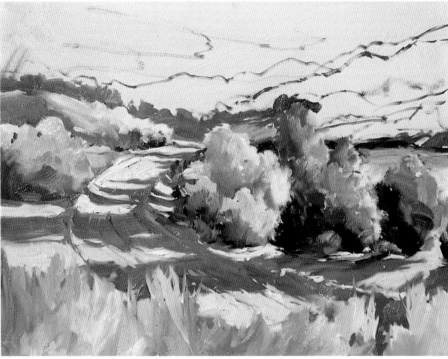

5 Add Bushes and Water

The spherical bushes are immersed in the low light of the golden hour, which is coming in from the right and warming the various bushes and trees on the right side. Using Ultramarine Blue, Sap Green and Alizarin Crimson, begin forming the dark side of the middle-ground and foreground trees. After the darks are established, continue with the middle value using Cadmium Orange, Ultramarine Blue and Alizarin Crimson. Add a touch of Yellow Ochre and Cadmium Orange for the light, as well as a pinch of white. Sparkle the light side of the bushes and trees with a mixture of Cadmium Yellow Light, Cadmium Orange and white. Apply a few touches of Cadmium Yellow Light and white through the bushes for additional effects of "skipping" light.

Let's bring in the water, which often reflects the sky color—great for color repetition. Use Cobalt, Cerulean and Ultramarine blues with white. Add touches of Yellow Ochre and Cadmium Orange to suggest reflections of the nearby shore. We're in the middle ground of the painting, so begin softening some edges with your finger or a brush. Varying edges will make your shapes more realistic.

6 Begin the Background

As you begin moving toward the background, bring in darks to provide contrast and stage the fantastic light show on the road. Squint and give it your best guess; your value sketch will be of help, too. With mixtures of Ultramarine Blue, Cadmium Red Light, Cadmium Orange, Alizarin Crimson and a touch of white, use horizontal strokes to indicate the foothills, bushes and little notes of color along the foothills toward the horizon.

When painting the background foothills, remember to keep the colors muted to create the feeling of depth. In order to create the effects of atmospheric perspective, generally your colors should be grayer and the forms should have less detail in the distance.

7 Continue the Background

Continue with the horizontal, muted gray mountains. Often, beautiful grays will naturally form on your palette as a result of mixing the complements and warm and cool mixtures during the painting process. You'll find that some of the gray mixtures that inadvertently form on your palette are very effective to paint with, so think twice before cleaning them off. Scrape off only the muddy grays and keep the clean ones for areas in the distance. Harmony results from using the beautiful existing grays on your palette due to the fact that these colors have already been established in the painting.

The dark mountain really emphasizes the light effects, adding contrast to the painting. Paint it using Alizarin Crimson, Ultramarine Blue, Cadmium Red Light and Yellow Ochre, keeping the edges of the mountain soft so that they will recede.

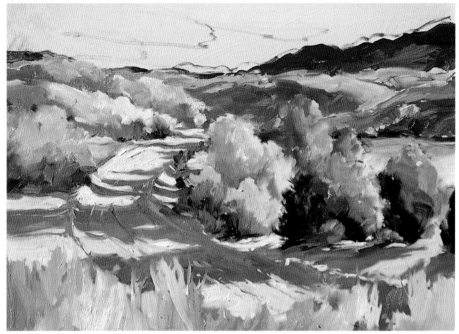

8 Paint the Sky

Just as in the watercolor version of this painting, we began with the light foreground and will end with a light sky. This approach is effective because we can determine how busy the sky should be by judging the painting as a whole. Remember to look at your painting from a distance to judge the value relationships along the way.

A soft cloud against a light, warm sky will work best for this composition. If you were to make a very busy sky at this point, it would detract from your center of interest. First paint the lighter distant mountain using Cobalt Blue, Thio Violet, Cadmium Orange and a touch of white. Soften the edges and keep the painting mixture on the bluer side. Sketch the cloud shape and finish the cloud using Cerulean Blue, Cadmium Yellow Light, Thio Violet and white. Freely move the brush, making an exciting, dynamic shape.

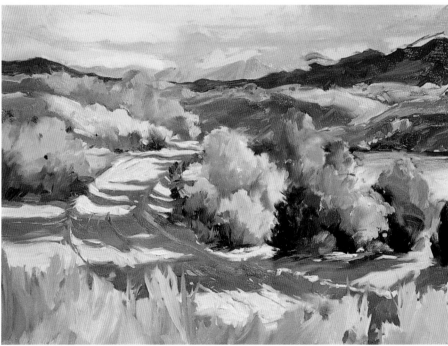

tip

Leave the Sky for Last

Oftentimes beginners want to paint the sky first. Unless it is the focal point of your painting, save it for last and judge whether you need a busy sky or a subtle one.

9 Finishing Touches

Concentrate now on cleaning up individual areas. Soften hard edges in the foreground and in the distance while giving extra attention to the center of interest: the orange and yellow trees and the shadow shapes surrounding the blue water. Finish the sky using Cerulean Blue and Ultramarine Blue with lots of white. The misty cloud which floats in and reflects the low light of the sun is a combination of Yellow Ochre, Thio Violet and white.

Throughout the process of your painting, whether you're doing a watercolor or an oil painting, you should squint your eyes at your reference, not at your art, to judge value relationships. Now squint at your painting and see if any awkward lines or shapes pop out. A few touches here and there, and you have a masterpiece.

Scenic Desert Shortcut • Oil • 18" x 24" (46cm x 61cm)

capture a warm building exterior bathed in dramatic light

In this scene, the light illuminating the glowing patio, surrounded by an arch that dramatizes it, was irresistible. The lighting was so inspiring that I found it tough to decide which medium to pick first, oil or watercolor.

Because watercolor sketches as well as value sketches are helpful in answering critical design and lighting questions, I decided to do a quick plein air sketch in watercolor. The total value sketch describes the value interplay and mood of light. A watercolor sketch also helps with color choices for both oil and watercolor.

Use your preliminary studies to establish these characteristics of your composition:

• Eye level

• Light direction and quality

• Value placement (light and dark)

• Value dominance (light or dark)

• Color dominance (warm or cool)

• Painting approach (tight, semi-loose or loose)

• Placement of the star of the show, the center of interest

This scene will be approached in a tighter manner than the previous demonstration. How does a painter handle more detailed work but maintain a loose, impressionistic style? You will find a few smaller brushes helpful, but continue to approach shape and value with confidence, using bold strokes.

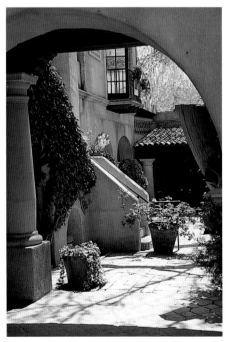

Reference Photo　　　　**Value Sketch**

Watercolor Study
My small, quick
watercolor sketch
for *Pleasant Surprise*.

1 Make a Drawing
Use a light pencil and don't press too hard. Keep your drawing loose, adding only a few details if you want. Check the drawing for its perspective and the direction of light and shadow.

2 Begin Wet-Into-Wet
With a large brush, wet the outer edges of the scene and then apply a warm wash of varying colors using Indian Yellow, Permanent Rose and Ultramarine Blue. Let the colors mix on the paper—no premixing on your palette. Tilt your board to move the paint around. Place warmer colors toward the center of the paper and cooler colors on the outer edges. Notice the different approach: instead of working from foreground to middle ground and background, we are starting with the outer edges and moving toward the middle, surrounding our center of interest—the light on the inner building's exterior and stair wall.

Begin the foreground grasses using a no. 10 or 12 round with Viridian, Burnt Sienna and Ultramarine Blue, making confident upward strokes. Gradate the pots from warm to cool using Burnt Sienna, Cobalt Blue, Raw Sienna and Permanent Rose.

At this block-in stage, not too much is recognizable. You are allowing paints to move about where you have previously put water. Let the colors mix naturally so that clean, colorful washes will result. Let this stage dry.

3 Start Developing Individual Areas

Test the dryness of the paper with the back of your hand, which is more sensitive to coolness. When the paper feels warm, it is dry and ready for a second wash using Raw Sienna, Ultramarine Blue, Alizarin Crimson and Burnt Sienna. Let colors blend on the paper, varying the wash and darkening areas toward the center of interest.

The arch, pots and stair wall all surround the areas of light. As you glaze the stair wall, pulling down vertical strips of color, leave white areas. You are carving the light by saving the white. Darken the green foliage next to the column on the left using Antwerp Blue and Burnt Sienna, bringing out its shape. When this mixture is semi-moist, scrape to create stems and twigs. Use this mixture in other areas of green to deepen values.

To create the small portion of sky and foliage that peeks through the arch above the patio roofing, we'll employ masking. First, dip the hairs of an inexpensive, small brush in soap, then in your masking fluid, and paint a tree trunk and twigs. Save the little lights on the iron railing, tree trunk and twigs by masking them here and there. After the masking has dried, wet and drop in color on a semi-moist surface. Use Cadmium Orange, Manganese Blue, Indian Yellow, Cobalt Blue, Sap Green and Viridian, and let the colors move about, suggesting leaves, twigs and sky peeking through.

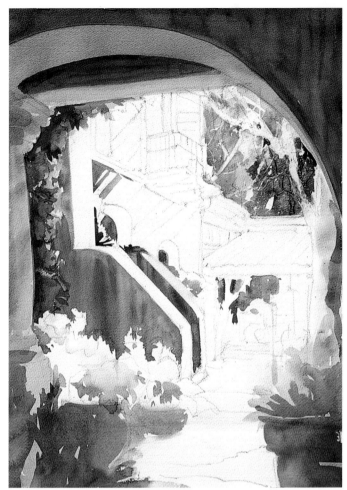

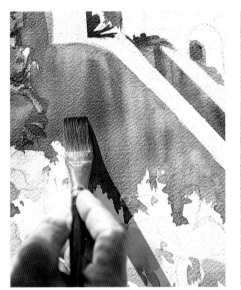

Detail
Paint the wall with a mixture of Indian Yellow, Permanent Rose and Ultramarine Blue, using vertical strokes.

Detail
When the green mixture of paint is semi-moist, use your palette knife to create little leaves and scratches in the foliage that suggest twigs and sticks.

Detail
When the surface is still slightly damp, sprinkle a little salt and let it dry. The salt will loosen up the area and give the effect of foliage and twigs. If the paint is very light in color, the effects of salt aren't as dramatic.

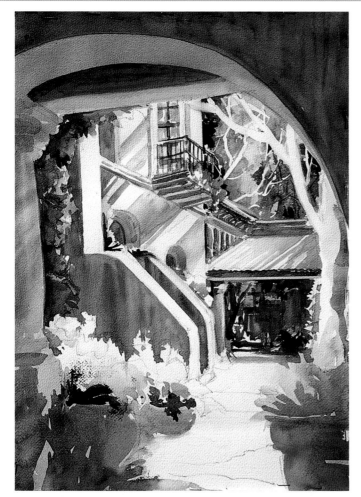

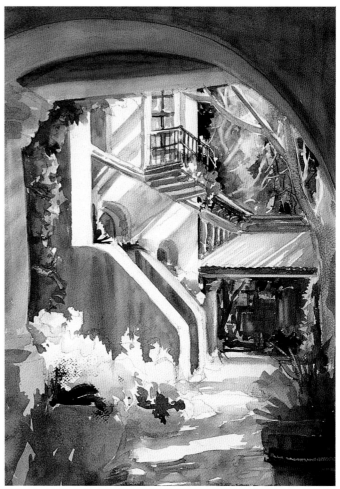

4 Surround the Light and Remove the Masking

Continue suggesting details and medium to dark values of nooks and crannies: the lit wall arches, the orange tile roof and the background space, keeping it simple. Use a palette knife to help maintain a loose approach. Suggest various details for the background balcony and patio. Use vertical and horizontal strokes of various values and intensities to suggest the distant patio area. The background patio is an important element in the painting because it acts as the contrasting middle-to-dark value, showing off the light.

After the entire painting surface is dry, remove the masking fluid with a rubber cement pickup. The masking fluid has saved your whites and enabled sparkle to follow. The only problem with using masking fluid is that it creates hard edges on the shapes underneath. Let's see what we can do to create soft edges.

5 Work on Shadows and Unmasked Areas

When an edge is hard and crisp, it grabs attention. Because we want soft edges behind the center of interest, soften the twigs and tree trunk wherever the masking once was. Dip your Fritch scrubber in water and rub the hard edges. (A cut-off oil painting brush will also work.) Paint the wall shadows in a diagonal manner using Cadmium Orange, Permanent Rose and Manganese Blue, and soften the far edges of the shadow. Use confident strokes, and let it flow.

Take a look at your painting through a mat. This step is very helpful, especially when painting impressionistically in watercolor. Since the edges of your painting can become rather messy while throwing paint around, the mat tends to isolate the image and show what a great painting is actually going on.

6 Finishing Touches

I found the value on the stair wall and left column too light. Using a mixture of Alizarin Crimson, Ultramarine Blue and Raw Sienna, I glazed them, which made the sunlit wall and its shadows glow more. I glazed the arch with the same mixture to enhance the patio's light. I also darkened the plant in the lower-left corner. (When glazing colors, remember to wait for the previous layer to dry for the best results.)

Continue now with more flower shapes and detail work. Touch on a few Opaque White flowers and paint a few darks around the whites. Loosely painting the flowers with a little spatter work and palette knife action provides a nice contrast to the architectural lines of the setting.

Add a final glaze here and there to warm up any remaining stark whites. Use Cadmium Yellow Pale, Cadmium Orange and Raw Sienna, but keep it very light; mostly just water with a touch of pigment. Now finish the ground shadows using Permanent Rose, Cadmium Orange and Manganese Blue. Pick up a neutral dark with a small round and lightly indicate the lines between the bricks of the patio. Spelling out every brick will result in a distracting pattern, so just suggest a few lines.

Pleasant Surprise • Watercolor • 16" x 12" (41cm x 30cm)

capture a warm building exterior bathed in dramatic light

before you begin

Eye level—middle to low
Light quality and direction—luminous and coming from the right
Dominant value—low key
Color dominance—warm

materials

Surface
Prestretched, gesso-primed canvas,
16" x 12" (41cm x 30cm)

Oils
Alizarin Crimson • Cadmium Orange •
Cadmium Red Light • Cadmium Yellow
Light • Cerulean Blue • Cobalt Blue •
Sap Green • Terra Rosa • Thio Violet •
Ultramarine Blue • Viridian • Yellow
Ochre • White

Brushes
Bristle flats nos. 4 and 6 • bristle filberts
nos. 6, 8 and 10 • Ruby Satin filbert
no. 6 • soft brush (for blending)

Other
Palette knife (for mixing) • painting
medium (for thinning paint) • odorless
mineral spirits (for cleaning brushes)

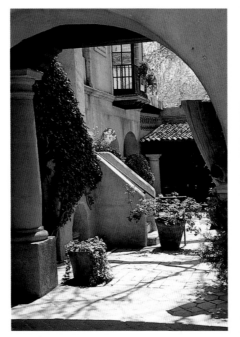

Reference Photo

Value Sketch

1 **Tone the Canvas and Make a Drawing**
Lightly tone your canvas with Yellow Ochre and turpentine. Using Alizarin Crimson and Yellow Ochre with a touch of Ultramarine Blue, pick up a small pinch of paint with a no. 2 or no. 4 bristle brush and loosely sketch the painting. Keep your design loose and painterly rather than a tight rendering. This will help you approach your painting in a loose and impressionistic manner.

Just as in the watercolor version, the foreground wall will act as a dark frame accenting the light. The middle ground contains the center of interest and the entry arch provides contrast.

2 **Surround the Light and Begin the Shadows**
Begin with your darks. The foreground wall acts as a dark frame surrounding the light. Build a base of dark using Alizarin Crimson and Ultramarine Blue, and tap in some Yellow Ochre. Use more Yellow Ochre for the underside of the arch.

We'll use a marbling effect on the column to indicate strong directional light. Using a no. 6 or 8 brush, lay in Alizarin Crimson, Yellow Ochre and Cerulean Blue with a touch of white for the dark shadow area on the column. Visualize a cylinder while laying in the darks around the column. Apply white with a touch of Cadmium Yellow Light for the warm light on the column.

Begin the adjacent ivy shape and foreground greenery with Alizarin Crimson, Sap Green and Ultramarine Blue. These greens surrounding the column accentuate the light. Suggest a distant sky with a few touches of Cobalt Blue, Yellow Ochre and Cadmium Orange.

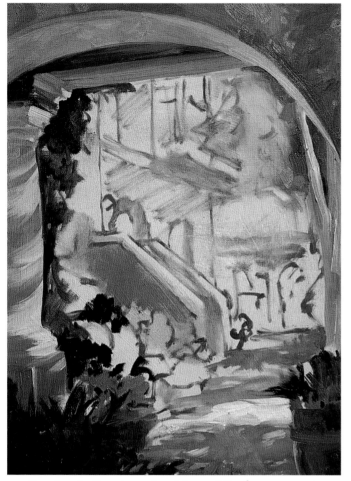

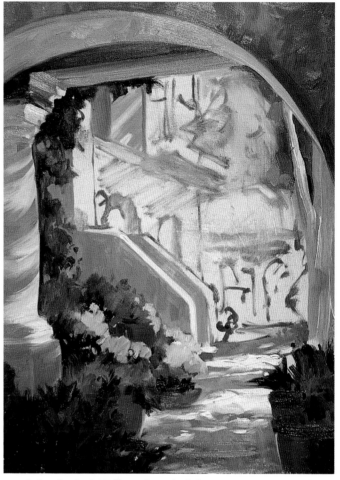

3 **Develop the Foreground and Ground Shadows**
With the exception of a few little details you may decide to add later, finish the foreground. For the foreground pots, use Terra Rosa, Ultramarine Blue and Viridian for one and vary with Alizarin Crimson, Ultramarine Blue, Cobalt Blue and Yellow Ochre for the other. Continue with dark greens using Viridian and Yellow Ochre varied with Cobalt Blue and Cadmium Orange. Use aggressive, impressionistic strokes, primarily with an upward swing. Paint with broad strokes, using the palette knife as well. This mosaic block-in of dark shapes will be refined later after the middle ground and background are completed, and we'll save the smaller brushwork for later when we get to the center of interest.

Use Thio Violet, Cobalt Blue, Yellow Ochre and white to lay in the ground shadows. Make sure to leave interesting negative shapes for the light later. To create the illusion of depth, make the foreground shadow darks larger and cooler. The shadows should become narrower and warmer as they recede toward the center of interest.

4 **Paint the Stair Walls and Nestled Flowers**
The flowers and pots nestled in the cozy corner next to the stairs should be painted as a group, not separately. See this area as a mass of closely related values. Paint the potted flowers with various combinations of Alizarin Crimson, Ultramarine Blue, Cadmium Orange, Yellow Ochre, Cadmium Yellow Light, Thio Violet and white. Use Sap Green, Alizarin Crimson, Viridian and Yellow Ochre for the greens dancing around the pots. Paint the stair walls with Cerulean Blue, Thio Violet, Cadmium Orange and white.

tip

Don't Miss the Forest for the Trees
It is important to understand that you can't judge how much to develop a section until you've blocked in the rest of the painting. One thing is for sure: you'll generally want to leave the foreground a little unfinished so that the center of interest will get more attention. Refrain from doodling and move on.

5 Paint the Diagonal Shadows and Railing

With the same mixture used for the stair walls—Thio Violet, Cerulean Blue, Yellow Ochre and white—continue with the shadows on the inner building's exterior, keeping in mind the light direction. Place the shadows first, then add light by painting white with a touch of yellow next to the shadow. Paint architectural details such as the balcony and the small arches on the inner building.

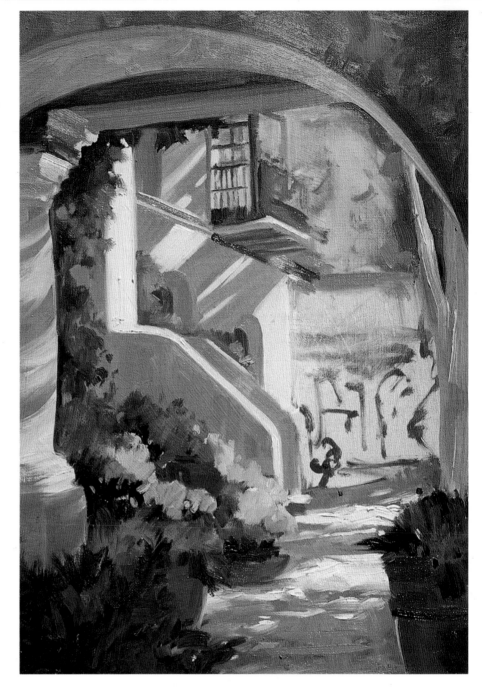

6 Finishing Touches

Finish the background using various mixtures of the paint still on your palette, or by using Alizarin Crimson, Ultramarine Blue and Yellow Ochre with a few touches of Cerulean Blue and Cadmium Red Light. The values are what is important here. The dark value under the roof—with little spots of light added for sparkle—and the vertical tree created with a mix of Yellow Ochre, Cerulean Blue, Thio Violet and white help set the stage for dramatic light in this scene.

Stand back from your painting to check its performance. Go back to your original checklist and begin evaluating. More detailing and overworking can destroy a fresh painting, so leave a little for the viewer to finish, but not enough to annoy. Add a few darks to connect forms, soften an edge or two on a shadow or background form, and touch on a spot of white, red or yellow for color harmony, and you're finished.

Pleasant Surprise • Oil • 16" x 12" (41cm x 30cm)

let a sunny subject take center stage

before you begin

Eye level—straight ahead
Light quality and direction—ambient and coming from the right
Dominant value—high key
Color dominance—warm

materials

Paper
Arches 140-lb. (300gsm) cold-press,
14" x 20" (36cm x 57cm)

Watercolors
Alizarin Crimson • Antwerp Blue • Burnt Sienna • Cadmium Orange • Cadmium Yellow Pale • Cobalt Blue • Cobalt Violet • Indian Yellow • Manganese Blue • Permanent Rose • Raw Sienna • Sap Green • Ultramarine Blue • Viridian • Opaque White

Brushes
Nos. 8, 10, 12 and 14 rounds • ½-inch (12mm) or 1-inch (25mm) flats • a few smaller brushes

Other
Pencil • palette knife • salt

I always look forward to early spring, when the numerous sunflowers that have been planted earlier in the year pop up. A favorite flower of mine to paint, its seeds are scattered all around from sunflower heads saved from last year. It's amazing how many actually pop up from this random scattering. The lively personality and posture of the sunflower lends itself to an action-packed approach in painting the flower's shape.

Different approaches to the painting process are like dances: sometimes it's a tango, other times a mambo or the waltz. Or you can think of painting styles in terms of athletics: sometimes a slow, thought-out approach works best, as in golf, while at other times the energetic pace of tennis is more appropriate.

In the following demonstration for *Dancing Sunflowers*, you will paint largely with an aggressive approach, moving your brush quickly, slowing down only once in a while. The wild, fresh-picked sunflowers will be painted loosely and impressionistically.

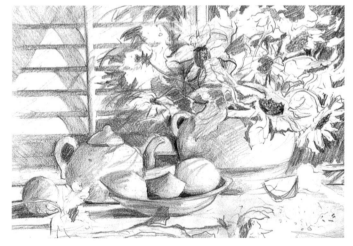

Reference Photo

Detailed Value Sketch

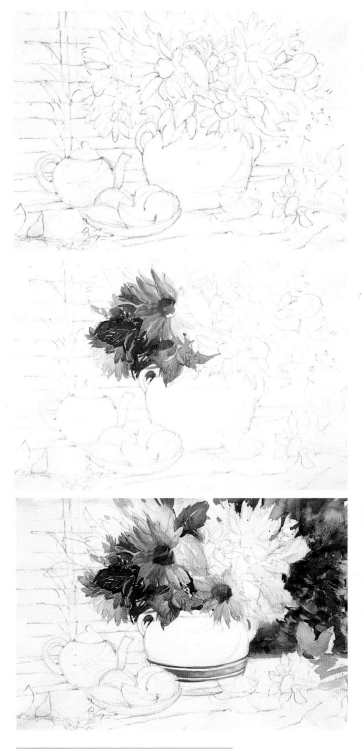

1 Make a Drawing

Lightly pencil in your drawing onto watercolor paper. Keep your drawing loose, holding your pencil as you would a brush and moving with confident action. Don't hold it as though you're writing a letter.

2 Begin With the Darks

Begin with the darks and zero in on the center of interest. Paint confident dark greens with Antwerp Blue, Viridian, Indian Yellow, Burnt Sienna, Sap Green and Raw Sienna. With a no. 12 round, pick up dark mixtures of Indian Yellow, Cobalt Violet, Raw Sienna and Sap Green for variety in your greens. Remember to keep your brushwork loose and just have fun with creating an almost abstract shape.

Yellow is the toughest color to darken because its value is so light. It's best to lean either to the green side or the orange side of yellow to push the value darker or lighter. The colors should be watered down to become tints as you approach the light source. For the lighter greens of the sunflowers, use Manganese Blue, Cadmium Yellow Pale, Sap Green and Raw Sienna. Apply Cadmium Yellow Pale and Indian Yellow for the yellow-orange flowers, and establish their centers with a not-too-dark mixture of Burnt Sienna, Alizarin Crimson, Indian Yellow and a touch of Viridian. Use large rounds or flats, and keep your strokes confident. No "petting" the strokes!

3 Start the Background

Put individual puddles of dark colors—blues, browns and violets—as well as Indian Yellow on your palette, but don't mix them together on it. Wet the area around your light-value sunflowers with water and drop in these colors, letting them blend naturally on the paper. Tilt the board to move the flowing paint. Do not overmix or you will have a muddy frame for your flowers. Let the area dry. If it's not dark enough, you can always re-wet and glaze the area to deepen the value.

Too often students forget that even details on forms are affected by changing light. The bands of color on the vase are a good example of gradation. As you move from the light side of the vase to the dark side, subtly change the value of the detail. Use a watery tint of Permanent Rose and Cadmium Orange to begin and change it with Alizarin Crimson, Ultramarine Blue and Permanent Rose as it continues to surround the pot. Manganese Blue changes to Cobalt Blue for the outer two bands, finishing the detail. Continue developing the sunflowers and their greens.

tip

Shadows Affect Details, Too

Usually, it is better to paint details before adding the shadow shapes over them. If you try to paint the detail on top of the shadow form, the shadow form may lift and make a mess. Also, placing unshadowed detail on top of a shadowed form will look unnatural.

4 Paint the Network of Shadows

Paint the vase with various grays, changing the proportions of the warm and cool. Use more blue in the core shadow of the vase. Add more warm color to the gray as the shadow finds the light on the vase.

To paint the shadows on the vase and windowsill, use Manganese Blue, Cadmium Orange and Permanent Rose, following the light direction and eye level. Keep in mind the warmth in the gray-violet mixture. The gray mixture is warmer where the sunlight first approaches and cooler as it disappears off to the left and the outer edges.

Move on to the shutters with the same colors used for the shadows. Add more blue to the mixture for the area at the upper left; make Cadmium Orange and Permanent Rose more dominant in the mixture for the center of interest near the flowers. As you work on the shadows of the shutter, remember the light direction is coming from the right; as you close in from the left corner to the lower portion of the shutter, save some light areas.

Move on to the teapot using the same technique but with more blue in the form and in the cast shadow, cooling the pot even more. Paint with warm and cool grays as well as with Alizarin Crimson, Cadmium Red Light and Cadmium Orange—the reflected colors resulting from the red apple.

Begin painting the fruit next. The light side of the apple is a mixture of Cadmium Orange and Alizarin Crimson; leave a little white highlight. Paint the dark side of the apple with Alizarin Crimson, a touch of Viridian and Ultramarine Blue.

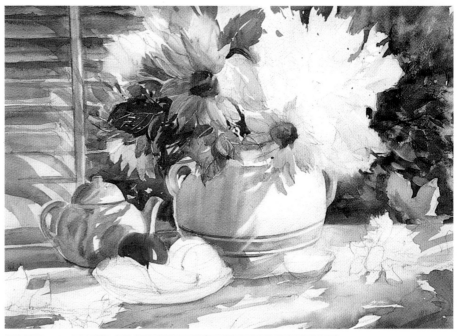

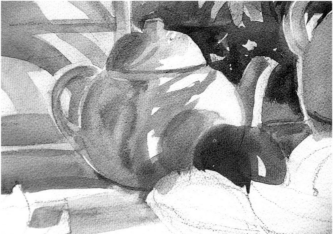

Detail

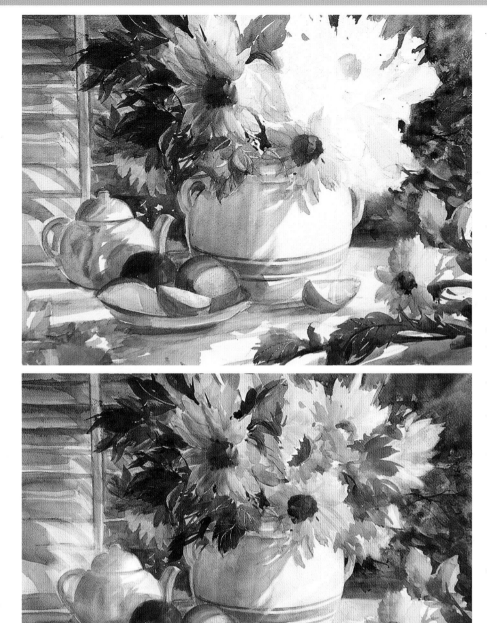

5 Finish Some of the Key Players
Take a look through a mat to check your progress. Finish the dark sunflowers using Alizarin Crimson and Cadmium Orange with a touch of Viridian; use Antwerp Blue, Burnt Sienna and a touch of Sap Green to finish the dark green leaves. Add a foreground flower and foliage along with a shadow to the lower right corner. Use Antwerp Blue and Burnt Sienna for the greens, Cadmium Yellow Pale and Cobalt Violet for the yellow and Alizarin Crimson with Burnt Sienna and Viridian for the inside of the flower center.

Continue with the fruit using various warms to create the simple shapes. Use Raw Sienna, Alizarin Crimson and Viridian for the orange slices; Alizarin Crimson, Cadmium Red and Viridian for the apples; and a mixture of Cobalt Violet and Raw Sienna with a tad of Sap Green for the peach. Sprinkle some salt onto the peach to liven up the texture. Paint the fruit bowl with Manganese Blue, Cobalt Blue and Viridian, applying touches of yellow for the reflection.

Use a Fritch scrubber for continued softening of the hard edges in the background. Save the hard edges for the focal point.

6 Finesse the Lights and Model the Teapot
Using watery versions of Cadmium Yellow Pale and Cadmium Orange, paint with a soft touch the sunshine on the flowers in the light. Be careful to save the white of the paper for areas of light that we will perfect later. Use Raw Sienna and Manganese Blue to create a light tint of green for the sunshine hitting the leaves in light. Deepen the value of the teapot's shadow side with strokes of Manganese Blue, Permanent Rose and Cadmium Orange. With Alizarin Crimson, add a few reflections to the sunny side of the teapot.

7 Finishing Touches

Darken the fruit bowl using Ultramarine Blue and a little Viridian on the shadow side, with a touch of Opaque White for the side getting a glimpse of light. Darken the cast shadow underneath the bowl with Permanent Rose, Manganese Blue and a touch of Cadmium Orange to accentuate the light. Use small touches of Opaque White for the tips of the flowers in light.

As you stand back from the painting and view the subtle warm and cool colors that envelop the forms, check for balance or awkward details that pop out and seem out of place. Put the painting aside, enjoy it and re-evaluate it in the morning. It seems to have captured the light of the scene effectively, and it looks like there won't be a need for any final touch-ups. Remember to leave a little bit to the imagination of the viewer.

Dancing Sunflowers • Watercolor • 14" x 20" (36cm x 51cm)

let a sunny subject take center stage

Reference Photo

Value Sketch

1 Tone the Canvas and Make a Drawing
Pick up Yellow Ochre and spread it around with a palette knife.
Dip a paper towel in turpentine and push the color around, wiping up
the excess with additional paper towels. Next, pick up a small amount
of Yellow Ochre mixed with a touch of Alizarin Crimson and make
your drawing.

2 Start With the Largest Sunflower Surrounded by Darks

Start with Ultramarine Blue, Sap Green and Alizarin Crimson and begin the loose shapes of dark greens surrounding the sunflower shapes. Squint your eyes at your setup to check shapes and appropriate darks and lights. Using a no. 4 or 6 filbert, pick up Yellow Ochre and Sap Green with a touch of white, as well as a few touches of Cadmium Yellow Light, to establish smaller light greens.

When painting the sunflower, confidently pull petals outward with a loaded brush of Cadmium Yellow Light, Cadmium Orange and Alizarin Crimson for the shadow side and Cadmium Orange, Cadmium Yellow Light and white for the side in light. Think "lost and found" edges: crisp edges in light, soft edges in shadow. Vary a mixture of Terra Rosa and Ultramarine Blue from light to dark to paint the center of the flower. Touch a little Cadmium Orange on the sunny side of the center.

3 Begin the Background and Finish the Flowers

For the background, we'll use neutrals— grays mixed with blues and oranges and reds and greens, with a touch of white— and trap the light that's coming from the right and hitting the flowers. Keep this mixture lean, because basically we are just toning this area for future completion.

Assess the entire flower and leaf shape. Does it have an asymmetrical appearance, or does it look too perfect? Do the flowers turn here and there as if they were carrying on a spunky conversation? The posture of the flowers should give us the feeling of a lively conversation. Expand the flowers by picking up white, Cadmium Yellow Light and Cadmium Orange to finish the flowers in light. Apply additional strokes of Sap Green, Alizarin Crimson and Yellow Ochre to finish the green leaves. Continue the darks, checking areas on the flowers and the appropriate values on the leaves. Plop in the lights with heavy paint and use a lighter touch for the darks in the flowers.

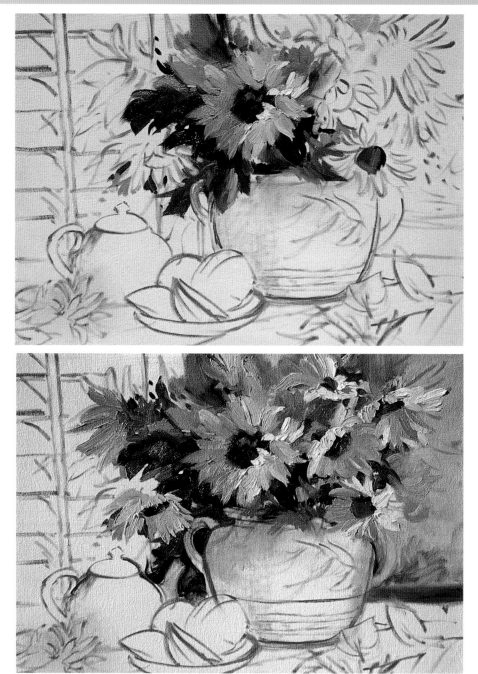

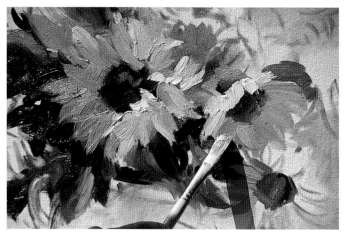

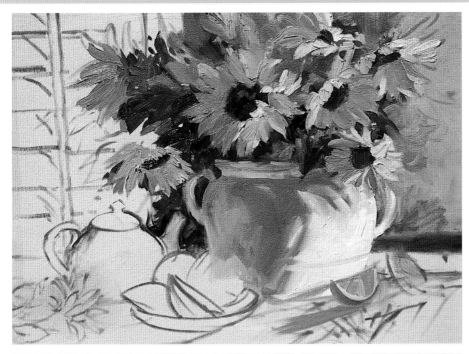

4 Paint the Flower Vase

In painting light on a form, you will have a form shadow and at times a cast shadow showing the form's dimension. Paint the shadow side of the vase with Cerulean Blue, Alizarin Crimson, Cadmium Orange and a touch of Viridian and white. Keep it cooler in the core part of the shadow—the area with the least amount of light. Make some light bounce into the shadow side with Cadmium Yellow Light and white. Paint the light area of the vase using Cadmium Yellow Light and white, with touches of Cadmium Orange reflected into the area.

Model the vase using gradation while bouncing light into the reflection. Soften the edges of the shadow side using your finger or a soft brush.

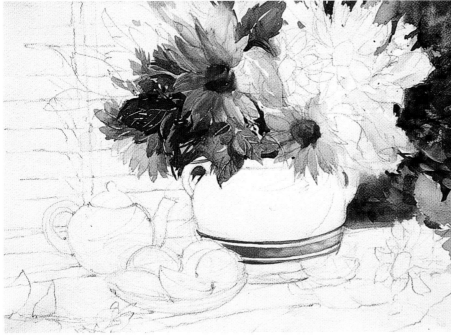

Compare Approaches: Thick vs. Thin Paint Application

Here we see the watercolor version of this painting at the same stage as the oil step above. The light is coming from the right in both paintings and is enveloping the sunflower bunch. The mass of flowers is taking a more or less asymmetrical shape in light. Petals are popping out here and there, catching the glittering rays.

In watercolor, thin transparent layers of yellow allow the white of the paper to show through for a luminous appearance. In oil painting, light-filled layers are built up with a thick, rich mixture of white paint and a tad of yellow. When portraying light, think thin for watercolor, thick for oils .

5 Paint the Fruit

In this case, the fruit is not the focus. Don't lose sight of the star of the show: the sunflowers. Paint the apples, lemons, orange slices and peach with warm colors that are muted and simplified. Use Cadmium Yellow Light, Alizarin Crimson and Cobalt Blue for the lemon; Alizarin Crimson and Sap Green with a touch of Cadmium Red Light for the apple, and Cadmium Yellow Light, Thio Violet and Sap Green for the peach. Add white to the light areas of the these forms.

Create the design on the vase using Cerulean Blue and Thio Violet with white, making sure its value gradates from light to dark.

6 Continue the Background and Windowsill

Pick up a substantial amount of white with a touch of Cadmium Yellow Light and continue with the background and windowsill, painting around the glowing shadows. Finish the red apple with a little more modeling using darker values of Alizarin and Viridian with a touch of Ultramarine Blue. Begin the lower-right flower using Sap Green and Cadmium Orange, creating an interesting asymmetrical shape. This is an important element of the painting because it leads the eye inward toward the light.

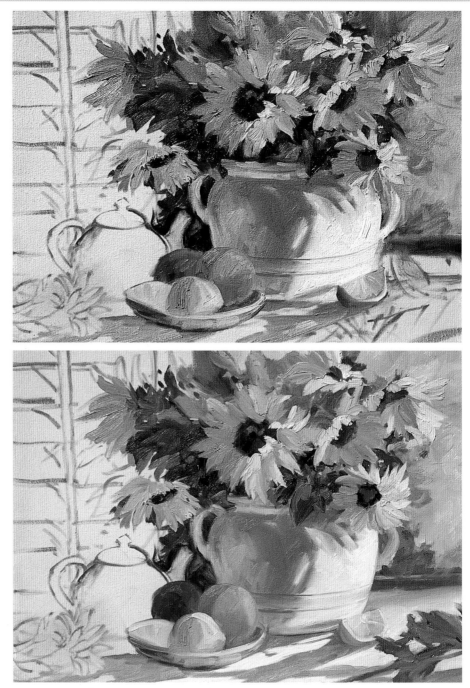

7 Finishing Touches

The windowsill is drenched in the light and shadow with reflections. Using Thio Violet, Cerulean Blue and Cadmium Orange, paint the shadows on the teapot and the shutters. Make sure to soften edges as you go, especially where the shadow disappears around the form. After the warm and cool shadows are placed on the teapot and the shutter edges are softened, use Cadmium Yellow Light and white to finish the forms. Vary the temperature, keeping the white mixture warm (more Cadmium Orange) in the center and cooler (more blue) toward the edges.

Stand back from your work to see if the balance is correct and if the values interweave according to the light direction. Mix white with Cerulean Blue, Thio Violet, Sap Green, Yellow Ochre and a touch of Viridian to finish the right side of the background. Keep the suggestion of a window reflection by painting soft edges, blending color and repeating the same colors that are in the flowers. Help lead the viewer's eye into the painting by adding a directional flower in the lower-left corner of the foreground.

Dancing Sunflowers • Oil • 18" x 24" (46cm x 61cm)

paint a still life in fast-moving light

before you begin

Eye level—straight ahead
Light quality and direction—luminous and coming from the right
Dominant value—middle key
Color dominance—warm

materials

Paper
Arches 140-lb. (300gsm) cold press,
16" x 22" (41cm x 56cm)

Watercolors
Alizarin Crimson · Antwerp Blue ·
Burnt Sienna · Cadmium Orange ·
Cadmium Red · Cadmium Yellow Pale
· Cobalt Blue · Cobalt Violet · Indian
Yellow · Manganese Blue · Permanent
Rose · Raw Sienna · Sap Green ·
Ultramarine Blue · Viridian · Opaque
White

Brushes
Nos. 8, 10, 12 and 14 rounds · ½-inch
(12mm) or 1-inch (25mm) flats · a
rigger · a few smaller brushes · Fritch
scrubber

Other
Pencil · masking fluid · palette knife ·
rubber cement pickup

Looking out my studio door, I realized it was time. With my garden in full bloom and the next day's weather prediction being fantastic—filled with great light and shadow—my plan for still-life painting was in place for the next morning.

Which flower combinations to pick, which still-life objects to set up, the compositional layout, light direction, eye level and value and color dominance were in my mind the night before. Because light changes quickly when the sun is rising, it is crucial to decide as much as possible beforehand.

When morning light struck, I quickly picked my gorgeous peonies, still damp from morning dew, and arranged the flowers according to my directional plans. The dramatic light resulted in strong diagonal shadows, instantly creating movement and glow. When completing this scene in both oil and watercolor, notice how the brush technique is similar but the approaches for "trapping" the quickly moving light are different.

Reference Photo

Value Sketch

1 Make a Drawing and Begin Surrounding the Light

The focus here is to capture the luminous light presenting the glowing peonies while drifting through the various props. Surround the light—the white of the paper—by painting the areas around the peonies. Start with a drawing and then mask a few peony edges. Wet the upper-right corner and tilt it slightly. When semi-moist, drop Antwerp Blue, Cadmium Yellow Pale, Ultramarine Blue, Sap Green and Alizarin Crimson and let the colors move about. Don't muddy the mixture with excessive brushwork. The soft edges in this area will contrast effectively with the crisp peony edges.

Model the orange vase—whose top goes off the picture plane—with dark and light values, making sure to add more water when painting the light areas. The vase colors are Alizarin Crimson, Indian Yellow, Cobalt Violet, Ultramarine Blue and Viridian, while the details are done with Sap Green and touches of Permanent Rose and Indian Yellow. Keep the right side of the vase light.

2 Work on the Areas Hidden in Shadow

For the window passing behind the orange vase, apply muted grays (mixed with Cobalt Blue, Alizarin Crimson and Viridian) using vertical strokes. Keep these mixtures light to mid-value for contrast against the dark side of the vase. Paint the ginger jar using various blues and Burnt Sienna, leaving little areas for details and highlights. Use masking fluid to save some of the whites. Suggest a few shadows on the right side. Bounce blue into the background window to the left of the orange vase to echo color. The jar and the left side of the vase hide in the dark, so keep their edges soft.

Use Antwerp Blue, Burnt Sienna and Indian Yellow to begin the overall asymmetrical dark-green shape of foliage. When the paint is semi-moist, scrape stems and rub effects with the flat side of your palette knife. Drop paint onto moistened paper with directional strokes for the cast shadows. Use Manganese Blue, Alizarin Crimson and Viridian for the darker area and add Raw Sienna for the lighter portion.

tip

Decide How You Will Tackle the Darks

In time you will be able to envision a painting completed, and tackling the dramatic darks first will become second nature. The key is confidence and clean strokes of color. Sneaking up on the darks—by glazing the entire painting surface and building them slowly—is safer, but at times this may involve too much paint-stroking and end up being overworked. Your personality has a lot to do with how aggressively you tackle darks. What's your approach?

3 Begin the Peonies

Use Permanent Rose, Alizarin Crimson, Raw Sienna and Ultramarine Blue to paint the pink peony on the lower right. Drop a touch of Sap Green when the pink is semi-moist to neutralize it. Remember to have in mind the hue, intensity and value on your brush before you confidently and spontaneously put the brush to paper. Continue the greenery around the pink peony, which will enable it to stand out more.

For the white flower next to the ginger jar, wet the area to be painted, then drop in Permanent Rose, Cadmium Yellow Pale and Manganese Blue. The primary colors will mix on paper and establish beautiful grays. Paint the pink flower near the top with Permanent Rose, a little Sap Green and Cadmium Orange, keeping it light so it glows against the dark background. Add a large yellow flower shape using Indian Yellow.

Soften the edges as you paint. Remember that crisp, hard edges grab the eye's attention. Soft edges are not attention-getters and therefore work well in this area.

4 Finish the Flowers, Table and Lace

Glaze the shadow side of the flowers with either the mother color or its complement color. For example, glaze the pink flowers in the shadow side with Viridian to deepen the intensity and value. Warm up the white flowers in the light with Cadmium Yellow Pale and Cadmium Orange. Bring out a few petals using a small brush and touches of gray. Apply small, dark leaf veins. Glaze the table and lace with a shadow, contributing to the directional flow of light. Remove the leftover masking fluid, which pops out the light on some of the petal edges.

Detail

Touches of form shadow are placed on the cylindrical vase using a darker version of the mother color, plus a touch of violet. Here the mixture is Permanent Rose, Raw Sienna and Cobalt Violet.

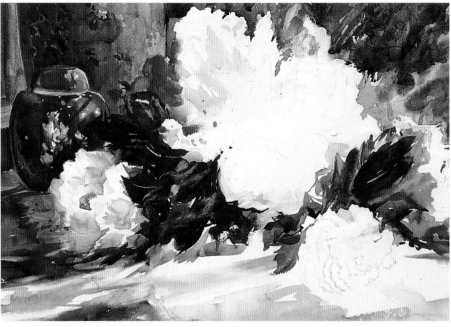

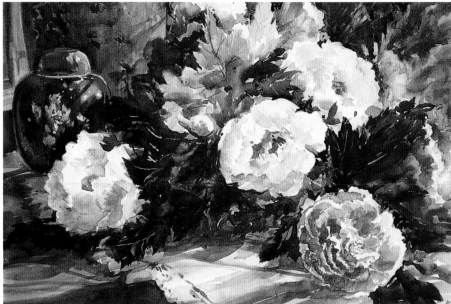

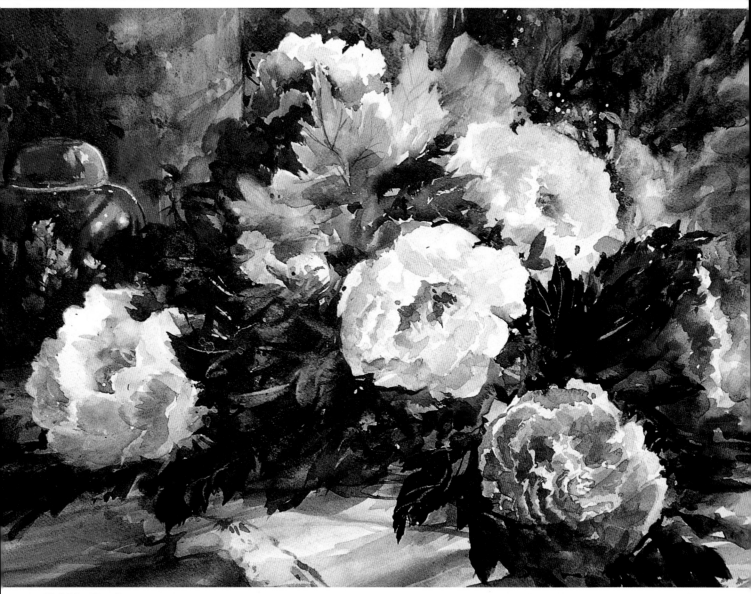

5 Finishing Touches

Glaze the lower-left corner of the table to deepen the value and show more value contrast. Detail the upper right with a little spattering of paint, but don't overdo it. Use Opaque White for touches of reflections on the blue ginger jar and a few tips of the flowers.

The pink peony in the lower-right foreground seemed to float. I fixed it by tying it down with more green foliage and shadow work. Also, the left side of the ginger jar was softened and lost more to the background. The painterly approach has been maintained, and the painting boasts clean color, great contrast and beautiful lighting effects.

Blooming Light • Watercolor • 16" x 22" (41cm x 56cm)

paint a still life in fast-moving light

before you begin

Eye level—straight ahead
Light quality and direction—luminous and coming from the right
Dominant value—middle to high key
Color dominance—warm

materials

Surface
Prestretched, gesso-primed canvas,
16" x 20" (41cm x 51cm)

Oils
Alizarin Crimson · Cadmium Orange · Cadmium Red Light · Cadmium Yellow Light · Cerulean Blue · Cobalt Blue · Sap Green · Terra Rosa · Thio Violet · Ultramarine Blue · Viridian · Yellow Ochre · White

Brushes
Bristle flats nos. 4 and 6 · bristle filberts nos. 6, 8, 10 and 12 · Ruby Satin filbert no. 6 · soft brush (for blending)

Other
Palette knife (for mixing) · painting medium (for thinning paint) · odorless mineral spirits (for cleaning brushes)

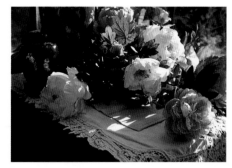

Reference Photo

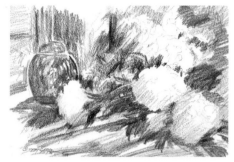

Value Sketch

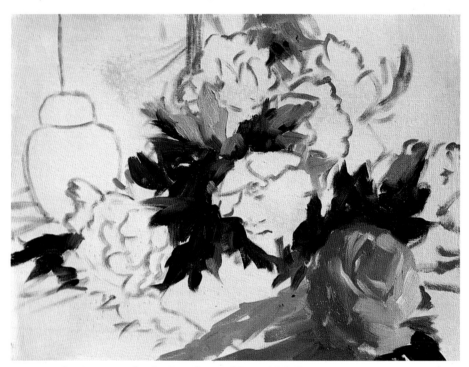

1 Tone the Canvas, Make the Drawing and Jump Right In

After toning your canvas with Yellow Ochre, line out the composition using a mixture of Alizarin Crimson and Yellow Ochre. Keep it simple and loose.

Starting with the positive forms, first paint the foreground pink flower, suggesting petals catching the light. Squint at your setup so you will not be tempted to paint every single petal. Using various pinks and reds, deepen the value on the side of the flower that is not in light. Pull the diagonal shadow using Cobalt Blue, Thio Violet, Cadmium Orange and white. Vary the shadow color from warm to cool.

With a variety of blues, yellows, reds and greens, paint the overall greenery in an asymmetrical manner, using gradation of value to indicate the light. Where the light warms the foliage, use more yellow; where the warm light isn't apparent, use more blue and deep green. Use a no. 10 or no. 12 filbert to help you achieve painterly gusto. The greenery carves spots for a couple of peonies to be added later.

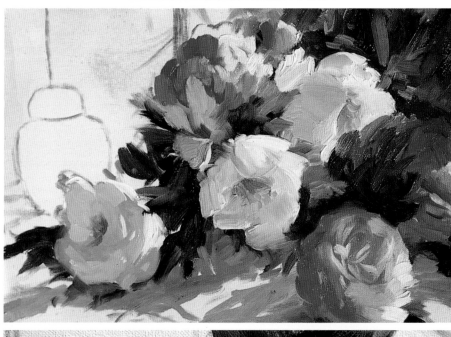

2 Finish the Flower Block-In and Start the Background

Load your brush with Cerulean Blue, Cadmium Yellow Light, Thio Violet and white to paint the white peony. Keep your brushwork exciting and confident while continuing to squint at the subject to eliminate unnecessary details. Soften the edges on the shadow side of the flower to help that side recede. Continue to paint shadows cast by the peonies, leaving some negative spaces to fill in the light later.

Finish blocking in the rest of the peonies. The eye blends the spots of color into the dark value. Use contrast in value to pop the sparkling white peonies. Light also caresses the other flowers, creating the feeling of warmth. Add flower centers with Yellow Ochre, Cerulean Blue and Alizarin Crimson. Paint the contrasting background in the upper right with various dark greens, applying a few colorful blues and violets here and there for a little sparkle.

Detail

The petals of this peony sparkle in the morning light because of the surrounding darks. The shadow also glows with violets and yellow-oranges, reinforcing the feeling of light.

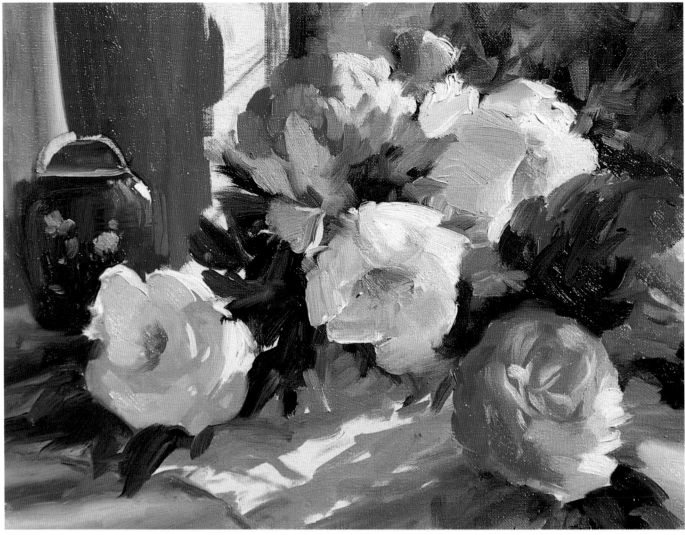

3 Block In Surrounding Areas

Paint the orange vase using Terra Rosa, Cobalt Blue, Cadmium Orange and Viridian. Use touches of Cadmium Red Light for detail. Apply various blues (Ultramarine, Cobalt and Cerulean) with touches of Viridian and Sap Green to the ginger jar to deepen its value. Make a highlight with white and a touch of Cadmium Yellow Light. Think in terms of gradation when painting these spherical and cylindrical objects: light to dark, warm to cool, bright to dull. Add Cerulean Blue and Cobalt Blue to the shadows.

Paint around the shadows to form the areas of table lace that are in direct light using white and a tad of Cadmium Yellow Light. Using Sap Green, Alizarin Crimson and Yellow Ochre, suggest the corner of the table. Add white to the mixture to suggest the light coming through the flowers and hitting the table. Place a gray mixed from Ultramarine Blue, Terra Rosa and white next to the dark side of the orange vase. Begin blending the shadow and form edges.

tip

Be a Tandem Painter

As you are painting your still life in oil, imagine how particular segments of the process might be handled in the watercolor version, and vice versa. The medium may be different, but whether painting light in oil or watercolor, the concepts to consider are the same:

• Hard and soft edges
• Warm/cool dominance
• Light/dark dominance
• Asymmetry
• Direction of light
• Design elements
• Balance

Shifting back and forth between mediums reinforces the basics and strengthens technical painting skills for both.

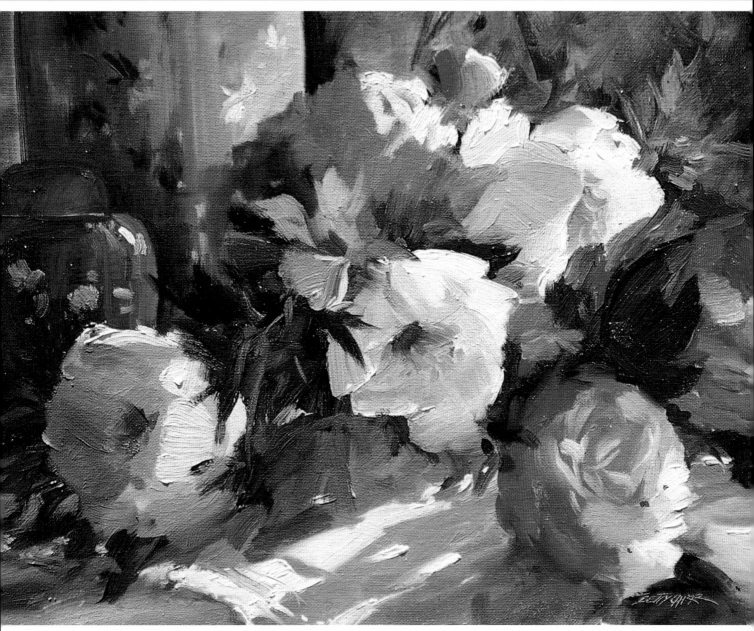

4 Finishing Touches

Model the background vases a bit more and add just a few small details for interest. Fine-tune the flowers by applying hard edges to bring some forward and softening the distant edges of others near the shadow areas. Warm up the edges in the light using Cadmium Yellow Light and white. By warming up and brightening the cast shadows near the flowers, you can suggest warm light bouncing in the area. Darken the centers of the white peonies with Alizarin Crimson, Sap Green and Yellow Ochre, adding contrast.

Add a few more touches of green here and there to connect the darks. Mute some of the window's color, and add more light to the table in the lower-left corner by applying a little more Cadmium Yellow Light and white. With your finger or a soft brush, soften the background edges in the window, the reflection of the orange vase and the left-corner shadow area on the table.

Blooming Light • Oil • 16" x 20" (41cm x 51cm)

portray the effects of light on rushing water

before you begin

Eye level—slightly high
Light quality and direction—luminous and coming from the upper left
Dominant value—middle to high key
Color dominance—cool

materials

Paper
Arches 140-lb. (300gsm) cold-press, 16" x 24" (41cm x 61cm)

Watercolors
Alizarin Crimson • Antwerp Blue • Burnt Sienna • Cadmium Orange • Cadmium Red • Cadmium Yellow Pale • Cobalt Blue • Cobalt Violet • Indian Yellow • Manganese Blue • Permanent Rose • Raw Sienna • Sap Green • Ultramarine Blue • Viridian • Opaque White

Brushes
Nos. 8, 10, 12 and 14 rounds • ½-inch (12mm) or 1-inch (25mm) flats • a rigger • a few smaller brushes • Fritch scrubber

Other
Pencil • palette knife • masking fluid • spray bottle • salt • single-edge razor blade • rubber cement pickup

A fly-fishing journey to the High Sierras took my husband and me to a gorgeous stream called Rock Creek near Bishop, California, where the painting and fishing conditions were excellent. The striking rhythmic movement of the water's path weaving its way through the gorgeous landscape caught my attention; what a great spot to paint as well as to try my new fly rod! The graceful movement of rushing water in dramatic morning light was the focus as I took a number of photos and completed small sketches for reference in the studio.

The following demonstrations are based upon the "S" format. The asymmetrical path of colorful, transparent water leads the viewer's eye pleasantly through the landscape. Dramatic darks glow in the water and contrast with muted grays, showing the effects of atmospheric perspective. Variety in the scale of rocks and trees, foreground textural details and overlapping shapes also contribute to this inspiring scene.

Skillfully gathering reference material, and knowing how to combine resources and make adjustments will make you a better and more inspired artist. Beginning painters often settle on the "prettiest" photo and attempt to copy every nuance and detail. It's better to compose your painting from a few sketches and photos so you can create the best possible design. Rather than just copy a photo, use your references to inspire more creative ways to express your own unique ideas.

Reference Photos

When using photos, be careful not to get caught up in cute little details and miss the main point—your inspirational source. The mood and spirit of a painting are generally more intangible. Details can mess with your inspirational thoughts and result in a cute picture instead of a masterful painting. Pick only the elements that enhance your center of interest, and leave out the rest.

tip

Go With the Flow

When painting water, try to "feel" its flow, movement and direction. Experience water through swimming, surfing, sailing or other aquatic activities. Sensing the directional flow of the water will help you avoid stiff, motionless water paintings. Your paint should flow as naturally as the water does.

1 Scale Up Your Value Sketch

After doing several preliminary sketches, it's time to scale up your final one so that the proportions of your paper are correct. In most cases you will intuitively know the approximate size paper on which to paint. To get the exact proportions, take your value sketch and align the top-left corner with the top-left corner of your paper. Place a straightedge diagonally through the upper-left and lower-right corners of the value sketch. Drag a light pencil line down the straightedge until you reach the far right side of your watercolor paper, and make a mark. Turn the straightedge horizontal on the mark and cut off the excess. Then make your final drawing with a light pencil.

2 Start Painting

Mask a few of the curling water ripples, but not too much since water edges are generally soft. Masking many whites creates problem blobs, so use just a little masking for sparkle.

Begin the distant trees with a light wash of Raw Sienna. Keep these shapes soft and simple. For the upper-right tree, drop Cadmium Orange and Ultramarine Blue onto wet paper, with a touch of Cadmium Red for the dark side and Cadmium Yellow Pale for the warm, light side. Let the colors mix on the paper with varied edges. The shape should have sky holes and an interesting overall design.

Paint the water by dropping Indian Yellow, Sap Green, Ultramarine Blue and Alizarin Crimson onto wet paper. Generously pour on the paint with loaded brushes, moving with the flow of the current. Start a few rocks by using Alizarin Crimson, Burnt Sienna and Ultramarine Blue for the dark side of the spherical shapes. Use gradation in value to make the rocks look round, with a sprinkle of salt for texture.

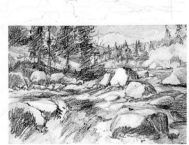

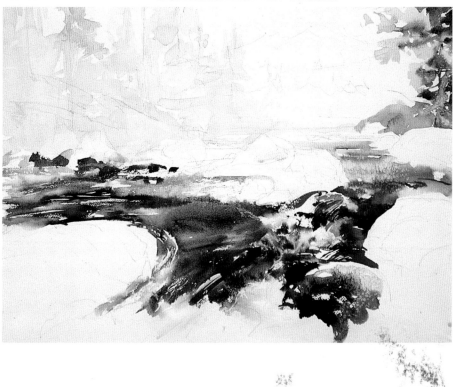

3 Sculpt the Foreground Rocks and Block In the Background

Use browns, violets and grays to mass in the foreground boulders. Build these large rocks with Alizarin Crimson, Burnt Sienna, Raw Sienna and Ultramarine Blue, with a touch of salt for texture. Leave a few whites by negative painting; also leave soft edges on the shadowed side of the rocks. Make sure to not overwork the color or you will have unexciting, muddy boulders.

Paint touches of water here and there in the background and drop Cobalt Blue, Raw Sienna, Viridian, Ultramarine Blue and a touch of Burnt Sienna to establish the distant horizon filled with tree shapes. Paint the larger middle-ground trees on the right, carving out the distant rocks and water shapes. Soften edges as you go for the atmospheric effect of distance.

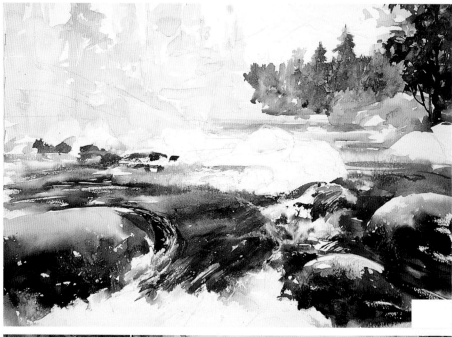

4 Work the Middle

Paint the middle-ground rocks and trees and the distant trees using muted greens: mixtures of Viridian, Burnt Sienna, Sap Green, Raw Sienna and Cobalt Violet. Be sure to keep the colors muted, not brilliant. While the paper is still moist, scratch in detail and add texture to the rocks with a palette knife. You can scratch, scrape and pull paint with the knife to create great natural effects.

Paint the sky using touches of blues and Raw Sienna, keeping it light. Paint the mountain with Permanent Rose, Manganese Blue and Raw Sienna in mixtures from light to dark to suggest the light coming in from the left. Later, glaze with Cobalt Blue to gray the area to create more distance.

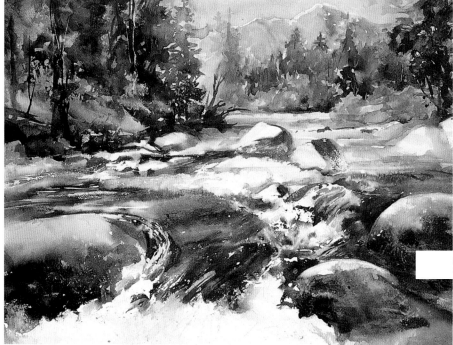

Detail

Leaving the whites while painting a shape helps to enliven a form. The warm side of the tree has more Raw Sienna for warmth and the cool side has more Ultramarine Blue.

5 Finishing Touches

Remove the masking fluid and place a mat over your painting to evaluate the composition: its values, center of interest, movement, rhythmic flow and harmonious unity. Does it hold together if you turn it upside down? Address the whites with blues and a Fritch scrubber. Finish the rocks in the background with additional touches of grays, Cobalt Blue, Raw Sienna and Permanent Rose.

Apply a very light wash of Cobalt Blue, Manganese Blue and Ultramarine Blue to the white water here and there. Echo the colors used for the sky in the distant waters. Spatter some Opaque White onto the water foam coming forward. Use a razor blade to scrape some of the curving, glittering lines that come down the waterfall.

The center of interest—the water—is highlighted through contrasting color and value. The muted gray, blues and browns contrast with the yellows and greens to create the luminous glow of slow-moving water. The turbulent white water creates excitement; its bouncing energy contrasts with the preceding slow, graceful water motion.

Rock Creek Waters • Watercolor • 16" x 24" (41cm x 61cm)

portray the effects of light on rushing water

Value Sketch

1 Tone the Canvas and Make the Drawing
Tone the canvas with Yellow Ochre. Line out the drawing with a
small filbert using Yellow Ochre with a touch of Alizarin Crimson.
Keep the drawing loose, simplifying the basic forms and leaving out
unimportant details.

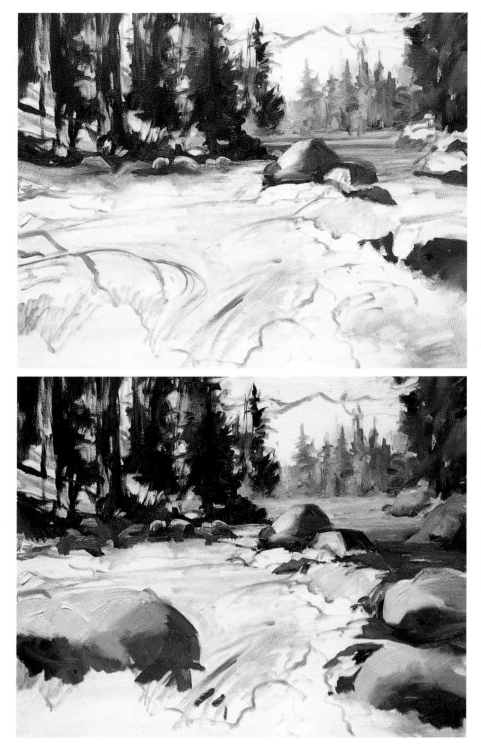

2 Begin the Background

The light is coming in from the left and delightfully dancing through the trees. Using Sap Green, Ultramarine Blue, Burnt Sienna, Yellow Ochre and Alizarin Crimson, loosely establish large tree mass on the left. Add white to the blue-greens and yellow-greens to create the distant muted trees. Gray the overall shape and warm the distant left side.

Continue with the background using muted gray-greens and squinting while looking at the distant shapes to be painted. Paint the middle-ground rocks in light using various grays created with mixtures of Cobalt Blue, Cadmium Orange, Alizarin Crimson, Ultramarine Blue, Yellow Ochre and white. The mixtures can vary for variety's sake, but keep the lighting direction consistent. Soften edges with a light touch. Begin the distant water with light gray-blue tones.

3 Progress Toward the Foreground

Gradate the blues for the river, from the light gray-blue in the distance to darker Ultramarine Blue as the river approaches the foreground. This adds to the sense of depth in the painting. Size is also a key player; distant rocks should be smaller and more muted in color, with less detail.

Continue to use various grays and blues while adding a little texture to the foreground rocks. Your painting approach is to encircle the center of interest: the glowing, translucent moving waters to come.

4 Move On to the Center of Interest

Using Sap Green, Cadmium Orange, Yellow Ochre, Cobalt Blue and Ultramarine Blue, surround the rocks and produce the transparent water. The key is to keep the colors clean. To paint the foam for water excitement, use a brush loaded with white and a tad of blue. Add pure white here and there to add sparkle to the glistening curl of the water. A touch of gray softens the foam as it leaves the foreground edge. Keep the focus near the center of interest, not at the edges of your painting.

Add the distant mountain with a touch of Alizarin Crimson and Cobalt Blue with lots of white, plus a touch of Viridian. Keep the sky very light using white plus Cerulean Blue and Cadmium Yellow Light. Apply a few touches of Yellow Ochre and white with a little bit of Sap Green for additional glow to the light hitting the side of the middle-ground trees. Using a loaded brush and light values of white with touches of Yellow Ochre, Cerulean Blue and Cadmium Red Light, add glittering light to the rocks along the shoreline.

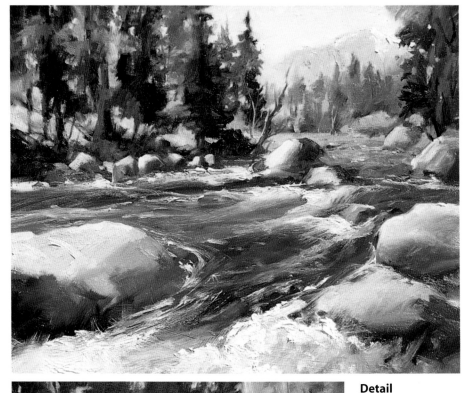

Detail

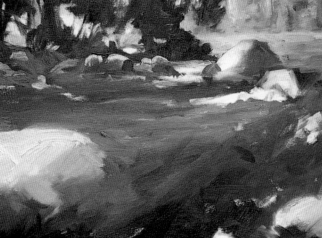

Detail

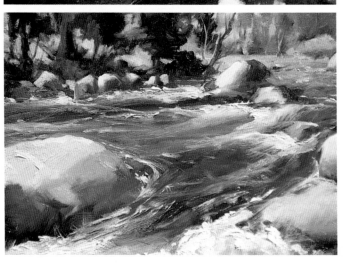

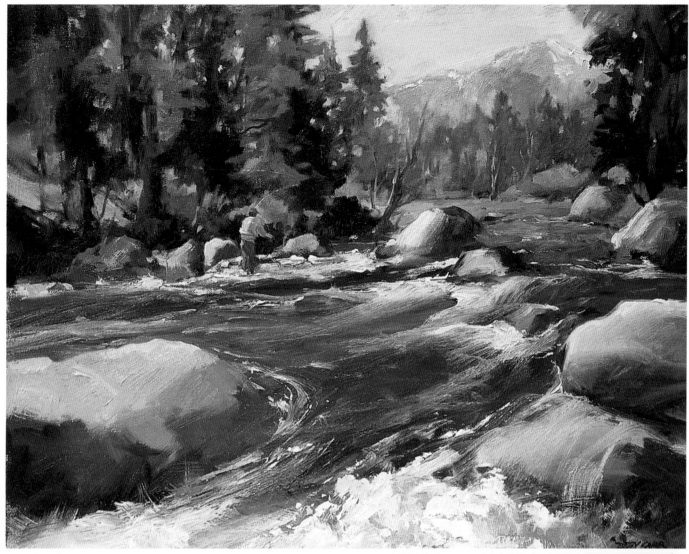

5 Finishing Touches

Stand away from the painting and evaluate it for harmony, unity, balance, repetition and contrast. Soften edges in the distance and on foreground shapes, guiding the eye to the center of interest. Confidently lay the foam in the foreground waters with white and touches of either Cerulean Blue or Cadmium Yellow Light. Think of rushing, bouncing waters as you do this to capture the spontaneous movement. Remember that the more you mess with this kind of paint action, the easier it is for mud and the disastrous effects of overworking to result. Blend touches of Yellow Ochre into nearby trees and rocks, along the mountain's edge and onto bits of foamy water.

Placing a fisherman in a water scene gives a better sense of scale and adds life to the moving scene. If there were a number of fishermen, the group should be arranged in an interesting manner—not just here and there. Since this fisherman—my husband, Howard—is moving, concentrate on the proper distribution of weight. Consider gesture as well as his size.

Rock Creek Waters • Oil • 16" x 20" (41cm x 51cm)

Detail
Before adding figures to your painting, make a few practice strokes on a separate canvas. Figures are just simple shapes—overdetailing will make them jump out instead of gently blending into your painting. For distant figures, keep the head small and concentrate on just the gesture and mass. Less is best when detailing a distant figure.

convey the personality of a seaside scene

before you begin

Eye level—slightly high
Light quality and direction—morning light coming from the left
Dominant value—low key
Color dominance—warm

materials

Paper
Arches 140-lb. (300gsm) cold press,
16" x 22" (41cm x 56cm)

Watercolors
Alizarin Crimson • Antwerp Blue • Burnt Sienna • Cadmium Orange • Cadmium Scarlet • Cadmium Yellow Pale • Cobalt Blue • Cobalt Violet • Indian Yellow • Manganese Blue • Permanent Rose • Raw Sienna • Sap Green • Ultramarine Blue • Viridian

Brushes
Nos. 8, 10, 12 and 14 rounds • ½-inch (12mm) and 1-inch (25mm) flats • a rigger • a few smaller brushes • Fritch scrubber

Other
Pencil • palette knife • spray bottle • masking fluid • salt • rubber cement pickup

The design options for seaside compositions seem endless at Morro Bay, California, a favorite spot of mine in searching for marine subject matter. The ocean, sky, variety of boats, weathered buildings, fishing paraphernalia and seaside activity contain a wealth of unique forms to gather and rearrange for great paintings.

The following paintings in oil and watercolor represent the general flavor of the coastal town of Morro Bay. Although the techniques are different for each medium, the goals of capturing limited directional lighting, water reflections, the texture of old weathered boats and the charm of the area were all in my mind when composing the scene.

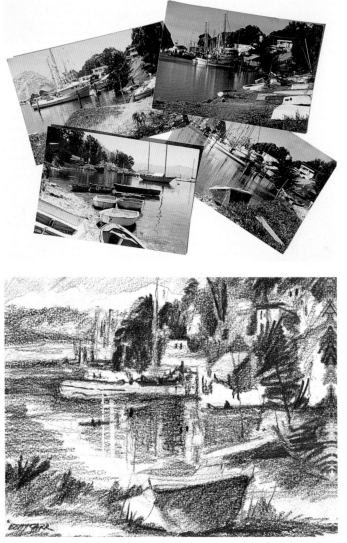

Reference Photos

Thumbnail Sketch
A number of preliminary sketches, including this final sketch, were valuable in contributing to the final painting. Deciding what to put in and what to leave out takes place at this stage. It's best not to do a great deal of second-guessing on your actual painting.

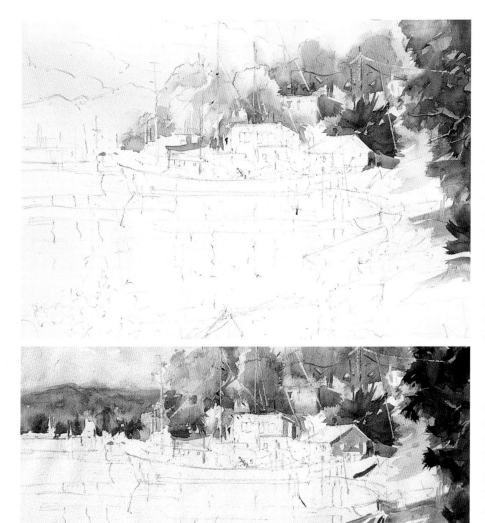

1 Make a Drawing, Apply Masking and Begin the Background

Keep the sketch light so that some of the lines can be erased later after the watercolor is completed. Mask a few rigging lines, masts and foreground grasses for light effects.

Using various grayed greens, Cobalt Blue, Raw Sienna, Burnt Sienna, Viridian, Alizarin Crimson and a touch of Cadmium Scarlet, begin the distant trees. Vary the values and soften edges as you go. The darker middle-ground tree begins to establish the dimensional aspect of the painting. Use violet shadows to anchor the larger tree and begin the horizontal movement in the painting.

While the paint is still wet in some areas and drier in others, use your palette knife to suggest telephone lines and rigging, and to break up the vertical trees.

2 Develop the Distant Scenery and Foreground Boats

After adding a few more dark values to the middle-ground tree and distant trees, glaze the sky with a very light wash, warming the horizon. Wet the sky area and use Manganese Blue and Cobalt Blue above with a touch of Alizarin Crimson and Raw Sienna along the mountain's edge. The Alizarin Crimson helps to keep the Raw Sienna and various blues from resulting in a green hue. Paint the distant mountain with various violets, keeping the edges soft and values light.

Begin the seaside buildings using Ultramarine Blue, Permanent Rose and Cadmium Orange. Add touches of Cobalt Violet to strengthen the cool sides. Group these buildings to form an overall shape instead of approaching them as individual structures.

Start the boat shapes that are resting in the sunlight. Establish the light direction by keeping the shadow side of the boats darker and clean while pulling directional shadows to the right. Various dark greens deepen the local color of the grass, while Cadmium Yellow Pale warms the sunny beach. Reflected light bounces into the underside of the boats from the glowing shoreline, while violet shadows stretch along the bay.

3 Begin the Water

Wet-into-wet painting naturally works well for painting water. Leave the white in the water to suggest the boat's reflection. Paint around the various white shapes in the water by wetting the paper and dropping in the blue; make sure the edges are left soft. While laying in washes of blues and reflected colors from nearby shapes and the sky, pay attention to the dryness of the paper, while keeping the painting support at an angle of at least ten degrees.

After the blue water is dry, re-wet the area and add Manganese Blue, Cadmium Orange and Permanent Rose to gray the white reflection, using horizontal strokes. When the area is dry, lift a few highlights: narrow horizontal lines near the horizon, and wider lifts closer to the foreground.

Develop the foliage to the right by deepening the value using Indian Yellow and Antwerp Blue with a touch of Ultramarine Blue. This dark area will help frame the light in the seaside setting.

4 Remove the Masking and Start Shaping the Details

Remove the masking fluid with a rubber cement pickup, then take a look through a mat to check the balance of your painting before starting details. Develop the foreground grasses using Indian Yellow and Antwerp Blue, remembering that they will be catching some of the light coming from the left. Apply some nice violet shadows to the middle-ground boat, mixed from Permanent Rose, Cadmium Orange and Manganese Blue. Add them to the inside of the foreground blue boat as well.

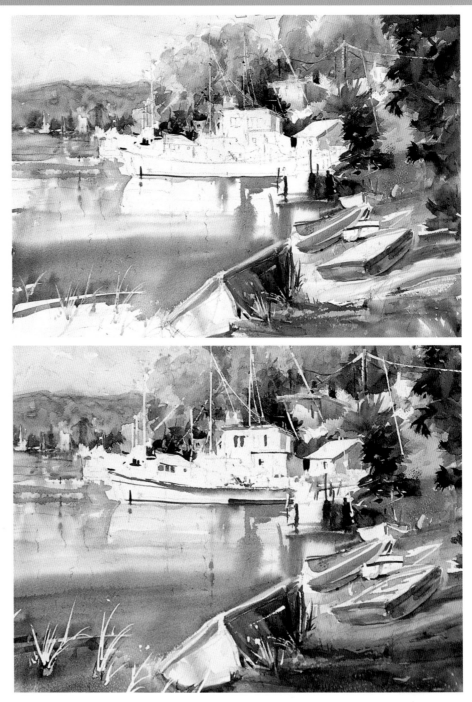

5 Finishing Touches

Glaze a few bright spots here and there, adding more contrast and dimension to the scene. While the right corner of the water is still semi-moist, sprinkle a little salt on the area. Using a small rigger or round and thicker paint, develop details such as little fences, grasses, suggestions of windows and rocks. Make sure not to overdetail; keep the viewer interested by simply suggesting. The little fishing village is at rest in morning sunlight.

All Ashore • Watercolor • 16" x 22" (41cm x 56cm)

Detail

Touch up details after removing the masking. Soften hard edges, especially in the background, with a Fritch scrubber and water.

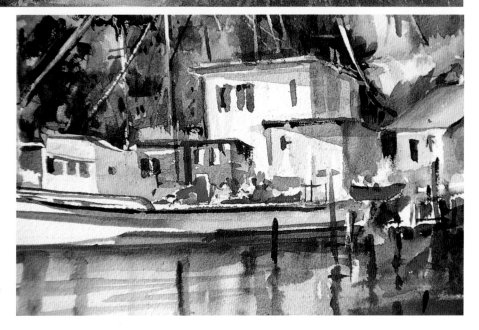

convey the personality of a seaside scene

before you begin

Eye level—slightly high
Light quality and direction—radiant and coming from the left
Dominant value—high key
Color dominance—warm

materials

Surface
Prestretched, gesso-primed canvas, 16" x 20" (41cm x 51cm)

Oils
Alizarin Crimson · Cadmium Orange · Cadmium Red Light · Cadmium Yellow Light · Cerulean Blue · Cobalt Blue · Sap Green · Terra Rosa · Thio Violet · Ultramarine Blue · Viridian · Yellow Ochre · White

Brushes
Bristle flats nos. 4 and 6 · bristle filberts nos. 6, 8 and 10 · Ruby Satin filbert no. 6 · soft brush (for blending)

Other
Palette knife (for mixing) · painting medium (for thinning paint) · odorless mineral spirits (for cleaning brushes)

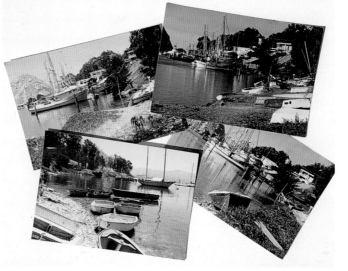

Reference Photos

Value Sketch

tip

Color Becomes Cooler and Less Intense in the Distance
Remember the importance of muting color to establish the illusion of depth in a painting. The brilliance of the hue decreases the farther away you go. All colors generally become cooler as they recede.

1 Tone the Canvas and Make a Drawing

Tone your canvas with Yellow Ochre. Using a small bristle brush and a touch of Yellow Ochre and Alizarin Crimson, sketch your composition. The weathered dinghy gently leaning inward suggests movement towards the center of interest: the fishing village and white fishing boat.

2 Start the Foreground and the Center of Interest

Paint the dark side of the dinghy with Terra Rosa, Thio Violet, Yellow Ochre and a touch of Ultramarine Blue, using slightly more Yellow Ochre for the reflective light. For the light side, apply Terra Rosa, Yellow Ochre, Ultramarine Blue and a small touch of white and Cadmium Yellow Light. Marble the colors by not mixing them completely. Generally, if you mix more than three colors you'll get mud, so marble color when you have more than three.

Paint the grass with Yellow Ochre and Sap Green. Paint the shadow cast by the boat with dark greens, the local color of the grass. Establish the darks first, then continue with the light side. Begin the cozy village buildings and the fishing boat with white, Cadmium Yellow Light and touches of Alizarin Crimson. Gradate the white on the boat by adding Yellow Ochre, Thio Violet and Cerulean Blue as you approach the shadow side. Add roofs and small details to the buildings with Alizarin Crimson, white and Yellow Ochre with a touch of Cerulean Blue. Paint the buildings' shadows with Yellow Ochre, Alizarin Crimson and a touch of Viridian.

3 Develop the Outer Parts of the Painting

Begin to sculpt the small fishing village with dark tree shapes. Paint the darks of the trees first using Ultramarine Blue, Alizarin Crimson and Sap Green, and then the lights using Yellow Ochre, Sap Green and white. Finish off the tree shapes with a touch of Cadmium Orange. Soften edges as you go; but you can do final softening later.

The overall grouping of boats, buildings and trees should appear as a pleasing, unified shape. Use small dabs of color to suggest buoys, workers and other signs of seaside life. The various grays that are on your palette at this point can be picked up and cooled with blues to create distant mountains. For the sky, use Ultramarine Blue with lots of white. Warm the horizon with a tiny amount of Yellow Ochre. Begin the distant part of the bay with Ultramarine Blue and a bit of gray and white. Keep the mixture clean; no overstroking!

The dinghies lining the shore create an immediate sense of distance and a good compositional lead-in. Paint them with various hues, keeping in mind the light direction from the left and your point of view. Using Ultramarine Blue and Viridian, add a strong, dark tree on the right to set off the center of interest. Add small touches of light to the right side of the fishing boat and to some of the buildings to develop more sparkle.

4 Work on the Boat's Reflection and the Right Side of the Painting

The white in the fishing boat's reflection on the water is slightly darker than the boat itself. Use small touches of Ultramarine Blue and Alizarin Crimson in white to begin establishing the boat's reflection.

Add a few more shadows to the right side of the painting using various greens near the boats in the lower-right corner. When painting positive and negative areas such as this, darks are usually painted first. Leave interesting shapes, not odd unpainted areas. Don't leave behind circles, triangles or other symmetrical shapes that will pop out like a sore thumb. The path of light created by the foliage along the shore is an example of a nice shape of continuing, connecting light.

5 Paint the Water

From light to dark and middle ground to foreground, paint the water with Cerulean Blue, Cobalt Blue and Ultramarine Blue. Add white to gradate the mixtures. Repeat variations of the colors of the shore in the water reflections, using horizontal brush action and keeping the edges soft. Paint the reflections of the boat and distant trees in the water using Cadmium Yellow Light, white and a little Sap Green with Yellow Ochre to suggest warm greens against the gray reflection of the boat. Suggest more tree reflections with Ultramarine Blue, Viridian and white.

The key to painting this area is to avoid overdoing. It is easy to muddy the water if you are not careful. Keep the rigging, boom, mast and reflections to a minimum.

Paint the subtle escape route on the right—the path of light—using Cadmium Yellow Light, Cadmium Orange and white. Add a little more light to the foreground grasses with Sap Green and Yellow Ochre.

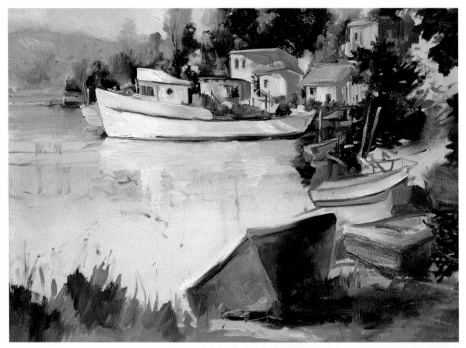

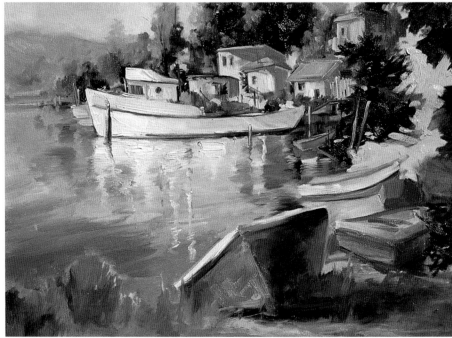

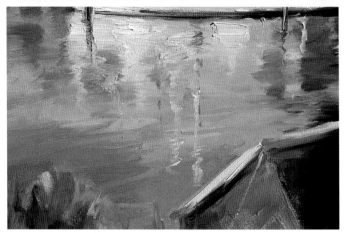

Detail
The movement of the water adds some pleasant textural variety to the painting. Keep it simple.

6 Finishing Touches

Place a few clouds using Cadmium Red Light, Yellow Ochre and white. Add a few more grasses to the foreground to bring the viewer close to the scene, but not enough to distract. Apply white to make the rigging and a few poles catch the light. The red boat on the right grabbed too much attention from the star of the show, so I replaced it with sandy shoreline. By softening the edges and limiting the light on the right, the viewer's eye is directed and held without venturing out of the upper-right corner. Add a few highlights for sparkle.

If you've ever looked carefully at boats along the shore, you've noticed all the lines—rigging poles, nets, sails, crates—that could be included in a scene like this. In your painting, however, most detailing should be done in and around the center of interest—suggestions of maybe a fisherman, some buoys and other fishing apparatus. Keep these details to a minimum to let the light take center stage.

All Ashore • Oil • 16" x 20" (41cm x 51cm)

re-create the charm of a loose floral arrangement in morning light

A random gathering of picked flowers awaiting a formal display can be more exciting as a still life than the actual "planned" arrangement. These flowers resting against a warm picnic basket and drenched in morning light caught my eye. I set aside the still-life arrangement in my mind, grabbed paper, brushes, pencil and camera, and went to work. The basket's geometric weave pattern gives variety in texture and interest to the free-flowing edges of the flower petals.

Reference Photo

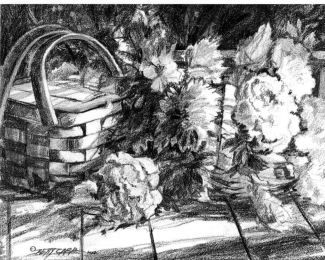

Value Sketch

1 Make a Drawing and Save the Lights
Loosely place the geometric forms of the cube-shaped picnic basket, spherical peonies and other shapes. Avoid including picky details. The pencil lines should guide you in placing the light enveloping the scene, not fill in the drawing. Keep the block-in sketch lively and spirited. Mask a few lights, including the basket handles and parts of some of the flowers that will be touched by the light.

2 Begin the Background Flower Shapes
The background will eventually be a dark value to contrast with the glowing white peonies to come. Begin the upper-right section by dropping Manganese Blue and Cadmium Yellow Pale onto a wet surface, keeping your brushstrokes limited.

Start the darker flowers with Cadmium Yellow Pale, Cadmium Red and Permanent Rose. Add a touch of Cadmium Orange to warm the violets. Paint the green shape with various values of Antwerp Blue, Sap Green and Indian Yellow. Produce an interesting overall shape, while leaving little whites (I call them "holidays") to keep the colors from blending too much. Do not paint individual petals, leaves and flowers. The holidays will be glazed later when deepening the values.

For the background, a wooden banister overlooking a tree-lined backyard evokes the sunny outside. Suggest the railing using up-and-down strokes with a 1-inch (25mm) flat and Burnt Sienna, Raw Sienna and Alizarin Crimson with a touch of Cobalt Blue. Charge various blues, yellows and greens onto moistened paper for the background greens.

Detail
A no. 10 round paints the colors quickly in four to six strokes—no patting or overstroking the paint mixture, which deadens and dulls the paint.

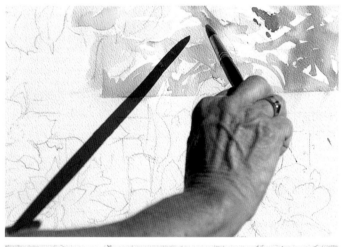

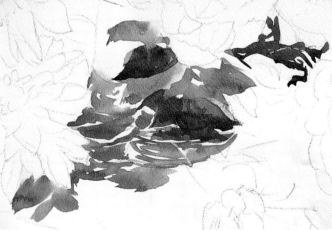

Detail
This closeup shows the variety in color, shape and value that makes this overall shape interesting. Notice the various holidays. Because the wet paint is always moving—in this case, downward, because the support rests at a fifteen-degree angle—the holidays help prevent the colors from running together. These white areas generally are glazed at a later stage.

3 Expand the Darks

Save small spots of dappled light while continuing to develop the darker flowers and greens using Alizarin Crimson, Burnt Sienna, Winsor Red, Viridian and Ultramarine Blue. Suggest a few sunlit leaves near the lighter flowers with Raw Sienna and Indian Yellow.

Using Permanent Rose, Manganese Blue and Cadmium Orange, lay in the flower shadows with confident brushstrokes. Remember that shadows are always affected by the local or mother color of the objects casting them, so the shadows should contain a bit of the mother color. Drop in water here and there to ensure soft, lost edges in the shadow areas.

Paint the weave of the "hidden" basket holding the flowers using Raw Sienna and Cobalt Violet, making sure to save areas of light on the basket's handle. Begin indicating the light with a few directional shadows.

4 Continue the Darks and Start the Basket on the Left

Continue the darks while saving lights, bearing in mind the light source and quality. Deepen the values while keeping the colors clean by not overstroking. Practice using your palette knife to scrape out lights, work paint onto the petals, and create stems and other textural details. Do this in the moistened darker and mid-dark areas, so the details will show up more due to contrast.

It's important to have an understanding of two-point perspective and the under-over/over-under method of weaving to paint the picnic basket. I marked one of the weave colors with pencil X's so I wouldn't get lost painting the weave. Begin the tan part with Raw Sienna, Cobalt Violet, and touches of Viridian. When dry, glaze again with the same mixture. Start the green part with Viridian, Raw Sienna, Alizarin Crimson and touches of Ultramarine Blue in the dark side. Deepen the value on the dark side with the same mixture after the area has dried.

Begin the shadow shapes around the bottom of the flowers and the basket on the left using Permanent Rose, Manganese Blue and Raw Sienna.

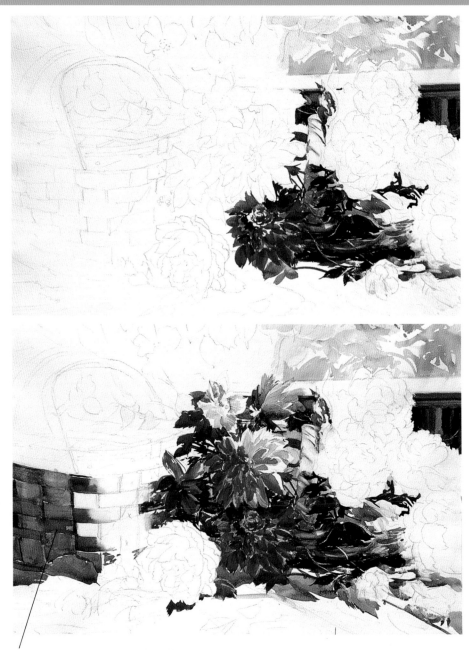

Notice the edges are blended, soft and lost in the shadow side of the basket. The dramatic light is saved for the side of the basket facing the light source.

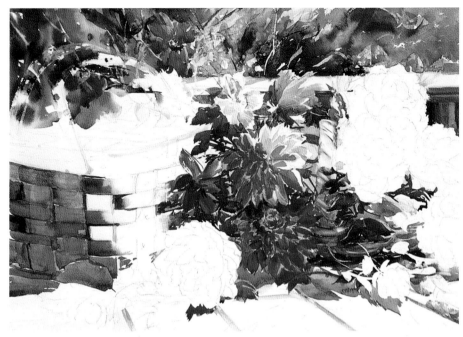

5 Loosely Paint the Background

Dampen the upper portion of painting (the background), saving a horizontal line where you will suggest a patio railing. For the first transparent glaze, drop in various warms and cools and let the colors do their thing, keeping them fresh. Make the colors more intense than you think you should. Remember, when you drop paint onto a wet surface, it automatically becomes lighter due to dilution. If you find that your background doesn't dry dark enough, you can reglaze after the first layer is dry.

Paint the dahlias using Cadmium Red, Permanent Rose and Cadmium Orange, thinking shape and value while keeping the details to a minimum.

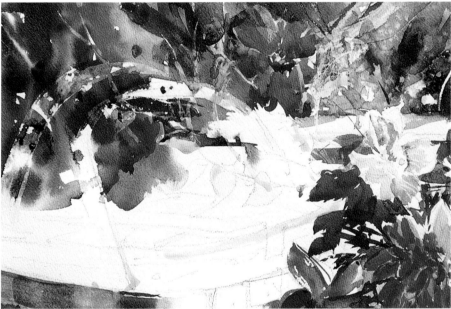

Detail
A few of the various colors around the basket handle suggest background flowers and foliage due to their soft yet descriptive edges. There are touches of masking fluid still under the glaze that will be removed when the glaze is dry, largely revealing the picnic basket's handle.

tip

Maintain Your Paint's Sparkle
Pigment consists of tiny "rocks" immersed in medium (gum arabic). These pigment particles have characteristic facets that catch light, very much like a diamond. If a diamond ring were to be sanded or the facets rubbed on concrete, well, there goes the sparkle. When your brush continually pats, putters and second-guesses, paint pigments dull out—like a damaged diamond. Keep your brushstrokes fresh to maintain the sparkle in your paint.

Notice the glowing warmth in the shadow side of the basket. Warm light is bouncing about from the picnic table's surface.

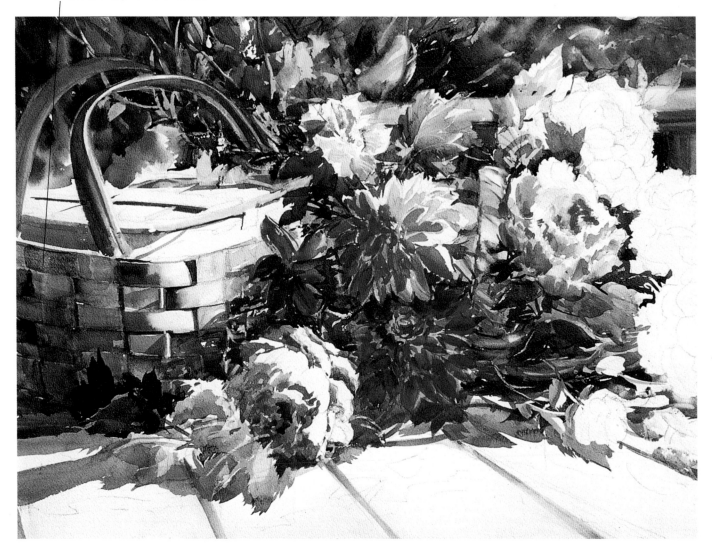

6 Work on the Light-Related Details

When the painting is dry, use a rubber cement pickup to remove all the masking. Add small shadow details on the flowers and leaves. The foreground picnic table now is in need of shadow work and a few lines for definition. Use a gray mixture of Manganese Blue, Raw Sienna and Permanent Rose—with more blue in the mix—for the cooler, darker shadows near the basket. As the shadows proceed toward the foreground light, warm and lighten the mixture by adding more Raw Sienna, Permanent Rose and water.

Develop areas like the basket handle and the top of the railing by deepening their values. Colors generally used when working on these areas are should be based on the mother color. For instance, deepen the values of the basket handle with Raw Sienna, Permanent Rose and touches of blue. Deepen the background's value with darker greens and violets. Add some detail to the lighter flowers.

tip

Squint to Eliminate Unnecessary Details

Such little pigment is needed when painting the effects of light. Squint your eyes and observe the shapes and values of the flowers in the light. Compare light values and dark values. If you can't see the details with squinted eyes, then leave them out. The suggestion of something can go a long way. Paint what you see, not what you know.

7 Finishing Touches

On the dry upper background, glaze a thin layer of Ultramarine Blue to cool the area. Use a thin layer of Viridian or a transparent green mixture that you prefer to darken and deepen the intensity of the darkest flowers. This action gives additional depth to your still life. Add a little Cobalt Blue for a bit more greenery detail.

A blue-violet glaze is needed for the foreground shadow to heighten the drama of this limited-light extravaganza. Use Ultramarine Blue and Alizarin Crimson with a touch of Viridian here and there in the flowing mixture. Tilt the board to help the shadow shape move along. Let dry and place the painting in a mat to check its overall appearance.

Use Permanent Rose, Manganese Blue and Cadmium Yellow Pale with a bit of Cadmium Orange to paint the white flowers, and a touch of Cadmium Yellow with plenty of water for the yellow flower. Moisten the paper first to ensure soft edges, and avoid excessive brushwork and overmixing to keep the colors clean. Darken a few shadows , apply a few final warm glazes and add a few touches of Opaque White to finish.

Picnic Parade • Watercolor • 24" x 30" (61cm x 76cm)

experience light effects on location

before you begin

Eye level—low
Light quality and direction—luminous and coming from the back (backlight)
Dominant value—low key
Color dominance—warm

materials

Canvas
Prestretched, gesso-primed canvas, 16" x 12" (41cm x 30cm)

Oils
Alizarin Crimson • Cadmium Orange • Cadmium Red Light • Cadmium Yellow Light • Cerulean Blue • Cobalt Blue • Sap Green • Terra Rosa • Thio Violet • Ultramarine Blue • Viridian • Venetian Red • Yellow Ochre • White

Brushes
Bristle flats nos. 4 and 6 • bristle filberts nos. 6, 8 and 10 • Ruby Satin filbert no. 6 • soft brush (for blending)

Other
Palette knife (for mixing) • painting medium (for thinning paint) • odorless mineral spirits (for cleaning brushes)

For a painting workshop in Sedona, Arizona, I took my students to a number of gorgeous spots to paint. One of the favorites was Telaquepaque, a quaint, unique spot filled with dappled light and the flavor of the Southwest. The challenge for the week, this two-day painting experience in particular, was to gather at least six plein air sketches for future studio work.

The plein air painting experience is incredible. Being there makes all the difference, especially when you're creating references for paintings that you'll later do in the studio. You feel the intangible effects of light enveloping form, the air, the atmosphere and subtle changes of the scene. An artist's presence at a scene is certainly apparent in his or her work.

This oil painting is a plein air sketch originally intended as a reference for a watercolor to be done later, but it is a fine painting in itself. The watercolor version is shown at the end of the demonstration.

Reference Photo

Detailed Value Sketch

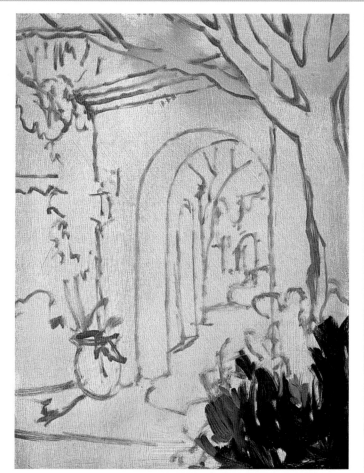

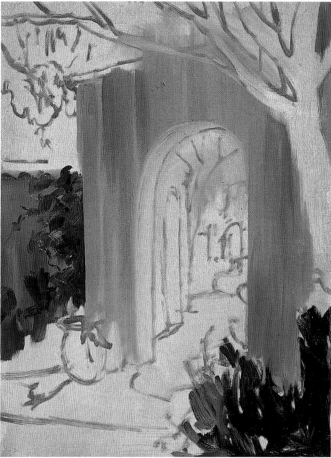

1 Tone the Canvas, Make a Drawing and Begin the Foliage
Tone the canvas with Yellow Ochre. Using a small bristle brush and a dark color such as Alizarin Crimson, sketch the composition, concentrating on correct perspective and positioning the main structure, the arch, according to the eye level. Using Viridian, Ultramarine Blue and Alizarin Crimson, loosely establish the positive shape of the dark foreground foliage. Using Yellow Ochre, tap on a little reflected light here and there, bouncing into the greens.

tip

Setting Up for Plein Air Painting

A major consideration for plein air sketching is placing the easel in the best position relative to the time of day. Evaluate your lighting situation, especially in early morning or late in the evening. The light quickly changes, and since you will be painting the changing light and shadow shapes, your position is important. Here are some tips to keep in mind:

- Shadows quickly change in the morning and in the evening, but not so drastically around noon.
- Avoid allowing the sun to shine directly on your canvas or watercolor surface; this will affect the values of your painting as bright light bounces off the surface back into your eyes.
- Will the sun move over your position, putting you in direct, hot sunlight later on, or will you be in the shade for most of the time you are painting?

2 Start the Arch
Holding fast to accurate perspective, begin painting the largest form: the arch. In order to infuse this backlit, fairly dark structure with some color "snap," keep the colors clean. Using Cerulean Blue, Thio Violet, Cadmium Orange, white and a touch of Viridian, paint the structure with confident, vertical brushwork. Use a no. 8 or no. 10 filbert or flat with strong, clean strokes.

This structure is basically weathered adobe, so keep that in mind as you paint the surface texture. Scatter touches of Cadmium Orange and Thio Violet to accurately portray the rain-stained adobe. The building also has a few imperfections of gray texture contributing to a weathered look: mineral stains like the stains on a rocky cliff. Create this effect with pulled-down brushstrokes. Warm the area toward the opening with Cadmium Orange and Yellow Ochre, which will suggest light from the patio and reflected light underneath the arch. Continue with the side walls using darker values of the same arch colors. Suggest some greenery on them—perhaps crawling ivy—repeating the foreground foliage colors.

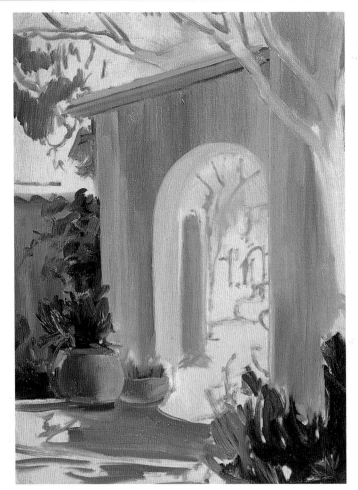

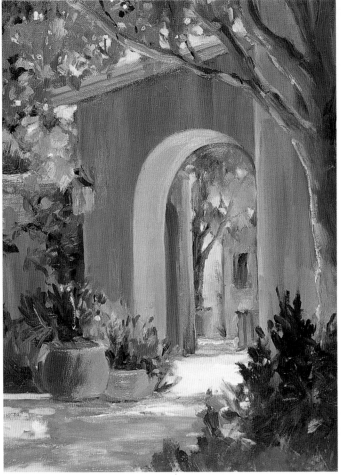

3 Block In the Patio Shadows

Begin painting the shadows on the patio with Thio Violet, Cobalt Blue, Cadmium Orange and white. Maintain the warmth close to the opening of the arch, with mostly Cadmium Orange and Thio Violet in the mixture. Add touches of Cadmium Yellow Light, Cadmium Orange and white under the arch. The beauty of the reflected light under the arch begins to sparkle. At this point start adding a few details to enliven the foreground, like potted plants and maybe a close structure right behind the arch to add contrast to the arch's glowing underside.

4 Paint the Tree and Add Surrounding Details

Paint the ground shadows to finish up the foreground lead-in. Use Terra Rosa, Ultramarine Blue and white for the cool shadow in the corner area, and touches of Thio Violet, Cadmium Orange and white for the warm areas. Produce the foreground light with Cadmium Yellow Light and white, blending the shapes together.

For the texture above the building, use various greens, yellows and oranges with a smaller brush to suggest the leaves and hanging foliage. Let pieces of blue sky peek through (made with Cerulean Blue and white). Paint the tree using various mixtures of violets, oranges and blues, keeping the warmth on the side facing the arch. To indicate glowing light on the foreground tree, apply touches of Cadmium Orange, Cadmium Yellow Light, Cerulean Blue and white.

Shape the foreground green bush with upward strokes and a dark value (Alizarin Crimson and Ultramarine Blue). By keeping the greens duller and darker in the foreground, the glow beyond will be more apparent. Treat the potted plants with minimal detailing and remember that they are affected by the light coming through the arch.

Suggest trees, distant buildings and perhaps the far horizon through the arch. Using Ultramarine Blue, Alizarin Crimson, Sap Green and white, block in the lantern, which helps to break up the vertical and add character.

5 Make Color Adjustments and Finish

After looking at the painting from a distance, I realized that the color punch was lacking a bit in the foreground. I made a few adjustments with the colors and the shadows, including the colors of the pots filled with flowers. I felt the color of the pots matched the color of the building too closely. I used Ultramarine Blue, Alizarin Crimson and Venetian Red were used on the dark side of the bluish pot, while adding white to the mixture on the sunny side. For the other pot, I used Thio Violet, Cadmium Red Light and white.

Finish the details, including the lamp, tree foliage and fallen petals in the foreground. Place a second lantern in the inner walkway. Detail the patio tree slightly more and add a few more sky holes for interest.

This plein air sketch was done quickly and spontaneously in preparation for a watercolor version back in the studio. This sketch holds together and successfully re-creates the warm, summery feeling of light and shade.

Summer Shade • Oil • 16" x 12" (41cm x 30cm)

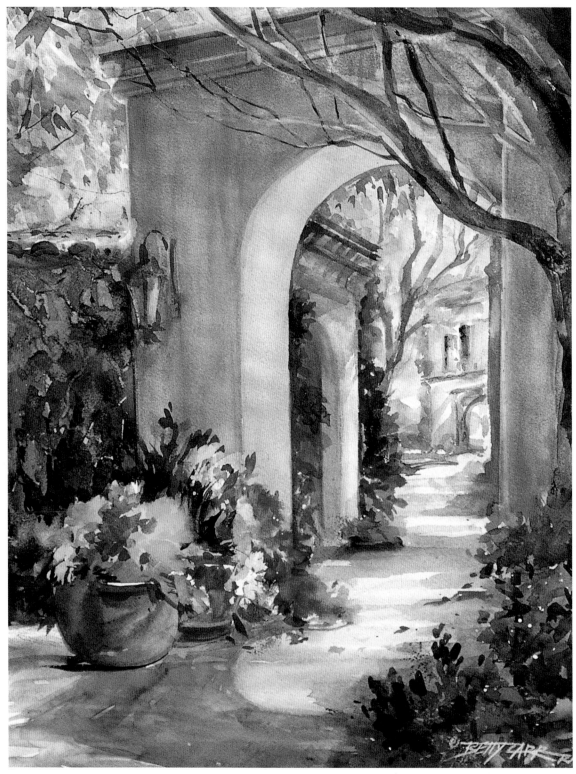

Interpreting a Studio Painting From a Plein Air Sketch

This watercolor painting shows how a plein air sketch might be interpreted once back in the studio. Starting on location with a value sketch and a plein air sketch and then continuing with a larger painting in the studio completes the circle of a true art experience. Certainly there is more you could add by looking at more photographs and by doing additional sketches and studies, but simplicity can make a statement and be just as beautiful.

Summer Shade • Watercolor • 24" x 20" (61cm x 51cm)

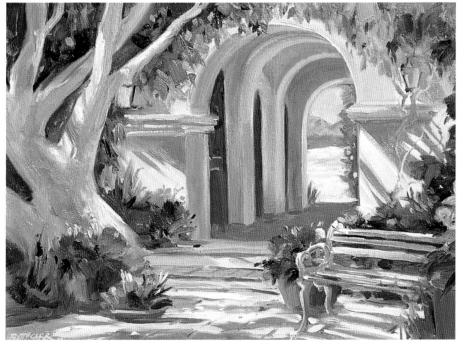

Look Around for Another View

When I turned around, I spotted another jewel just waiting to be painted plein air. I just happened to have another canvas ready to go. I adjusted my easel and did another painting. What great reflective light. What fun!

When you marvel at a scene before your eyes, listen to the inspiration you feel. That scene will be something you will enjoy painting and probably from which you will end up creating your best paintings. You'll never forget it.

Bouncing Light • Oil • 12" x 16" (30cm x 41cm)

Back in the Studio

I couldn't resist doing a watercolor painting from my "turn-around" plein air sketch in oil once I returned to my studio.

Bouncing Light •
Watercolor • 28" x 36" (71cm x 91cm)

take a cozy street scene from daylight to moonlight

before you begin

Eye level—middle to low
Light quality and direction—mysterious light coming from the left and back
Dominant value—low key
Color dominance—cool

materials

Paper
Arches 140-lb. (300gsm) cold press, 16" x 22" (41cm x 56cm)

Watercolors
Alizarin Crimson • Antwerp Blue • Burnt Sienna • Cadmium Orange • Cadmium Yellow Pale • Cobalt Blue • Cobalt Violet • Indian Yellow • Manganese Blue • Permanent Rose • Raw Sienna • Sap Green • Ultramarine Blue • Viridian • Opaque White

Brushes
Nos. 8, 10, 12 and 14 rounds • ½-inch (12mm) and 1-inch (25mm) flats • small rigger • a few smaller brushes • Fritch scrubber

Other
Pencil • masking fluid • palette knife • spray bottle • salt • rubber cement pickup

Strolling through the unique side streets of New Mexico is a favorite photo-and-painting treasure hunt for me. Alleyways, side roads, winding streets, country pathways, city shortcuts and weathered trails all present great compositional lighting effects along with unique artistic settings.

Different times of the day and evening provide challenges for the brush—the moonlit night being one. Night scenes evoke imaginative aspects of hidden forms in shadow. Every season also expresses a mood unique to the particular time of year. A clear, stark autumn sky framing the moon's form and light is inspiring; it subtly suggests mystery around corners and in hidden shapes among the trees.

The following painting, *Moon Shadows*, takes a daylit Santa Fe alley scene and transposes the mood and atmosphere into a surrealistic, low-lit, glowing setting. The moon is full and the lights are on in the cozy dwelling, creating directional lighting from the left that bounces about nearby forms.

Reference Photos

Value Sketch

1 Make a Drawing and Mask the Lights
Sketch the design using a light touch and begin applying masking fluid. Glistening power lines, glowing street lights and luminous cabin windows are some of the details you should mask with a brush and palette knife. Remember that masking fluid is generally used when you have a small light detail placed near a heavy dark, and where the momentum of the brush could be inhibited by trying to paint around the little light details.

2 Move In on the Moonlit Glow
Various approaches can be taken when painting this type of subject matter. Beginning with the sky, moon and background, then moving outward to capture the evening glow is one way. Here we will take the approach of moving inward while painting around various lights.

Create the adobe walls by blending together various violets and yellows on a moist surface. Paint the wall with vertical action using Raw Sienna, Cobalt Blue and Permanent Rose, and pull the mixture into a horizontal stroke for the ground shadows.

While the paper is still wet to ensure soft edges, drop in a mixture of Viridian and Burnt Sienna for the nearby foliage, creating an interesting shape. As the shape reaches around the building on the right toward the moonlight, drop in Raw Sienna for glow. Drop Antwerp Blue and Burnt Sienna with a touch of Cobalt Violet to suggest the hidden foliage in the corner.

3 Continue the Luminous Foliage

The diagonal tree branches create a backlit silhouette against the moonlight. To achieve the warm glow, use Indian Yellow and water droplets to paint the tree edges. Moving inward and leaving sky holes, darken the tree's value using Burnt Sienna and Sap Green. The intensity of color in the tree's contour stands out now, but later will be glazed and muted to heighten the silhouette effect.

When dry, use Ultramarine Blue to apply a cool glaze on the area to begin establishing a nighttime look. Touch up the background buildings and wall with a little Alizarin Crimson.

4 Establish Shapes

Using a light, warm violet, establish the beginning stages of the middle-ground building at the center of interest. Begin some foliage in that area with Antwerp Blue and Raw Sienna. Paint the foreground connecting shadows horizontally using a large round with Alizarin Crimson, Ultramarine Blue and Raw Sienna.

The light direction is now becoming apparent. The buildings are old and weathered—no rules here! By further glazing the adobe walls and deepening the value on the tree, we're emphasizing the area of light to the left. Lift a few subtle rays in the tree on the left when the paint is dry, using a toothbrush or Fritch scrubber.

Detail

The mysterious foreground is void of hard edges in the foliage, making certain the eye flows beyond and toward the center of interest: what will eventually be a lit window. This is a night scene, so keep the values dark and the paint mixtures cool.

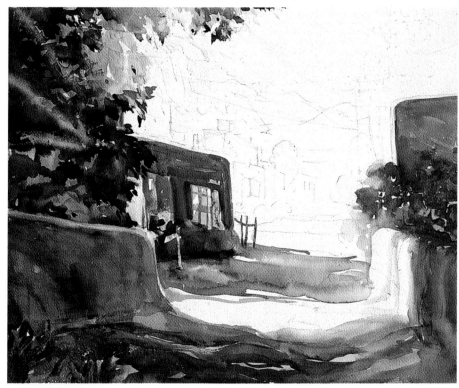

5 Darken And Deepen the Values

Use Permanent Rose, Raw Sienna and Cobalt Blue to deepen the dwelling's value. The only way to lighten a value to create glow is to place a dark next to it. Lightly add touches of Cadmium Yellow Pale to the window. The luminous glow from within the window is emphasized by adding deep blue shutters using Ultramarine Blue and Burnt Sienna. Continue the middle-ground shadows using the same colors that you used in the foreground, only warmer. The surrounding muted darks exaggerate the window's light. A reflective tin roof will be added later, strengthening the lighting effects.

6 Develop the Details Before Night "Falls"

Continue framing the center of interest—the glowing dwelling—with background shapes. Add foliage of various greens, continuing to frame the moon's light. Apply additional moonlight on the trees using Manganese Blue and Raw Sienna. Use Cobalt Blue and Raw Sienna for the buildings in the background, as well as adding foliage with Antwerp Blue, Burnt Sienna and touches of Raw Sienna. Paint distant trees with Cobalt Blue and Raw Sienna, keeping the colors and values muted so you don't upstage the center of interest.

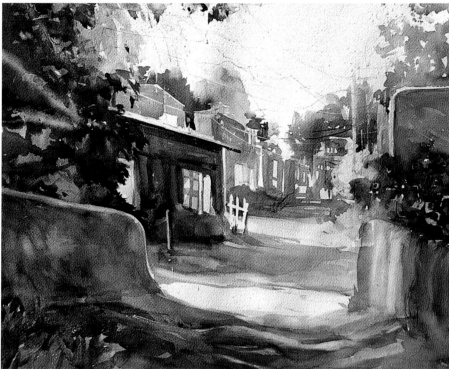

Detail
A closer look shows the variety in sizes, shapes and colors that makes the distant view more intriguing.

7 Take the Painting from Daylight to Moonlight

Have puddles Raw Sienna, Alizarin Crimson, Ultramarine Blue and Cobalt Blue ready for quick painting action. With a round brush, paint water around the moon and drop in Raw Sienna and Alizarin Crimson around the circle shape. Tilt the painting left and right while dropping in your blues for the sky. Gradate the sky from cooler near the buildings on the left to warmer near the street.

Using Burnt Sienna, Ultramarine Blue and touches of Alizarin Crimson, paint the distant mountain range, keeping the mountain's edge soft. Glaze the warmth of the moon here and there using Raw Sienna. Use touches of blue over the background buildings to continue cooling the area around the sky. Deepen the value of the wall in the right foreground to limit the light for contrast in the area.

Tilt the wet painting to move the paint while establishing the soft warm and cool edges. Paint around the trees to establish the glowing silhouettes. While the sky is still slightly moist, sprinkle small touches of salt to suggest stars, then let it dry. Using water and a stiff bristle brush or Fritch scrubber, soften the moon's edges, creating an atmospheric effect. Let dry.

8 Remove the Masking

Remove all of the masking with a rubber cement pickup. The crisscross network of power lines glistens in the autumn moonlight. Street lights, fences, mailboxes and other street scene details will help viewers recall times spent in such mysterious settings.

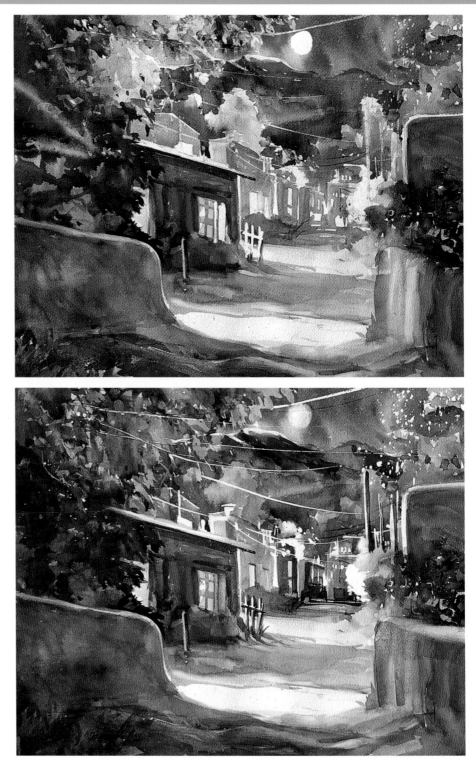

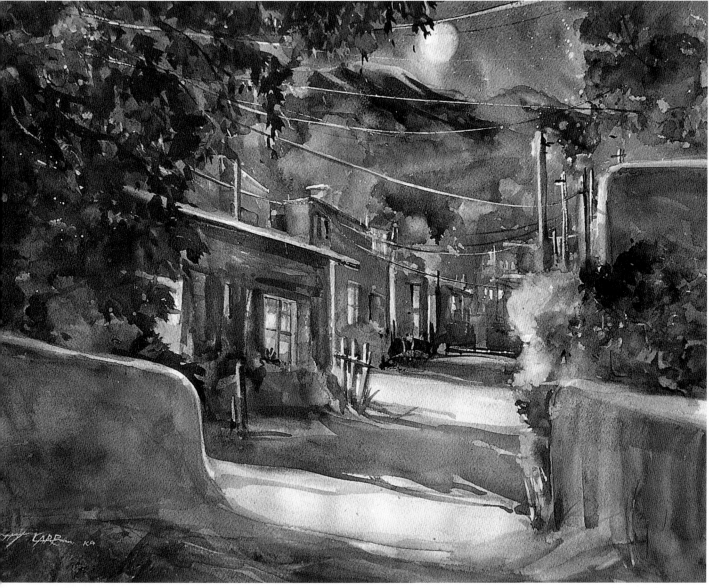

9 Finishing Touches

Using a Fritch scrubber and a small toothbrush, soften the edges where the masking once was. Also lift edges on foliage and forms on which the moonlight gently falls. Stand back from the painting to check the compositional aspects, mood and lighting. The middle-ground shadow may need to be deepened in value and cooled.

Deepening the value in the middle ground pops the light. Also, lifting more glow on the foliage at right helps the directional luminosity. Mix Antwerp Blue and Burnt Sienna with a touch of Alizarin Crimson and add to the tree shapes, giving depth and emphasizing the light direction. I covered some of the moon rays to move the eye closer to the center of interest and limit the effects of light for a more mysterious scene. Apply warm and cool glazes as needed to touch up various areas. With a few small darks and details, your moonlit scene is complete.

Moon Shadows • Watercolor • 16" x 22" (41cm x 56cm)

tip

Study Painters of the Night
One favorite painting that comes to mind is Vincent Van Gogh's *Starry Night*. How he captured the feeling of the clear, blue, autumn evening with such beauty is remarkable. Before painting night scenes, study the mastery of artists who have painted the night. Researching a variety of nocturnal subjects for painting is challenging as well as rewarding—it sparks the imagination.

portray multiple textures in the same light

before you begin

Eye level—slightly high
Light quality and direction—shimmering and coming from the left
Dominant value—low key
Color dominance—warm

materials

Paper
Arches 140-lb. (300gsm) cold press, 24"
x 30" (61cm x 76cm)

Watercolors
Alizarin Crimson • Antwerp Blue •
Burnt Sienna • Cadmium Orange •
Cadmium Red Light • Cadmium Yellow
Pale • Cobalt Blue • Cobalt Violet •
Indian Yellow • Manganese Blue •
Permanent Rose • Raw Sienna • Sap
Green • Thio Violet • Ultramarine Blue
• Viridian • Winsor Red • Opaque
White

Brushes
Nos. 8, 10, 12 and 14 rounds • ½-inch
(12mm) and 1-inch (25mm) flats •
small rigger • a few smaller brushes •
Fritch scrubber

Other
Pencil • masking fluid • palette knife •
spray bottle • rubber cement pickup

In composing this still life, the excitement of color and contrast as well as the challenge of reflecting textures was on my mind. Limited low light shows off the bowl of fruit and the scene's dramatic reflections. Overlapping shapes give depth to the scene, and connecting shadows are used to create harmony, eye movement and intimacy.

Be sensitive to various surface textures as you paint your still life. How would the forms feel if you were holding each in your hands? Cool and smooth, or warm and fuzzy? Does the form reflect light or absorb light? Sensing the surface of the objects in a still life is just as important as sensing the gestures of a person for a portrait painting. Aim to capture the spirit or the feeling of the scene rather than a literal depiction. Don't just paint a tree; paint a statuesque redwood or a tranquil willow.

Most painters are a bit intimidated by reflective surfaces, transparent forms and shadows, particularly in still lifes. Keep in mind to paint what you *see* and not what you know. By really seeing the shapes, the reflections, and the patterns that shadows take as they follow the form's contour—then grasping and translating their correct values and maintaining the proper edges—your paintings will come alive.

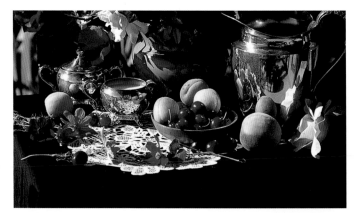

Reference Photo
The setup demonstrates a variety of textures as light is absorbed, reflected and bounced around. Through contrast, the dark background exaggerates surface textures and colors.

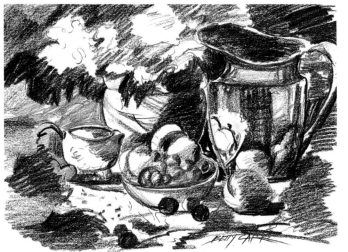

Value Sketch

1 Make a Drawing and Begin the Lace
Loosely sketch the placement of the various shapes. Imagine that you are actually painting the composition, using your entire arm to move the pencil for a lightly weighted, gentle line. To understand the shape of the round forms, you may want to draw the hidden ellipse (draw it through). Begin to suggest the negative spaces for the lace using Permanent Rose, Raw Sienna and Manganese Blue. Apply masking fluid to small areas in the light that will be placed within dark areas, such as the silver pitcher handle and cosmos stems in the foreground.

2 Start Painting the Center of Interest
The smooth, shiny cherries contrast nicely with the soft, warm, fuzzy peaches. Mix a variety of reds with Alizarin Crimson, Permanent Rose, Winsor Red and Ultramarine Blue to create the mini-spheres. Allow the paint to mix on the paper's surface, and leave a few small whites on the cherries for highlights. Repeat with the same colors in the pitcher's reflection of the cherries. Show the pitcher's contour by distorting the reflections.

Paint the peach with Indian Yellow and Cobalt Violet. Model the form using water first, then dropping in Indian Yellow on the left side and Cobalt Violet on the right side, allowing the paint to mix on the paper. Repeat this form in the reflection of the silver. Notice the negative space left for the bowl's rim in the pitcher's reflection.

3 Sculpt the Vase

Sculpt the blue vase using a large round brush loaded with water and paint, allowing gravity to help you. Gradate the blue around the vase, shifting from light blue (Manganese) and Cobalt Blue to Ultramarine Blue, Cadmium Red Light and Burnt Sienna, which should be applied on a semi-moist surface while leaving soft highlights. Turn the board sideways and let the pigment and water flow naturally, and soften edges as you go.

Begin the background near the dark side of the vase using Indian Yellow and Alizarin Crimson with a touch of Viridian. Make sure the edges are soft in this area. Add another peach to the fruit bowl.

4 Begin the Background Darks

Begin the background darks on the right using Antwerp Blue, Thio Violet and Burnt Sienna. Surround the silver pitcher with dark and light flowers using various violets. Create additional greens using Alizarin Crimson, Burnt Sienna and Antwerp Blue. Add a third peach to the bowl of fruit.

Paint the reflections of fruit on the pitcher with the same colors used for the actual peaches and cherries (see step 2). Make sure to follow the directional contour of the pitcher when painting the reflections. Antwerp Blue with touches of Burnt Sienna is reflected around the violet flower mirrored here. Use Manganese Blue, Permanent Rose and Raw Sienna to create variety in the silver-grays, using vertical strokes on a moist surface.

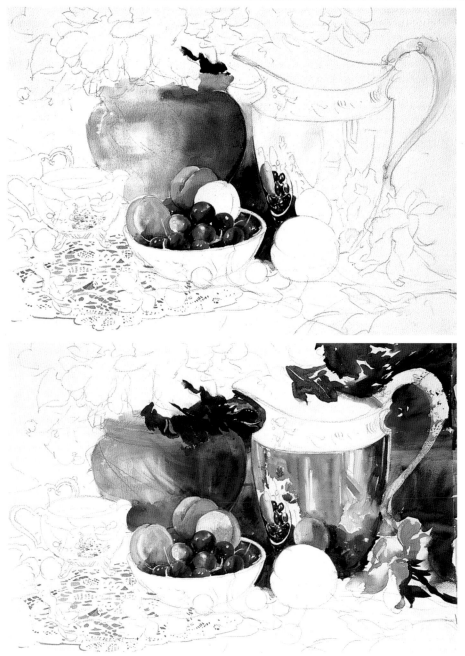

Detail

Here we see the dark violet flower's lost edge in the dark side of the vase. Notice the violet reflected in the vase. Alizarin Crimson and Burnt Sienna are glazed into the dark form shadow of the vase. This backdrop showcases the soft edges of the peaches in the foreground.

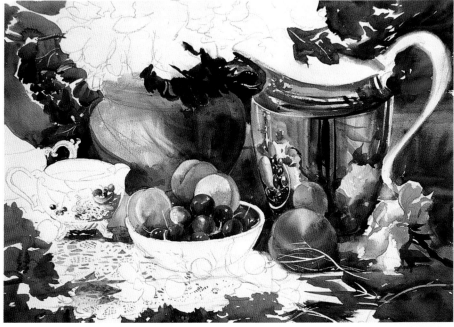

5 Remove the Masking

Remove the masking. Soften exposed edges in various areas of the background with a Fritch scrubber, and let dry for painting later. The asymmetrical shape of the lace and the white flowers in the vase harmonize the foreground flowers through repetition. Surrounding the reflections of the pitcher with various dark greens and grays helps the eye to zero in on the focal point.

Add warm colors in the lower left to further establish the shape of the lace in the foreground. Add another peach for interest and begin the reflections in the little creamer. The large peach, which is reflected in the silver pitcher, is painted and modeled using Indian Yellow, Cadmium Orange and Cobalt Violet with a touch of Viridian. Notice the masked-out lines of the foreground flower shape that appear as you paint the peach.

Detail

Paint colors confidently and allow them to blend on the paper. Building contrasting values, working edges, avoiding tangents and concentrating on directional lighting produces an effective, colorful grouping.

Detail

A variety of subtle and abrupt contrasts creates excitement in a painting. Here a controlled, tight approach is employed in painting the fruit and lace, while a looser approach is taken with other parts of the painting. Avoid "filling in the lines," which can tighten your work and dampen its spunk and spirit. It's really OK to go out of the lines and still maintain a sense of shape.

6 Develop the Bowl, Flowers, Creamer and Teapot

Using the same mixtures of grays, pinks and dark blues, continue painting the gradual, smooth transition of value on the cherry bowl and on the more detailed creamer. Loosely suggest the flowers and leaves in the vase using Manganese Blue, Permanent Rose, Alizarin Crimson and Cadmium Yellow Pale. Make the flower and leaf edges primarily hard to bring these shapes forward in your composition, but keep their overall shapes simple to avoiding eclipsing the center of interest: the fruit and its reflections. Add darker touches of green using a mixture of Antwerp Blue and Burnt Sienna, connecting various darks in the painting.

Develop the top of the pitcher, the handle and the teapot to the left of the creamer. Place a few random cherries on the lace, as well as their little shadows that show directional light. The bottom of the bowl holding the fruit has a cast shadow which is lost to the right and helps to connect the most recently added peach.

tip

Create Contrast With Textures

Throughout the book we've been working with contrasts and variety. Textural play is a subtle way to encourage viewers to become engaged in your painting. Cool versus warm, smooth versus rough, tall versus small, and dry versus juicy are all contrasts that create interest and move the eye through a painting.

7 Finishing Touches

Use a small rigger and small rounds to fine-tune details. Also use the edge of your palette knife to add a few loose touches of paint. Pick up Manganese Blue and Cadmium Yellow Pale with a touch of Cadmium Orange to paint the cosmos stems and small leaves. Continue the dramatic cast shadows on the vase, which will add movement and excitement to the piece.

Mix a darker version of the local color of the vase using Manganese Blue, Viridian, Cobalt Blue and Ultramarine Blue with a touch of Burnt Sienna. Use this color to gradate the shadow surrounding the form and to paint the cast shadows. Make confident strokes with a loaded brush, carving out the light on the left side of the vase. Lose the shadow's edge in the dark side of the vase, and add a little Alizarin Crimson there. Check all shadows, and add Opaque White highlights to a few cherries.

Tone down the activity in the lower-right foreground by glazing grays made with Permanent Rose, Cadmium Orange and Manganese Blue. Develop the pitcher by adding little darks, highlights and suggestions of reflections with a small rigger and thicker paint.

Fruitful Reflections • Watercolor • 24" x 30" (61cm x 76cm)

index

Atmospheric perspective, 16, 22, 24, 71, 102

Backgrounds, 26, 29, 36, 52, 64, 66, 71-72, 75, 77, 81, 85, 90, 92-93, 96-97, 99, 101, 104-105, 107, 111, 113, 119, 121, 131-133, 136, 138-139
Backlighting, 31, 36, 124-125, 132
Balance, 37-38, 101, 109, 112
Boats, 110-112, 115-117
Brushes
 oil, 54-55, 60, 68-71, 79-81, 89-91, 98, 101, 106, 108, 124-126
 watercolor, 46, 51-53, 60, 64, 74-78, 84-85, 94, 96, 102-103, 110, 113, 118-119, 130-132, 134
Buildings, 74-83, 110-111, 115, 125-126, 132-134

Canvas, 54, 60, 79, 89, 98, 106, 114, 124, 129
 toning a, 68, 80, 89, 98, 106, 115, 125
Center of interest, 15, 17, 37-39, 59, 67, 69, 72-77, 80-81, 85-86, 102, 105, 107-109, 115, 132-133, 135, 137, 140
 See also Focal point
Color harmony, 28, 83
Colors, mixing, 18-19, 75, 103
 blacks, 50
 browns, 49-50, 56
 darks, 50, 56
 grays, 18, 49-50, 56, 65, 72, 86, 95-96, 100, 107, 122
 greens, 56, 85, 138, 140
 oils, 56, 72
 watercolors, 49-50
Color temperature, 16, 19
 cool, 46, 49-50, 56, 74-75, 86, 88, 93, 102, 104, 106, 111, 115, 121-123, 130
 warm, 33, 35, 46, 49-50, 56, 64-65, 67-69, 74-75, 79, 84, 86-89, 92-94, 96, 98, 103-104, 116, 118-119, 121-126, 132, 136
Color, using, 16-19
 adjusting, 127
 analogous, 18
 blending, 52, 85
 complementary, 16, 18-19, 24, 28, 46, 49-50, 56, 72, 96
 lifting, 33 (see also Techniques, lifting)
 local, 24, 29, 111, 115, 120
 manipulating, 49
 muddy, avoiding, 48
 primary, 18, 46, 54
 reflective, 86, 105, 112
 repetition, 70
 secondary, 18

tertiary, 18
 values of, 17, 24, 56
Color wheel, 18, 28, 49
Composition, 37-43, 59, 94, 137, 140
Compositions, types of, 37-39
 asymmetrical, 26-27, 37, 101-102
 dramatic, 36
 "L", 26, 38
 off-center placement, 39
 "O", 38
 pattern, 39
 radiating, 33, 39
 "S", 37, 43, 102
 three-spot, 38
 triangle, 39
 tunnel, 38

Darks, 80, 85, 95, 119-120
 mixing, 50, 56
 See also Values
Depth, creating, 22, 81, 107, 114, 136
Details, using, 17, 29, 36-37, 46, 54, 57, 64, 71, 75, 77-78, 81-82, 85, 88, 95, 100-102, 104, 109, 113, 115, 117-118, 121-122, 126-127, 133-134
Diffraction, 30
Drawing, practicing, 58
Drawings, 47, 54, 58, 64, 68, 75, 85, 98, 111, 118, 136
 canvas, 68, 80, 89, 95, 106, 115, 125, 131
 contour line, 58
 gesture, 59

Edges, 13, 53, 57, 90
 hard, 26, 42, 77, 87, 90, 95-96, 101
 soft, 19, 46, 54, 66-67, 69-70, 72-73, 77, 83, 87, 90-91, 93, 95-96, 99, 101, 103-104, 107, 109, 111-113, 115-117, 120
Escape routes, creating, 15, 26-27, 42, 116
Eye level, 12, 14, 22, 32, 59
 determining, 23-23, 26, 37
 high, 64, 68, 102, 106, 110, 114, 118, 136
 low, 114, 124
 middle to low, 74, 79, 130
 straight ahead, 26, 58, 84, 89, 94, 98
Eye movement, 26-27, 35, 37, 58, 64, 69, 92-93, 117, 132, 136, 139-140

Flowers, 50, 60, 81, 84-101, 118-123, 137-141
Focal point, 29, 72, 87, 139
 See also Center of interest
Foliage, 32, 53, 65-67, 69-70, 73, 75-77, 80-81, 83, 85, 87, 90, 95-98, 112, 116, 120-123, 125-127, 131-133, 135

Foregrounds, 26, 64-65, 69-70, 72-73, 75, 80-81, 87, 93, 97-98, 104, 107-109, 111-112, 115-117, 122-123, 126-127, 132-134, 138-139, 141
Forms
 connecting, 27, 33
 creating, with color, 19
 seeing, 12-15, 23, 30, 33-34, 58-59
 simplifying, 17
Fritch scrubber, 46, 52, 67, 77, 87, 105, 113, 132
Front lighting, 31
Fruit, 35, 86-87, 92, 136-141

Gesso, 54
Gradation, 13, 19, 27, 30-31, 49, 51, 75, 85, 91-92, 98, 100, 103, 107, 115, 134, 138, 141
Grass, 111, 113, 115-117

Highlights, 13, 71, 86, 95, 100, 112, 117, 137-138, 141
Human figures, 109

Landscapes, 30, 48
 oil, 68-73, 106-109, 114-117
 watercolor, 64-67, 102-105, 110-113
Light
 characteristics of, 13-14
 color of, 24
 designing with, 26-27
 phenomena of, 30
 radiating, 33, 114
 reflected, 13, 34-35, 65, 91, 111, 115, 125-126, 129
 sources of, 15, 24, 59
 types of, 31, 36
Light, direction of, 14, 26, 31, 34, 58, 82, 101
 back, 31, 36, 124, 130
 left, 102, 104, 106-107, 110-112, 114-115, 130, 136
 right, 26-27, 64, 68, 74, 79, 84, 89, 91, 93-95, 98, 118, 120
Light, quality of, 14, 34
 atmospheric, 84 (see also Atmospheric perspective)
 glowing, 64, 68
 luminous, 34, 74, 79, 89, 94-95, 98, 102, 105-106, 124
 morning, 36, 110, 118
 mysterious, 130
 shimmering, 136
Light, temperature of, 16, 24
 cool, 24-25, 28
 warm, 24, 28, 80, 98, 101, 122

Masking, 29, 36, 47, 53, 76-77, 95-96, 103, 111,
 118, 131, 135
 applying, 46, 76, 131, 137
 removing, 53, 96, 105, 112-113, 121-122,
 131, 134, 139
Masking fluid, 47, 77
Mat, using a, 77, 87, 105, 112
Middle grounds, 26, 64, 66-67, 69-70, 75, 80-81,
 104, 107-108, 111-112, 116, 133, 135
Moon, 130-135
Mountains, 16, 42, 66, 72, 104, 108-109, 111,
 115, 134

Night scene, 130-135

Oils, 33, 54-56, 61, 63, 110
 demonstrations, 68-73, 79-83, 89-93, 98-101,
 106-109, 114-117, 124-127
 materials, 54-56
 mixing, 56, 72
 plein air painting, 60, 124-127, 129
 techniques, 57 (see also Techniques)

Palette knife, 46, 53-55, 66, 76-78, 81, 95, 104,
 111, 120, 131
Palettes, painting, 46, 54-55
Paper, watercolor, 47-48, 51-53, 60, 64, 74, 84,
 94, 102-103, 110, 118, 130, 136
Penumbra, 13
Perspective, 22-23, 69
 atmospheric, 16, 22, 24, 71, 102
 one-point, 22-23, 39
 two-point, 22-23, 120
Photos. See Reference materials
Pigments, transparent, 29, 47
 See also Watercolors
Plein air painting, 16, 48, 59-60, 74, 124-129
Point of view. See Eye level

Reference materials, 59, 64, 68, 74, 79, 84, 89, 94,
 98, 102, 110, 114, 124, 128, 130, 136
Reflections, 13, 34-35, 66, 70, 87, 93, 97, 101,
 110, 112, 116, 136-139, 141
Refraction, 30, 32
Repetition, 26, 70, 109
Rocks, 35, 53, 103-105, 107-109, 113
Rubber cement pickup, 47, 53, 74

Scenes, simplifying, 15
Seasides, 110-117
Shadows, 23
 cast, 13, 24, 86, 88, 91, 95, 99, 101, 115, 140-
 141
 color in, 24-26, 29, 64, 122-123

core, 13
darkening, 65
designing with, 26-27
drawing, 68
edges of, 13, 24, 26
form, 13, 16, 96
shapes of, 25-27, 34, 69, 71, 94
shapes of, connecting, 27, 36, 85-88, 132, 136
values of, 13, 34
Shadows, temperature of, 13, 24-26, 91, 93
 cool, 24-25, 27, 36, 69, 91
 warm, 24, 27, 34, 36, 69
Shapes, 15, 23, 90, 122
 See also Shadows, shapes of
Side lighting, 31
Silhouettes, 24, 31, 36, 132, 134
Sketches
 doing, 37
 plein air, 60, 74-75, 124-129
 preliminary, 58
 thumbnail, 110
 See also Value sketches
Skies, 16, 22, 35, 42, 76, 80, 104, 108, 111, 115,
 117, 126-127, 131-132, 134
Still lifes, 48, 60
 oil, 89-93, 98-101
 watercolor, 84-88, 94-97, 101, 118-123, 136-
 141

Techniques
 blocking-in, 54, 65, 69, 75, 81, 126
 calligraphic, 57
 direct painting, 57
 doodling, 57
 drybrush, 51
 fanning, 57
 glazing, 36, 46-49, 66-67, 76, 78, 85, 95-97,
 104, 111, 113, 119-121, 123, 132, 134-
 135, 138
 knifework, 53, 66, 95 (see also Palette knife)
 lifting, 33, 46-47, 52, 67, 112, 132, 135
 linework, 54
 marbling, 80, 115
 oil, 57
 pushing, 57
 salt, 47, 52, 74, 76, 84, 87, 103, 113, 134
 scraping, 51, 53, 61, 76, 95, 104-105, 120
 scumbling, 57
 side action, 57
 smudging, 57
 spattering, 46, 52-53, 78, 97, 105
 springing, 57
 wash, 46, 51, 75-76, 105, 112

watercolor, 51-53
 wet-into-wet, 52, 65, 75, 112
 See also Masking
Texture, 13, 15, 22, 46-48, 52-53, 103, 120, 125-
 126, 136, 140
Tints, 54, 56, 85, 87
Top lighting, 31
Transparency, 34
Trees, 16, 36, 59, 66, 70, 73, 103-104, 107-109,
 111, 115, 126-127, 130, 132-133, 135-136
Turpentine, 54, 60, 68, 80, 89

Values
 balancing, 37
 building, 65
 color of, 17
 contrast of, 36, 97, 99, 139
 darkening, 66, 76, 87, 96-97, 100, 112, 120,
 122, 132-135
 evaluating, 73, 78, 105
 high-key, 17, 36, 64, 68, 84, 89, 98, 102, 106,
 114
 lightening, 33, 133
 low-key, 17, 74, 79, 118, 124, 130, 136
 seeing, 12, 15-17, 42-43, 58, 74, 81-82, 90
 shadow, 13, 34
 shifts in, 31
 using, 12-13, 19, 29
 See also Darks
Value scale, 17
Value schemes, 17
Value sketches, 14-15, 27, 37, 43, 47, 58, 60, 64,
 68, 71, 74, 79, 84, 89, 94, 98, 106, 114,
 118, 124, 128, 130, 136
 scaling up, 103
 See also Sketches
Vases, 34, 85-86, 91-92, 95-96, 100-101, 138-141
Vegetables, 58

Watercolors, 33, 36, 46-48, 57, 61, 63, 101, 124,
 128-129
 demonstrations, 64-67, 74-78, 84-88, 94-97,
 102-105, 110-112, 118-123, 130-141
 manipulating, 49
 materials, 46-47 (see also Watercolors, demon-
 strations)
 mixing, 49-50
 plein air painting, 60
 techniques, 51-53, 94 (see also Techniques)
Water, painting, 32, 42, 48, 66, 70, 73, 102-110,
 112-113, 116
Whites, saving, 47, 61, 76-77, 87, 95, 104

Check out these other great North Light titles!

Learn how to act upon your artistic inspirations and appreciate the creative process! This book shows you how to express yourself no matter what unusual approach your creations call for! Experiment with and explore your favorite medium through dozens of step-by-step mini-demos. Start today and make your artistic dreams a reality!

ISBN 1-58180-102-5, hardcover, 144 pages, #31790-K

Here's all the instruction you need to create beautiful, luminous paintings by layering with watercolor. Linda Stevens Moyer provides straightforward techniques, step-by-step mini-demos and must-have advice on color theory and the basics of painting light and texture—the individual parts that make up the "language of light."

ISBN 1-58180-189-0, hardcover, 128 pages, #31961-K

Here's the information you need to master the exciting medium of water-soluble oils! You'll learn what water-soluble oil color is, its unique characteristics and why it's generating so much enthusiasm among artists. Water-soluble oils make oil painting easier and more fun than ever before, plus you get gorgeous results. You may never go back to traditional oils again!

ISBN 1-58180-033-9, hardcover, 144 pages, #31676-K

Ensure that your compositions work every time! Inside you'll find an insightful artistic philosophy that boils down the many technical principles of composition into a single master rule that's easy to remember and apply. Greg Albert provides eye-opening examples and easy-to-follow instructions that will make your paintings more interesting, dynamic and technically sound.

ISBN 1-58180-256-0, paperback, 128 pages, #32097-K

These books and other fine North Light titles are available from your local art & craft retailer, bookstore, online supplier or by calling 1-800-448-0915 (US) or 0870 2200 200 (UK).